Five-Inch Heels

Library and Archives Canada Cataloguing in Publication

Lee, Belynda, 1968-, author
 Five-inch heels : when women step into their power
/ Belynda Lee.

ISBN 978-1-77141-063-2 (pbk.)

 I. Title.

PS8623.E4355F58 2014 C813'.6 C2014-905141-7

Five-Inch Heels

When Women Step
Into Power and Success

Belynda Lee

Cover design and layout: Marla Thompson
Typesetting: Greg Salisbury
Author photo: Charlie's Photography
Cover photo: Black Label Photography

Dedicated to the greatest inspiration, mentor and
man in my life, Lee Yat Man.

To Benjamin and Sue-Lee, thank you for having faith in me.
Love you always!

"Belynda Lee delves into the true meaning of leadership in 'Five-Inch Heels'. She shows how effective leadership is compassionate and motivating. Read this book and be inspired."
Jeff Olson, Founder/CEO, Nerium International
Best-Selling Author of *The Slight Edge*

"'Five-Inch Heels' is a book that will leave you feeling ready to face life's challenges. Belynda Lee draws you in from start to finish. Her optimism rubs off on the reader and her positive energy jumps off every page."
Kate Muker, CEO, Conscious Divas

"This is no ordinary book; this is inspirational energy for the world. The message that Belynda Lee has created will greatly impact anyone who has the privilege of reading a copy. Inspirational, engaging, thought-provoking, motivational beyond belief..."
Gerry Visca, Inspirational Speaker, Publisher of *Defyeneurs*

"Powerful, moving, humorous and honest— 'Five-Inch Heels' is a book about determination, resilience, and, most importantly, about love. Belynda shows how a realization of her own worth and power altered the course of her life."

Sharon Lechter, author of *Think and Grow Rich for Women*, co-author of *Outwitting the Devil*, *Think and Grow Rich—Three Feet From Gold* and *Rich Dad Poor Dad*

Acknowledgements

I would like to express my gratitude to the many people who supported me in writing my story—to all those who provided motivation, reviewed, discussed, offered comments and allowed me to quote their remarks.

Thank you to all the special individuals in my life who pushed me towards publishing this book, especially Julie Salisbury for believing in my story, and the entire team at Influence Publishing for helping me in my endeavour of becoming a published author.

To the rest of my family and friends who supported and encouraged me despite the time it took—thank you for being so understanding. Those who nominated me for awards, those who saw and knew me before I could see myself and those who challenged me—thank you for reinventing the new "me."

Above all, I want to thank my children, Benjamin Wright and Sue-Lee Wright, for their constant reminder to never give up in pursuing my dreams of sharing and empowering others. Sue-Lee honey, I am done!

Last but not least, to all those who have been a part of my life over the course of the years and whose names I have failed to mention—please know that I am grateful to you for being part of my journey.

Contents

Dedication
Testimonials
Acknowledgements
Contents
Why "Five-Inch Heels"?
Foreword
Introduction

Why did I pick "Five-Inch Heels" as the title for my book? Heels are never easy to walk on, it takes balance, strength, and endurance to squeeze our feet into those tightly fitted shoes, and not forgetting that when we have them on, we are standing on our toes for hours. Even though it hurts, women love heels, because they allow us to stand up taller, look slimmer and feel more confident. Walking in heels can be tricky, and walking in them fearlessly needs a lot of practice. We start off with small and slow steps, we balance ourselves so we don't trip and fall. Eventually as we get comfortable with them, we begin taking bigger strides, holding our head high, shoulders back, abdominal muscles engaged, as we stand up straighter and taller. Aside from vanity reasons, women wear heels so they can see eye to eye to their male counterparts and have a comfortable eye level conversation with them.

When you think about it, it is a learned skill, just like riding a bicycle—the more you practise, the easier it is. Isn't wearing a pair of heels like living life? We learn to overcome adversity one day at a time, and after a while we don't consider them as life issues anymore. Life is simple, we all tend to strive to reach higher, while at the same time aiming to develop balance, mental strength and endurance so we can get through painful and uncomfortable situations. The roads we take in life are never easy. If the road is easy and painless, we are likely going in the wrong way. Comfort will not take you to where you need to go in life. Women are so good at the balancing act.

They balance themselves wearing these heels, at the same time balancing work and family. It is a true balancing act. Balance is also metaphorically linked in the mind to the concept of parity, and our subconscious awareness of common metaphors has the power to influence our actions—actions that we need to take care of business.

Ladies, let's put on those heels, stand straighter and taller, show up confidently to face these adversities and take actions to achieve a higher life.

Enjoy the book!

FOREWORD

A wise man once said that people who lose track of their yesterday can have no meaningful tomorrow. The great tragedy of history is that people rarely learn from it. When we learn from the successes and failures of those who have gone before us, we can wisely evaluate the present and plan properly for the future. Much of the aimlessness we see in today's society testifies to the grim realities of what happens when societies begin to crumble because people lose track of what makes them strong.

It is precisely this reality that makes *Five-Inch Heels* so inspiring and timely. Out of the crucible of her own life and experience, Belynda Lee reminds us that taking the wrong path can misdirect and misguide us to a different destination, or can lead us to walk in circles, just like the game of maze. Yes, dreams are within all of us and some will be challenging. We must decide whether we are going to allow those challenges to weigh us down to the point of not fulfilling our dreams.

In this book, you will be inspired by Belynda Lee's story of her early years of trials and tribulations that taught her how to love unconditionally by first learning self-love. She shares how she was able to let go of resentment and focus on being joyful again. In Belynda's darkest hour, her will to live was reignited by three simple words, "I Love You," as she immediately decided to live, never settle, and take control of her life. Today we have a successful international corporate executive, speaker and author; a woman who is passionate about empowering

women around the world. I challenge you to let *Five-Inch Heels* be the catalyst that draws you to the greatness of your purpose in life.

Deavra A. Daughtry
CEO, Philanthropist, Author
TWEF Founder

"In her five-inch heels, white suit and rolling her Louis Vuitton luggage, she makes her way quickly through a walkway towards the convention centre where she's scheduled to speak. Soon after she arrives, they wire the microphone on her and give her the signal she's next.

"She walks at a leisurely pace to the side of the stage, gently and with ease as if speaking in front of a thousand people is as comfortable as blinking an eye. The voiceover introduces her, the crowd roars with applause, and she steps up on stage to welcome the crowd to the Montreal conference.

"She delivers a message that resonates with the audience and soon enough, they stand and applaud her as she exits the stage. Soon after, she puts on an aqua blue sequin dress and matching hair extensions to host a game show on stage. She jokingly says, 'I'm now my alter ego, Belynda Boo.'

"In truth, this woman wears many hats—vice president, game show host, world traveller, mother of two and much more. With each hat she wears, she jumps through obstacles with her hard work and determination. This woman is Belynda Lee."

As I read the online blurb by an old colleague, Trudy Tran, old memories flood my mind. I certainly used not to be that sure of myself. I was so uncomfortable in my own skin, I hated looking at myself in the mirror. But when a person encounters defeat, she learns what she is truly made of and fights to rise above it.

> *"You may encounter many defeats, but you must not be defeated. In fact, it may be necessary to encounter the defeats, so you can know who you are, what you can rise from, how you can still come out of it."*
> **Maya Angelou**

I became pregnant at the age of twenty-one with my first child in the winter of 1990. At that time, I was unsure of myself as a young woman; I was a young immigrant. It took me a while to decide whether a child should bring another child into the world. Forrest Gump was right on the money when he said, "Life is like a box of chocolates. You never know what you are going to get." However, I think life is also more like a jar of chili peppers, because what you choose to do today may burn you tomorrow.

My grandfather used to tell me that in life there are a ton of unexpected curveballs; he advised me to "Learn how to catch them, or they will hit you in the face."

As a young girl, I wanted to be a designer of some sort, living in a prestigious community and enjoying life at large. That way I could be safe and certainly would not be entertaining any curveballs. Despite all my efforts to make it in the design world, I ended up as a young, single mother of two, a pregnant student struggling in a foreign country to put food on the table. That was some twisted curveball all right. And since I wasn't expecting it, yes, you are right: it hit me right in the face. I was in pain, bruised, and hurt for many years, figuring out whether I should throw in the towel and call it quits.

But again, what doesn't kill you in life will make you stronger. So I decided to pick myself up, heal my wounds, train harder to refine my life skills to catch my next curveball, and now, I am a speaker, an executive, a mentor, and an author. That was a total 360° directional change from my dream as a little girl. Am I happy and content with my life? Absolutely! Life is what we make of it. We can live life to its fullest or we can be crabby about it. Happiness comes when we live on purpose, and I have clearly found my absolute purpose.

We need to look at the positive things in life, project them onto a giant screen, and celebrate every day as though it's a brand new day. As women, we have the tenacity to deal with issues, we are flexible enough to compromise, and we let our hearts, rather than our egos, do most of the thinking. For that reason alone, we soar in anything we put our hearts to, and—not forgetting—while still wearing those sexy-looking five-inch heels.

There are so many women in this world juggling the roles of being a wife, a mother, and a shining entrepreneur or an employee, just to make ends meet. Ladies, let's celebrate that, because we are outstandingly incredible! How do we ever do it all and do it so well? A small number of us will find our paths early without mentorship or sponsorship. Men find mentors and sponsors who are invaluable to their careers and life advancement, while there are very few of us women who have the time to take another woman under our wings for mentorship and guidance. There are many women who have taken a lifetime in the process of finding direction in life. And for that reason, I am writing this book.

This is not a self-help book, nor a memoir; however, as a storyteller, I hope the stories about my life can help you get through a day at a time. I do not have perfect solutions for deep complicated life issues, nor clear advice on career management. I do know that my authenticity will help you accept life a little more easily and find your purpose sooner. I hope this book will inspire men as much as it will inspire women. Whatever this book is, I hope to transfer some positive thinking from me to you.

So why are we here? Nothing happens to us by accident; we all have gifts within us to help manage challenges and obstacles. If you have the courage, the passion, and the belief in yourself, these gifts will shine through you. And the more you know yourself, the easier it is for you to find your direction in life by not letting others tell your story for you, because you will be writing your own story.

Having mental toughness is so important for moving ahead. It can lead you to greatness, both in life and at work. There are a few values I recommend in order for us to grow as individuals and be mentally prepared: in life we need to have self-responsibility, self-discipline, perseverance, enthusiasm, confidence, and the power of choice. And lastly, remember that we can never be too comfortable.

Writing this book has really gotten me out of my comfort zone! This is probably the toughest project that I have ever had bestowed upon me: the audiences who heard me telling my story suggested I write it. To describe it visually, I can say it would be like diving into complete darkness and hoping to hit something soft. This is exactly what I am doing here; I am

mentally diving into complete darkness. But my darkness is different from the darkness you are envisioning. My darkness is my past that I am trying hard to forget, as it has not left me with fond memories. I will be writing in my most vulnerable state, juggling my memories to tell the story. Hopefully they will inspire you and redirect you to the right path in an enthusiastic positive manner.

Enthusiasm, happiness, and positivity are contagious! Being around someone who is passionate about what they do rubs off on other people. It makes them want to be around you more and gravitate to that positive energy you're exuding. You will in turn, become the human magnet of positive energy. Through self-acceptance, confidence, and direction, positive energy will prepare you for a bigger, better, and more purposeful life. Ignite it with passion and let the flames go wild while standing taller and showing up in your five-inch heels.

> " *Everybody's time is limited, so don't waste it living someone else's life! Don't be trapped by dogma, which is living with the results of other people's thinking … and the most important, have the courage to follow your heart and intuition, they somehow already know what you truly want to become. Everything else is secondary.* "
> **Steve Jobs**

On to the first chapter…

THE
BOARDROOM

More charts and graphs flash up on the projector screen as the presenter continues on about the sales and profits of the company. With each slide, someone makes a comment. Graph after graph, comment after comment, the entire room has spoken except for one person. She sits in silence watching the interactions between the people in the room. The room is full of successful chief officers and vice presidents from different markets of a rapidly expanding, publicly listed company. Each person comes with experience, education, and their own theory as to what needs to be done for the company to grow even faster. The silent woman was one of three females in the boardroom. The other females spoke frequently but their comments were not well received. The ideas they shared didn't sit well with the men who were in power in the room. The two women didn't stop. They kept talking and commenting, hoping that something they said would get the attention and approval of their male peers. No approval was given.

Our protagonist continued to remain silent.

Some may see her silence as passivity; others may see her silence as a lack of thoughts and ideas, but in truth,

her silence was a strategy. While everyone barked out comments and ideas on everything, she listened intently, forming questions and ultimately solutions to their problems. She waited patiently until they had expressed all their comments, ideas, and objections.

Finally, she turned on her microphone and made a comment, not on a particular graph or idea, but on the overall movement of the company. Her comment caught their attention. For the first time in two hours, the room was completely silent as they waited to hear what else she had to say. She followed her comment with a solution to their problems. They listened, nodding every so often in approval of what they heard. As she spoke, she surveyed the room and knew she had their buy-in.

To her, it was no surprise she had won them over. After all, they didn't even come close to her toughest critic—her grandfather.

First Grandson

Her grandfather was also a great planner: every step in his life was a planning process. He was meticulous in the execution of his life, even when he was selecting his life partner. He had pictured in his mind what his wife would look like, and how many kids he would like to have. Everything he foresaw became reality. Although he had an arduous childhood in China, he was always able to conquer every battle in his life, and everything was going so well in his life except for one thing; the one and only thing that didn't go according to plan came on March 15, 1968.

Grandfather Lee was pacing back and forth in front of the delivery room, excited for what was to come. He was ecstatic for the birth of his first grandchild and, if all the stars were lined up, it would be a grandson. The clock ticked; thirty minutes passed; then another hour went by.

His heart was beating quickly, anxiously waiting. He looked up at the clock. The second hand made its tick-tock-tick-tock sound, hypnotizing him into a state of ecstasy where he saw himself proudly holding his grandson and showing him off to his business partners and friends. The sound of a passerby's footsteps took him out of his trance. The red light was still on, signaling that the doctors and nurses were still working on the delivery. He looked at the clock again; six hours had now passed. What could be causing it to take so long, he thought to himself.

The red light finally went off. He stood up so quickly he almost lost his balance. The arrival of his first grandchild had now become a reality. He was now just waiting for the nurse to announce that he had a grandson. His fingers continued to tap on the side of his legs and the nurse, whose surname was Poon, came out of the delivery room wearing a smile as she approached him.

"Mr. Lee, Congratulations! You have a grandson!" said Nurse Poon.

He unconsciously let out the biggest grin—a smile perhaps even larger than when his first son was born, thinking to himself that the Lee legacy could now continue on for another generation. He put his hands together, looked up, and said his thanks to his god. He made his way over to

Nurse Poon, shook her hands and probably mentioned a hundred thankyous, before he attempted to make his way into the delivery ward to carry his pride and joy.

Nurse Poon stopped him and said, "Mr. Lee, we are not ready yet. Give us another thirty to forty-five minutes to clean up before we bring you in."

A little bit in shock, he responded, "What? Another thirty to forty-five minutes? I can't wait that long to see my grandson. Can I take a peek at him?"

Nurse Poon sternly looked at him and said, "Unfortunately not. You will just have to wait. He will be right out within an hour."

Thirty minutes felt like an eternity to him. His excitement surpassed the level of normalcy as he pulled out yet another cigarette; he was a chain smoker but that day he must have had a pack within an hour. As the next shift of nurses came on board, Nurse Tan replaced Nurse Poon.

Smiling to Mr. Lee, Nurse Tan graciously carried the baby to him, "Mr. Lee, congratulations. You may now hold your granddaughter."

He turned his head to Nurse Tan, stunned and confused. "What do you mean by my 'granddaughter'? I have a grandson," he said in a slightly annoyed tone.

"I am sorry, Mr. Lee, you must have heard wrongly. This is your grandchild and it is a girl," replied Nurse Tan.

"That cannot be true, I think you made a mistake. I am not holding her! Nurse Poon confirmed earlier that I had a grandson. Not a granddaughter! Take her back into the room and bring out my grandson!" He started to raise his voice.

4

"Mr. Lee, please calm down; you are in a hospital. We have not made any mistake. This is your granddaughter. There is no other baby in there to exchange," she said.

By this time, he was not only confused, he was angry. "How can my first pride and joy, the successor of the Lee family be a girl, especially when Nurse Poon said I had a grandson? She must have the wrong head screwed on today."

He sat on the hospital bench, refusing to carry the baby as the other family members had hurried over to seek clarification with the doctors on the confusion that had taken place. They returned to the despairing fifty-seven-year-old man sitting on the bench, who was still in disbelief that his grandson might have been swapped with someone else's child. He stood up suddenly and went straight into the delivery room.

"Where is my grandson!" he yelled "What have you done with him?" he questioned. The doctor and nurses pushed him out of the room, as they were attending to the mother who had recently delivered a healthy seven-pound baby girl. His family pulled him aside to calm him down. Before long, tears started to run down his cheeks.

"Where is my grandson? Please return him to me." He cried like a little child. If he could ask for anything, it would be a grandson, the very gift he had always wanted.

"Father," his son Chee Kin said, "Nurse Poon made a mistake. It is a girl and not a boy. We have a daughter and you have a granddaughter now."

"There is a mistake. Nurses don't make mistakes. She said I have a grandson, Kin. Where is he?"

His son was not able to settle him down. Helplessly, he watched his father in despair. There was nothing he could do for him. Pained by his father's sadness and defeated by the situation, all he could say was, "Let's go home, father. You have had a long day; we will come back to visit again tomorrow."

The entire Lee family left for home. They left the new mom and her newborn baby girl at the hospital for the night.

The following day, the ladies of the Lee clan returned without the men to check up on the new mother and her daughter. Apparently, Mr. Lee was still distraught that evening; he had been up the entire night analyzing how a baby boy could have turned into a baby girl within an hour.

It didn't take long before the new mother and her baby girl were released from the hospital. Everyone was ecstatic to see their return home—everyone except Grandpa Lee, who still seemed quite confused by the situation. He would walk away as the family shared the baby girl's daily growth progress. He would excuse himself for a cigarette after dinner, then return home later than usual so everyone would be asleep including the baby girl and he wouldn't have to look at her.

One Sunday afternoon, the ladies had a plan to finally get the old man to look at his granddaughter—they would leave the baby girl at home as they shopped for the little girl's lunar celebration to celebrate her first month in the world. They figured when Mr. Lee came home to a crying baby in the crib, he would have no choice but to hold her

and soothe her. This was their way to put some sense into the old man and for him to finally acquaint himself with his grandchild. After three hours of shopping, the ladies of the Lee household returned home to a crying baby whom they had left at home all alone. She was sobbing so loudly and choking on her own tears that they knew Mr. Lee had left the baby in despair; he had left home for the racetrack with a few friends. They were smoking, drinking, and betting on his stallion named "Song." The ladies of the clan felt dejected; that was not the first time he had clearly shown no concern for the newborn.

The ladies didn't give up. Over the next few months, they continued to find ways to introduce her to him. Some days were better than others; months passed but still, there was no great success in bonding the two.

One day in December, when the child was almost ten months old, she became very sick. Running a fever of 40° Celsius (104° Fahrenheit), her tiny body rejected every little bit of nutrition; she was vomiting everything she had eaten. She was taken to the emergency department of the hospital that afternoon, and was diagnosed with severe food poisoning. She was to be kept in hospital for two weeks to ensure a full recovery.

The ladies of the Lee clan came to visit every day, crying each time they saw the baby girl so pale and weak in her crib. They were still confused as to how she could have food poisoning as all she was fed was natural baby food. However, their visits would brighten up the baby girl's world; she would recognize them and their presence would put a smile on her face.

One day, Mr. Lee had to drive the ladies to the hospital and, as usual, when the baby girl saw them coming, she would sit up by the crib extending her hands through the metal bars, trying to reach for them. Something unexpected happened that day—Mr. Lee went inside to see the child and when she saw him, she tried to stand, holding herself up with the help of the metal bars, in hopes of touching his hand. It was the first time she had stood on her own; it was a big moment for everyone to watch.

Mr. Lee stood back for a few minutes, not knowing what to do; everyone in the hospital was cheering him to respond. Finally, he made his first step toward her and stretched out his hand; she was ecstatic at his actions and made a loud chuckle. The touch of their hands connected the two that very moment. He touched the bruises on her head; she had made them by hitting her head against the metal bars on the crib every single night when visiting hours were over and the ladies said goodbye.

That day wasn't any different—when it was time to leave, the baby girl started to cry. As cries turned into sobs, she tried to stand with the help of the bars and knocked her head against the metal bars as a protest against their departure. Mr. Lee had never seen anything like that before. He saw the strength of not giving up, and determination in her wanting to be with her family; he saw that the pain didn't stop her.

Unknowingly, she won him over that evening: for the first time he saw the strength of a boy in her. Her actions reminded him of when he was a young teenager, fathering

his sister in a foreign country. The pain and suffering he endured didn't stop him from wanting to provide for his family. From that moment onwards, he accepted her into the family, and unknowingly fell in love with the strength of the child; he no longer wanted ever to part with her. She was bawling when he walked away from the hospital, and so was he.

Many said that it was after that ordeal that the two of them became inseparable. Whenever you saw him, you would see her. He would rush home from work to find out her progress that day, and she would only want to be around him. They became one person, one soul; they were united. They had such a close bond it was clear to many that they were the most connected in the family.

Growing Up as the First Lee Grandchild

As Peng was growing up, she would sit next to her grandfather while he worked; he would take her out on business meetings, discussing work matters and projects. Without her knowing, he was training and mentoring a successor for his family. Naturally because of such exposure, she already understood the basics of business ethics at a very young age. Grandpa Lee was indeed a very respected man in the community, especially in the timber industry. People tended to follow him for his leadership and his loyalty to his friends. He was not only generous, he was a great mentor and a genuine friend to many.

When one of his friends was in dire need of money, instead of giving him financial assistance, Grandpa Lee decided to teach him how to generate an income. He helped his friend set up a small restaurant, taught him how to cook, and even cooked alongside him to get his business going. Grandpa Lee gave up the time he would have spent with his family so that he could help a friend be financially independent. According to Grandpa Lee, there was no limit to giving. He gave by teaching sustainability in life; he gave by teaching life philosophy; and he gave generously to the local community. He believed that if one gave, he or she would receive it back tenfold and, if you are sincere and genuine, maybe a hundred or even a thousand times over.

One day Peng watched her grandfather finalize a business contract; in those days a verbal agreement would do the trick. He was very excited about the project as it was probably one of the most profitable ones for a long time. Time passed and he was at the final stages of completing the project, when he came across some major challenges that meant he would be unable to complete on time for his client. He could cut corners and still make his deadline for completion, or he could admit to failing to complete in time and lose the reputation that he had built up over the years.

Rather than admitting failure, Grandfather Lee injected his own savings into the project so it could be completed as agreed. Instead of making a profit, he lost a lot of money on the deal. The family asked him why he made that decision.

He said, "My word is gold. As a businessman, you can lose your reputation overnight, and it will take years to build it up again. It only takes a couple of dissatisfied clients to quickly lose our reputation. When we put our family name on the line, we must deliver as promised. That is called the Lee integrity. The timber communities are too small and word would travel fast if we were to be branded as an unreliable, unethical company; by not following through it would slowly diminish our name. Honest businessman who deals in big projects does not calculate small losses."

Those few words enlightened the family and helped him gain the respect of his peers and business partners.

Peng watched him over the years strategizing and handling tough situations daily and weekly. Somehow or another he managed to survive all of them. Throughout the years, he showed her that proper planning and strategizing would determine the success of the execution.

"Peng, you can never be too prepared. However, when it is time for execution, do not procrastinate. Move forward fiercely as planned. Don't let distractions get in the way. Trust your business partners and focus on the end result. This will set you on the right path of success," said Grandpa Lee.

After he retired, his sons took over the timber business as second-generation business owners and he acquired the position of an advisor. As a retired man, Grandpa Lee spent numerous hours playing his favourite card game, solitaire. His sons would interrupt his game of cards with business issues and concerns, proclaiming them impossible to

resolve. He would never be annoyed with them for inter-rupting his game of solitaire. Conversely, he would get ex-tremely upset if they repeated the same mistakes or asked the same questions over and over again. He was a man who had little patience for redundant questions. He always said, "Smart people will make mistakes but only the dumb ones make them over and over again. So if you have a choice, which would you rather be? Do you want to be the smart one or the dumb one in the family?"

Grandpa Lee was a very wise man; he was also very phil-osophical. He would mentor his family with philosophical quotes. No one was able to debate with him, because he was not only logical, he made so much sense; on top of that, he had a proven track record in both business and life. In his book of values, no one should be lazy; there was no room for sloppiness, irresponsibility, or vagueness. He believed that everyone has a purpose in life, whether they end up as a plumber, a cook, a businessman, or even the prime minister; we all need to perform at our highest peak. No "ifs," "ands," or "buts." When clarity and direction guide our life, we can move forward in a harmonious fashion.

His high expectations in life and of his family had him believing that life should not be easy—it should be fulfill-ing, as we were all brought to earth for a purpose.

~

A cell phone rang. Someone must have forgotten to turn it off. She looked around and noticed that they were still debating the same topic. She thought to herself, "What would my grandfather do in this case?" And a little voice

said, "Speak when you have something to contribute and listen to their concerns. When the right moment appears, you will have an answer for them. Remember, those who know do not speak, and those who speak may not know."

She feels that she has so much of her grandfather in her. Without his teachings, she would not have come this far in business or in life. All the traits he instilled in her came through when times were hard. Her life mirrored his—just like him, she had travelled overseas to find a better life and when life got tough, she got tougher and smarter. And, just like him, she has made a good life for herself and won the respect of her peers. She is, in a way, the first grandson he had expected and always wanted. If Grandpa were still around today, she knows he would be extremely proud of her. And if he sat next to her now, she would thank him for not only being her greatest life and business mentor, but also for being beside her spiritually in all of her life battles.

My Greatest Mentor—My Grandfather

We make the biggest sacrifices for the people we love. While my children were my core reasons to become a better person by working harder and not giving up that easily, my grandfather has been my greatest inspiration.

My grandfather, legally known as Lee Yat Man—alias Lee Foo—was a self-made millionaire who made his fortune from timber trading. Yat Man was born in 1911 in a farming village of Canton (now known as Guangzhou

in Guangdong province, China). His father passed away at a young age leaving his mother to raise her children on her own. She would pick up any odd jobs she could get at the rice paddy field in order to make a few dollars. Putting food on the table was an ordeal. Giving her kids any form of education was out of the question.

Canton in the 1920s was an ideal port for trading due to its geographic position. This made it a popular destination for foreign traders who came seeking fur, timber, and commodities like tea, ginseng, and opium. World trade with China, which was originally an enterprise of limited prospects involving significant risk, turned out to be extremely lucrative, especially opium—an addictive narcotic—for which China was the main supplier. More and more Chinese citizens also became addicted to opium. Young Yat Man witnessed businesses being lost and families broken due to the widespread use of opium nationwide. The streets were filled with beggars and the homeless. Jobs were nowhere to be found.

At the age of fifteen, Yat Man decided to take his sister Lee Chong Oi, aged thirteen, with him to Hong Kong to seek opportunities to earn a decent income in hopes of giving both his mother and sister a better life.

His mother was reluctant to let them go at first but when she saw his determination, she knew the young man had made up his mind. She also knew in her heart that it was the right decision: it was their only hope for a better life. With a heavy heart, she went around to borrow funds from her family and friends, she worked extra hours at

the rice paddy field and she sold the one and only piece of jewellery she had ever owned to purchase tickets in the cargo cabin on the next train to Hong Kong. The desperate teenagers left Canton in the summer of 1926 in search of a brighter future. Promising their mother they would soon return with their mission accomplished, they hugged her, and said goodbye. Little did they know that it would be the last time they would see their mother.

They made their way to the cargo cabins onboard the train. As soon as they opened the door to the cargo section, a toxic stench filled the air. They looked inside, barely able to see who or what was in there. Besides the light they let in through the door they held open, the cabin was sealed off from the outside world. The cargo cabins were meant for livestock and commodities; but for those who couldn't afford tickets in the passenger cabins, this was the only option. The cabin was filled with people from different provinces in China, mostly men looking to earn money to support their families back home. Just like Yat Man and Chong Oi, their fellow travellers all had high hopes of making a fortune and returning home in glory, but like most immigrants, they would eventually see a tougher life than what they had seen at home. After twenty-one days of living in darkness with little to no food, Yat Man and his sister finally arrived in Kowloon, Hong Kong, on a hot summer day in 1926.

For the first time in three weeks, they saw light. Sunlight was so foreign to their eyes, it pierced them. They were dehydrated from the weeks of travelling with little water

and no food. Their clothes were dirty and their bodies reeked, but neither of them cared; this was the beginning of a glorious new life. They felt right choosing to leave home for Hong Kong. The weeks of travelling may have tarnished their clothes and bodies; but they hadn't affected their strong young minds.

As the train crew yelled out, "Hong Kong," it reminded them that they had reached their destination. They were filled with excitement as they walked off the platform, through the train station, and took in their first glimpse of Hong Kong. Yat Man was stunned, his eyes were focused on how modern the city was, even better than he had heard back home. There were shiny cars on the roads, people were dressed in suits, and the roads were paved. Yat Man squeezed his sister's hand tightly, and, giving her the biggest grin of confidence, he announced, "We are here, sister. This is our new home now. Even the air is fresher, don't you think?" She nodded in excitement and they walked toward the big city before them.

Yat Man came to Hong Kong with three Hong Kong dollars in his pocket, given to him by his mother. The first thing he and his sister needed to do was to find a roof over their heads. After asking around, they found themselves in an old apartment building on Temple Street, where many street vendors and performers did their business as it attracted the temple patrons. They went up to the second floor of a brown building and knocked on the door. A short little lady in her forties opened the door. She asked what they wanted in such a vociferous voice that it shocked

Yat Man. He shortly found out she was the landlord and the rent for a bottom bunk would be two and a half Hong Kong dollars per week. He bargained for a better price, as all he had was three dollars. Seeing the desperation in his eyes holding his sister's hand while she hid shyly behind him, she agreed to rent the bed to them for two weeks for three dollars; he would have to find a job within two weeks' time in order to stay.

They were lucky to be living in a 650-square-foot apartment filled with bunk beds. Like Yat Man and Chong Oi, the other twelve people in the apartment had made their way mostly from China to Hong Kong looking for opportunities. To distract themselves from hunger, they talked about all the possibilities tomorrow would bring. The excitement made them temporarily forget the hunger, the pain, and the fear they felt; this marked the end of the first day of their life in Hong Kong.

The next morning, Yat Man woke up at 5 a.m. He knew he needed to find a job so he could afford food to feed his sister and himself. They couldn't go hungry for another day. He pulled out his nicest outfit from his battered old suitcase, which consisted of a white collared shirt and a pair of black pants made from the roughest linen. Chong Oi woke up just before he left to find work. He asked her to wash all their clothes, and told her that she may only rest after doing the chores; his sister was not in the best of health then, she was constantly ill due to the lack of nutrition during her childhood. Before leaving the apartment, he promised her that he would come home that evening with food.

Yat Man walked up and down the busy streets of Kowloon looking for hiring signs. The banks and offices were hiring junior clerks and assistants but he definitely wasn't educated enough; he recognized only a few Chinese characters and barely knew how to write. He walked and walked; his legs started to cramp before he was willing to sit and rest for a little bit.

The aromatic smell of freshly baked buns caught his attention and reminded him that he was hungry. He looked inside a restaurant, salivating as he watched the patrons inside feasting on sweet buns and egg tarts. Out of the corner of his eye, he saw a hiring sign that read "Dishwasher wanted. Thirteen dollars a month, seven days a week with two meals a day included." This was his solution to finding food and money.

He didn't even think twice before barging through the door and applying for the position. The restaurant owner felt that he was slightly too young and little to be the dishwasher, but Yat Man begged for a chance to try. His persistence granted him a trial at the restaurant. He wouldn't get paid for the day's work but he would get fed. Yat Man jumped at the opportunity. At the end of the day, the owner was impressed with his work and he not only got the job, he managed to save one of his two meals for his sister. As he walked home, he wore a grin with pride, knowing that he had fulfilled his promise with food that night and for many nights to come.

Money was tight; sharing the lower bunk with his sister at ten dollars a month, the three dollars at the end of

the month was not enough for both of them. Even so, he wouldn't allow his sister to have a job; he insisted on sending her to school for a dollar a month, keeping her as educated as possible while he was gainfully employed. After a long day at work, he would bring home a bigger share of his two meals for his sister; making sure she would not go to bed hungry. She would come by after school sometimes to help him with the dishes, and every time he would make sure that she finished her food before sending her home to do her schoolwork. Yat Man knew that in time he would need to make more money so he could send some home to his mother. He looked for opportunities everywhere, and because of the long hours as a dishwasher, he couldn't fit in another part-time job.

A year later, he spoke to the owner of the restaurant for a kitchen job, which was significantly more pay than a dishwasher's. Because he was only sixteen, he was turned down. He never gave up. Every time he had a free moment, he would jump into the kitchen and help with prep work, whether it was cutting up produce or meat for the chef. Whenever the chef yelled out for ingredients, Yat Man was the first to bring it to him. He injured himself so many times while doing prep work that finally the chef decided to take him on as an apprentice, at a dishwasher's pay. Yat Man saw this as an opportunity to learn skills without paying a tuition fee. He apprenticed with the chef for the next six months while still holding his job as a dishwasher. At times when he knew the kitchen would be busy, he would call his sister in to fill in as their dishwasher, so he would

be able to work more closely with the chef. The restaurant got away with paying one low salary for both a dishwasher and an apprentice cook.

A few months later, one of the cooks was fired when he was caught stealing some sausages from the kitchen. A position in the kitchen came up and Chef Tong saw the potential in the young Yat Man. He spoke to the owner and officially gave Yat Man an increase to twenty dollars a month as the first line cook in the kitchen working directly alongside Chef Tong. Yat Man was thrilled. He looked up to Chef Tong and shadowed his every move, including picking up his smoking habit. He worked as a line cook for three years. By this time, Chef Tong had taught him almost everything he could and Yat Man was filling in when the chef was not around. He was making more money than when he had first started as a dishwasher, and for the first time, he was able to send money home to his mother.

One day, he heard from one of the restaurant's customers that a company was looking for people with all kinds of skill sets in Malaysia, and that they were paying top dollars for these trades. Included on the employment list that the customer brought into the restaurant were chefs and cooks. They were paying three times more than what he was getting in Kowloon. All they had to do was pay their way to Malaysia and someone would be there to take them to their jobs. With three times the pay, Yat Man could buy his own little place and ensure his sister had the best school to attend.

He went home that night and told his sister that they were

moving to Malaysia for this great opportunity that he had just heard about. Again, a boat was leaving in a few days. The following day, he wrote a short letter to his mother in Canton, announcing that they would be relocating to Malaysia and would be in touch with her again, once they had settled down.

They packed up their things into two tiny little suitcases, went to the restaurant to say their goodbyes, and off they went to the pier where the boat was waiting for them. Yat Man paid the captain for two tickets to Malaysia. He asked the captain to please reassure him that jobs were waiting for him and the captain reassured him that there were plenty of jobs in Malaysia. Yat Man held his sister's hand as they boarded the cargo ship, ready to embark on their next adventure in life.

It was over thirty days of sailing in the rough South China Sea before they arrived at Kuantan, Malaysia, a small fishing village along the coastline. Even though Yat Man was overly prepared for this trip, he never thought they would both suffer from seasickness. He decided as soon as he stepped off the boat that he would never sail again; that held true until the day he died.

Once Yat Man and the few others who came with him for the opportunity reached the village, they were excited to report their arrival and were ready to work as soon as they were needed. Shockingly, the employment company that was supposed to assign them with local jobs had shut down a few days before, and the men stood there for a moment before reality set in.

What were they to do now? They had no money, no place to stay and didn't speak the Malay language. These men had left their secure jobs in Hong Kong for something greater, so they could support their families back home, but now they were left penniless, with nowhere to stay and nowhere to work.

Yat Man and Chong Oi slept on the beach that night. While his sister fell asleep, Yat Man stayed up all night smoking and thinking what they should do next.

"How stupid could I be?" he thought to himself. How could he gamble the security of his young dependable sister who hadn't even finished school yet? "How selfish could I be?" Angry tears rolled down his cheeks. The last thought in his mind before he fell asleep was that he needed to get a job, any job, as soon as possible.

He was physically shorter and smaller than most men of his age. Due to his physical abilities, Grandpa couldn't compete for the coolie jobs most Chinese immigrants did. He knew he had to work harder and smarter to compensate for his lack of physical strength. He knew that if he wanted a better life, he needed to outsmart everyone around him and make a living doing something other than selling his own labour.

Yat Man was a smart man. In order to make a few bucks, he would buy and sell whatever he could get his hands on for a small profit. He would acquire what most would see as garbage—for example, old and broken furniture, bicycles, and automobiles—refurbish them and sell them at higher prices. He'd bargain for everything in order to get

items at rock-bottom prices to ensure the highest profits possible for every sale. He was, in his own right, a hustler. The profits he made from his daily sales on whatever he could sell would put food on the table every night, a steel roof over their heads, and new clothing for his sister and himself. His determination to survive fuelled him to think creatively and outside the box just to make ends meet, and he did that very well. A few years after, he grew his small refurbishing business into a trading business between cities. He would travel from one town to another, bringing unique goods and trading them to businesses, and his regular customers. He was known as the popular "Travelling Tradesman Lee" in his hometown, because whenever he returned, the children in town would run to him for new innovative goods from another city. They would scream out "Tradesman Lee, what did you bring home this time?"

He would smile, and take time to show them his treasures from another city, teaching them all about the new products. He was indeed very pleased with his accomplishments from having nothing to creating his own little piece of success, just for the person he loved—his one and only sister.

WHAT WILL WE DO FOR THE PEOPLE WE LOVE?

The sacrifices people sometimes make for others is amazing. Millions of people earn a modest income sacrificing lucrative salaries for the opportunity to make a difference

in other people's lives. We put careers and finances on hold to raise families, send our kids to college, or create businesses, so we can have a better lifestyle. We find purpose in tragedies by dedicating our lives to preventing others from experiencing the same feeling and giving more meaning to the loved ones we lost. We are willing to risk time, personal reputations, and financial resources to attend colleges or pursue a dream for an opportunity to experience an unknown outcome. We quit jobs, move across the world, and leave our comfort zone behind for a new set of possibilities. We reorient our entire lives, so we can minimize the number of people who can tell us what to do. Some may choose to stay in their comfort zone at work or in relationships as they may fear change will destabilize their lives; it takes away control and security. Little do they know that sacrifices lead to greater and bigger accomplishments in life.

"Sacrifice" should not be a scary word; instead it should be used daily. Start asking yourself, "What did I sacrifice today for a better tomorrow?"

IT IS IN THE DELIVERY

"Welcome on board Air Canada flight 1068. We are preparing for takeoff. Please fasten your seat belts and turn off all electronic devices at this time," the inflight speakers broadcasted.

While the rest of the passengers were shuffling around to get comfortable, I had already settled in. My books, iPad, and iPhone were neatly placed in the spot where I always put them. It is the same pattern on each and every flight. From my extensive travel schedule I had set up an inflight routine. This year was exceptionally busy. It was only mid-March and this would be my ninth international business trip so far. Slightly exhausted from having just arrived home from another business trip the evening before, I hoped to get some proper sleep on this long-haul flight.

I looked out the window as the airplane accelerated along the runway. The spring rain had wet the pavement and, with the darkness of the evening sky, it felt as though the airplane was being swallowed by the dreary night. I closed my eyes to centre my thoughts. I attempted to map out the things I needed to accomplish on this trip but, plagued by exhaustion, I fell asleep as the plane ascended to higher altitudes.

I wasn't sure how long I had slept when I was awoken by an announcement. Another voice came on this time, saying "Ladies and gentlemen, thank you for taking Air Canada flight 1068. We have now successfully ascended to thirty thousand feet. The flight will be approximately nine hours and fifty minutes. The Captain has turned off the Fasten Seat Belt sign, and you may now move around the cabin. However, please keep your seat belt fastened while you're seated. You may now turn on your electronic devices. In a few moments, the flight attendants will be passing along the cabin with drinks, as well as your dinner menu. Now, sit back, relax, and enjoy the flight. Thank you." That announcement told me that the flight had probably taken off forty-five minutes earlier.

I closed my eyes hoping to get a few more hours of sleep but thoughts of work shot back and forth in my mind like flies around food—I couldn't get rid of them. Giving up the idea of sleep after ten minutes, I decided to review every important detail on my mind, but there seemed to be too many, and I could no longer rely on my memory, so I pulled out my laptop to type them all out.

The company I worked for had adopted a new direction for the market in China and my job was to execute this new direction by convincing my business associates that this change was for the better. There was a possibility that it would not sit well with the fifty top-performing associates flying in from all over North America. However, the win was in the delivery—I had to deliver it in ways they could relate to and see the positive aspects of the change. Each

one would have to be convinced in a different way, in a different tone, and each of them would have his or her challenges.

I have always enjoyed a good challenge, and I was confident that I could make them all see the good in this one. The goal was to execute the company's new direction and it was up to us to guide them toward it. It was going to be a two-day intensive closed-door meeting with the purpose of answering all their questions, so they would have no concerns at a later time.

LEADING VERSUS FOLLOWING

As human beings, we either lead or we follow. The majority of people choose to follow, because it is much easier to follow someone else than to stand out leading others. On the other hand, I am no follower. Even at a young age, I directed everyone where and when to go. That thought drifted me into my past and I could just envision my aunt calling out for me.

"Peng, let's go shopping. I need your help to carry the bags!" My Aunt Koan called out. My aunt loves to shop and she never minded being in a packed, overcrowded environment.

I would jump out of my chair, stop whatever I was doing, put on my shoes, and in no time, I would be waiting patiently inside the car for her.

As a little girl, I loved being with my aunt. She was tall, slender, and very pretty. She had graduated with a high

school diploma, and at that time as a girl from a Chinese family, she was considered well-educated. Grandpa Lee assigned his daughter Koan—with good education—a very important job within the family business: the task of being responsible for the entire household. Being in charge of a family of twenty-two members, all living in a nine-bedroom mansion in the most prestigious area of Singapore—Bukit Timah—was not an easy task. However, she never ever complained. She took weekly inventory of the household supplies, groceries, and even the women's delicates so she could shop for the best prices in town for everyone.

The Lee family was very protective. After school was over, the mansion gates would be locked up and no children under the age of eighteen would be allowed out of the house, unless an adult had given approval. There was nothing much to do at home besides watching an old black and white tube television with three channels.

As a young child, I relished the thought of getting out of the house and doing something more interactive and exciting. And the best and the safest way to do it for a little girl would be to follow her aunt shopping. Whenever Aunt Koan picked up the car keys, I was like a puppy hearing food being placed in my bowl; I would stop whatever I was doing, run to her, and beg to carry her shopping bags. It worked every single time.

The truth is that taking me along was by no means an easy feat. Even when I was a young child, I too had an independent mind. I am pretty sure I acquired my Type-A

personality from my aunt, so I would keep track of the shopping list at every trip. Aunt Koan was not only a perfectionist, she was also known as the beaver in the family because she would be up by 7 a.m. everyday to race to the market, get the freshest produce and organize daily dinner menus with the cooks." She kept all the "T's" crossed and the "I's" dotted. It seemed so easy for her to handle the details of day-to-day operations; however, if she got thrown off her schedule, it would get under her skin. It was so enlightening shopping with her. I learned to bargain, to plan the shopping route, and to develop relationships with stall vendors. So you see, I learned at a young age to wheel and deal in the marketplace. It was a challenge for two strong individuals hanging together in a super-packed shopping centre with hundreds of desperate discount shoppers, pushing and shuffling to get a piece of the savings.

One day after an entire day of line-ups, pushing, and shuffling at the mall for discount purchases, my aunt's face was looking pretty red and she was very disconcerted. I wondered which item it was that she could not compete for this time. She came home and went straight to my dad and said, "I am not taking your daughter out any more!"

"Why not? What's the problem?" he said, while reading a newspaper.

"She does not follow at all. She took off within fifteen minutes of being at the mall. I had to ask for help from the mall security to find her," my aunt said bitterly.

"Well, did you not give her some guidelines and rules, like I asked you to?" my dad said.

"Yes, I did. I told her to stay within my sight or I would leave her at the mall," my aunt replied. "I am done with her. She has a mind of her own and I spent all afternoon looking for her—I didn't even get to shop at all!"

I looked in the car. Both the back seat and the trunk were filled with merchandise, and I even helped grab that one pink t-shirt that she had really wanted. Which part of the shopping didn't she get to shop?

My dad gave out a big sigh and said, "I will take her out next week and do the shopping so you can take a day off."

She was appeased by his answer.

The following weekend, my dad took me out to the mall, just like my aunt had every other weekend. On the way there, he told me how busy the mall would be and why I needed to stay by him, just in case he were to lose me in the crowd.

"I promise to be good, Daddy, and I will be on my best behaviour." I said it with the biggest grin ever.

As my dad was parking the car, he once again reminded me why I should stay by him, warning that a stranger might pick me up and sell me to another family. I chuckled and thought he was being ridiculously funny.

We headed straight to the fish market where we needed to buy five pounds of prawns and a couple of rock cod for dinner. We paid our favourite fish vendor, said goodbye, and went over to the meat and vegetable stalls, always fresh and cheap at the outdoor food market. My favourite stop was to see my goldfish; there was a pet stall that sold all kinds of pet fish. I can remember squatting by the bottom

tanks, which had pretty goldfish waiting to be brought home to their new owners. Dad and I were naming them, but after a while we ran out of names, because there were just too many of them. He looked at me and said, "Peng, let's go to the mall. I need to find myself a shirt for work."

"The mall. Yes, let's go, Daddy." I grabbed onto his hand and we headed to the car.

Within minutes, we were at the mall parking lot to pick up a few items for him. He parked the car and said, "Now please hold onto my hand and don't go anywhere without talking to me." I nodded my head and gave him the assurance that I would obey.

I held my dad's hand and we walked into the ocean of people, all scooping up items that looked like they were free. My dad looked at me and smiled, he then pointed in a direction that he was interested in checking out some items. Not too long after, he was busy looking for shirts while I again felt the urge to do something more productive. I didn't want to waste any time just standing there; I was too short for the bins, and too bored to stand there doing nothing.

I left my dad at the bins for a moment and started to wander off to the other departments, wondering how magnificent sales are that they capture so many people's attention. And why the female departments are separated from the male departments; why the kids sections are next to the female departments. Why are all the sales signs bright yellow with red writing. Just too many questions and not enough answers.

I turned around and I couldn't see my dad. Where did he go? He was just behind me a minute ago. My aunt would have spotted me and yelled out for me to stop taking off. There was no dad in sight. I wandered back to the bins where he had been standing, but I could not find him there. He must have moved on to another department. I looked around for him desperately, but there were people everywhere; they were busy ransacking through discounted clothing, socks, shirts, pants, and even ties. No one was paying any attention to me.

After an hour, I started to panic but I refused to cry. Grandpa Lee would be angry if he saw me cry. He wasn't keen on us sharing emotions and tears to him meant weakness. An hour had passed and it felt like an eternity. I was determined to find my dad in the midst of all the bodies. People were standing tightly together, shoulder to shoulder, bin to bin. I didn't get it. Why were there so many people? What was the sale?

I walked from department to department, but still saw no sign of my dad. My tiny feet had started to hurt, and being pushed around in the "sardine can" type of shopping mall was not fun at all. I worked myself to the side of the department store and sat down on the floor. I wished I could hear my aunt's voice calling out my name. I started to make little prayers—"I promise to obey and follow. Please appear!" hoping that my dad would appear right in front of me. All I could hear was an announcement about an extra 10% coming off Bin 255 on the third floor and then a stampede of people ran toward the elevators or the escalators for the third floor.

I found a corner to sit down, as I rested my tired head on my arms. I felt a tiny uncontrollable tear roll down my cheeks. A bargain shopper with a few bags came toward me and stood right beside me. I didn't want to look up, as I wasn't sure who it might be. I saw the shadow of a man's frame standing in front of the spotlight. He put his hands on my head and it felt comforting. He bent down toward me, I saw a familiar smile, and it was my dad.

"Daddy!" I yelled.

He picked me up and gave me a big long hug.

"I was watching you all this time, my girl. I saw you walk from department to department, floor to floor. You were looking very nervous at the end, little one. I told you not to wander off, but you didn't listen, and I hope you have learned your lesson." He said it with a gentle voice.

Even though I felt sick at the game he had played, I got it that moment: sometimes we lead and other times we need to follow. I wrapped my arms around his neck, as if I had never hugged my dad before. I was Daddy's little girl holding on and not letting go of my warm security blanket.

That was the last day I ever took off without communicating with someone else; that experience taught me a huge lesson. There are different ways to deliver a training and a message. Some prefer to give you the answer, which will divert you from the learning process; others prefer to let you go through the process to experience the outcome. When I think back about it, nothing changed in my behaviour by hearing my aunt's constant reminder to not wander off, because she was always there to ensure I didn't.

I didn't get to experience the fear of being lost. My dad, on the other hand, did something drastically different and he allowed me to see the effects of danger and feel the sense of being lost, while all the time, he was watching over me from afar. I learned the lesson from my dad in a day, whilst my aunt had not addressed the issue in over a year. It was all in the delivery.

That simple lesson was profound for me; the thought of being lost and alone was not enjoyable, and if I could erase that feeling and turn it into something productive and positive, it would be the lesson in leading.

There is a difference between leading alone and leading a team. When you wander off and no one is behind you, you are pretty much leading by yourself. When you lead a team, you have to ensure there is an abundance of communication, so your team follows tightly behind you, and they understand which direction you would like to go. Have you heard of the quote: "From Me to We" by John Maxwell? His message is exactly what it says: removing the "Me" and replacing it with "We" to create a team.

Leaders are the heart of a pursuit. The essence of leadership means inspiring a group to come together for a common goal. Leaders motivate, console, and work with people to keep them bonded and eager to move forward. That means setting a direction, communicating it to everyone who will listen, knowing that probably many won't, and keeping people psyched when times get tough.

Keep in mind that people easily lose sight of the big picture when they get caught up in life's daily details. A

leader must know how to bring people back and make sure they know their way. Sometimes we forget a direction in the heat of excitement over a new idea. If it happens once or twice, it's not a problem. But too many diversions can cause the team to lose focus and end up serving in too many different directions.

LEADING VERSUS MANAGING

One day, my uncle Jun said to my dad, "Kin, you know your daughter has leadership qualities—look at her. Have you noticed how comfortable she is at leading? She is confident in conveying to the others where they should go and she delivers it so well. Naturally others follow her, no matter how much older they are. She is only seven years old! Give her some opportunities and I think she will shine like a gem."

It is more easily said than done, Uncle Jun.

Leaders bring people back to the original direction, ensuring they don't fall off course. We must also challenge and encourage them to evaluate their ideas with respect to the decision. In return, they can then decide whether the suggestion aligns with their mission.

Leaders create circles of influence and not a circle of power. Leadership refers to an individual's ability to influence, motivate, and enable others to contribute toward success.

You may wonder what the difference is between leaders and managers. Their characteristics are very similar: they both have a team of people following them. However, they

offer very different leadership styles. Influence and inspiration separate leaders from managers; always remember that power and control do not make you a better leader. If you are confused as to which category you belong, the simplest way to differentiate between the two is to see how many people outside of your hierarchy come to you for advice. The more people you have coming to you, the more respected and the more you are perceived as a leader.

Another way of differentiating between the two is that a manager will most likely count values while a leader creates them. How many pieces of garment have you sewn today? How many dishes have you cooked today? And even how many calls have you made today? These are all part of counting values, whereas a leader would go above and beyond what the team creates. He sets the example and leads by example. Leading by example and leading by enabling people are the hallmarks of action-based leadership.

No matter how difficult it is to be a leader or a manager, choose wisely between the two. I am sure one will outperform the other, both in business and in life.

Showing your people the value of the mission will elevate them to excel even higher than just a production quota. When they see the vision, they will desire to be part of the vision, and it will eliminate anyone from having to motivate them on a daily basis.

Servant Leadership

> *"Management is what you do; leadership is the person you are and the influence and impact you have upon the people you come into contact with. Management is not synonymous with leadership. Leadership is synonymous with influence."*
> **James C. Hunter**

According to *Leadership Styles* by Tony Kippenberger, there are many different types of leaderships and the four that are most recognized are the Autocratic Leader, the Transformational Leader, the Laissez-Faire Leader, and the Servant Leader. For those of you who own your own businesses, you may want to mark this chapter.

Autocratic leaders make decisions without consulting their team members, even if their input would be useful. This can be appropriate when you need to make decisions quickly, when there's no need for team input, and when team agreement isn't necessary for a successful outcome. This type of leader is quite demoralizing and really unsuitable for team-building environments, especially in direct selling.

The Transformational Leadership style depends on high levels of communication from management, in order to meet goals. Leaders motivate employees and enhance productivity and efficiency through communication and high

visibility. This style of leadership requires the involvement of management to meet goals. Leaders focus on the big picture within an organization and delegate smaller tasks to the team to accomplish goals.

Laissez-Faire Leaders give their team members a lot of freedom in how they do their work and how they set their deadlines. They provide support with resources and advice if needed, but otherwise they don't get involved. This autonomy can lead to high job satisfaction, but it can be damaging if team members don't manage their time well, or if they don't have the knowledge, skills, and self-motivation to do their work effectively.

A Servant Leader is someone, regardless of level, who leads simply by meeting the needs of the team. The term sometimes describes a person without formal recognition as a leader. These people often lead by example. They have high integrity and lead with generosity; in other words, they are selfless. Their approach can create a positive corporate culture, and it can lead to high morale among team members. Supporters of the servant leadership model suggest that it's a good way to move ahead in a world where values are increasingly important, and where servant leaders can achieve power because of their values, ideals, and ethics.

"I met a businesswoman called Bibiana Pau in 2006, just a few months after I started at my very first direct selling company." She had accidentally fallen into this industry through her sister-in-law's influence of "try it out." Her experience came from being the owner of a clothing manufacturing plant, managing her own retail store, and

being in real estate sales prior to being involved in network marketing. Having managed employees and worked with clients, naturally she felt she would be able to adapt to this business model quite well. She made a little progress at first and then, for months, she stalled at the same leadership rank (this is direct-selling terminology).

It was a simple welcome phone call from me that connected the two of us and since then, we have not just been business partners, but have developed a good friendship.

"I am stuck. I don't think I know how to motivate my team," she said. "This is harder than I thought, and I have been in sales and management for years, so why is it that I can't grab the concept of it? Can you help me, please?"

As this was also my first direct-selling job and her first time selling for our particular industry, we naturally bonded as rookies together. However, with my background in sales and team management, I knew quickly that succeeding in direct selling is definitely not easy. It has a simple model, but it is definitely not easy. It takes a certain individual who has great team spirit and great listening skills to be successful. And successful individuals in this industry also have a gift of servant leadership; their teams and followers are motivated based on daily empowerment and encouragement, rather than from being managed by an autocratic manager/leader.

So you may wonder what is the difference then: leadership requires the ability to influence. To test whether you have leadership, ask yourself these questions: Do you leave things better than you find them? Will people around you

grow to have a better life or a better career because they spend time with you? Have others learned and grown as a result of working with you? And because leadership requires the ability to influence, it is the mark we leave on other people and the mark we leave on the organization we involve ourselves with. All leaders leave footprints; are people around you glad to see your footprints and decide to follow them?

Everyone Has Responsibilities

Everyone has needs and wants. A want is a wish without regard for the consequences, whereas a need is a psychological requirement for the well-being of an individual.

What do people need? The basics are, of course, shelter, water, and food. But people have higher needs like appreciation, respect, value, encouragement, and being listened to. However, on the flip side, they also need accountability, rules, consistency, honesty, and feedback. And when you are able to identify and meet the needs of others, you will build influence with them.

Most people will agree that servant leadership is the most effective. If that is so, why are there so few? The challenge is that the majority of leaders have the logical principles required in their head; these principles need to move from their head to their heart. Because servant leadership is so unique, it requires the leader to care and to love, to be patient, humble, selfless, forgiving, honest, and committed. It takes heart work to lead.

If a leader were impatient, unkind, arrogant, disrespectful, selfish, unforgiving, dishonest, and uncommitted, how could they be inspiring enough to influence you into action? Leadership is a skill, and it takes years of practice to develop this skillset.

I have met people over the years who "know about" leadership, but don't "know" leadership. It's like knowing about soccer, without setting foot on a soccer field. So they know about soccer but don't know soccer. There is a world of difference between knowing about something and knowing it. A very small percentage of people actually take the time to study and make changes to their leadership abilities. Think about someone who has great leadership abilities. Do they possess these skillsets: humility, respect, self-control, honesty, commitment, determination, gratitude, and communication skills?

Bibiana worked on the list of required skillsets over the course of years. It is not a simple task as she was converting from being a manager with an autocratic leadership style required to run a traditional business to being an innovative servant leader.

"Belynda, this is not at all easy. The more I practise my servant leadership style, the less motivated they are, and they take advantage of my willingness to serve. I feel that I am always at their service. They are asking me to see their prospects, place the orders, and even train their team for them," she said.

"Have you differentiated clearly between what they need and what they want?" I asked.

"Yes, I have. They want extra cash on top of their monthly salary, and they need to pay off their mortgages. But they aren't committed to do any work," she replied.

Servant leadership is not about doing the work for others. It is about caring, loving, and being brutally honest with feedback so they work on achieving their goals in life. Do you know what makes a top-notch leader? Top-notch leaders hug hard and they spank hard as well, just like polar bears! When it comes time to appreciate, honour, and value excellence, the best leaders are the first in line. When it's time for their teams to perform, they demand excellence and have little tolerance for mediocrity. They learn the trick of accomplishing tasks through relationship building. These individuals have mastered the location where the sweet spot is between hugging and spanking.

In Bibiana's situation, the team she was working with was already making an income to cover her basic needs of shelter, food, and water; having those covered took care of her safety and security. According to Maslow's hierarchy of human needs, the next three stages are a little harder to achieve: belonging and love, self-esteem, and self-actualization. It was clear that Bibiana was struggling to move them from basic needs and security to feelings of belonging, self-esteem, and self-actualization. And this is where the respect, encouragement, and appreciation come in. I advised her to shower them with recognition, rewards, and so on the minute she saw some positive behaviour. It is the warm, fuzzy stuff that actually gets people going.

Visualize the servant leadership model as an upside down pyramid with five stages: Leadership, Authority, Service and Sacrifice, Love, and Will. Leadership still casts influence over others. Having the skills to influence people to work enthusiastically toward a goal is the highest level of leadership. Because relationship-building takes a while to build, there are many leaders who will choose authority over others to get the job done. Unfortunately, authority will only last a few years. When you run out of power, relationships deteriorate and so will the influence. So how can Bibiana get her team to move their business willingly?

Jesus said that leadership is built on service.

"When he had finished washing their feet, he put on his clothes and returned to his place. "Do you understand what I have done for you?" he asked them. "You call me 'Teacher' and 'Lord,' and rightly so, for that is what I am. Now that I, your Lord and Teacher, have washed your feet, you also should wash one another's feet. I have set you an example that you should do as I have done for you.**"**
John 13:12-15

Grandpa Lee was my first mentor, he knew what my needs were even before I knew them myself and he truly cared enough to correct me whenever he got an opportunity; he used tough love when he mentored; he knew I didn't need physical guidance but I did need mental guidance to grow and mature into the person worthy of being his successor. All grandfathers teach life values, but not all grandfathers out there spend time in cultivating and developing their grandchildren. He invested a huge amount of time to groom me into who I am today. Think about this curve ball that I am about to throw at you. Can you take Grandpa Lee's mentality and practise it on people to whom you are not related? This time use your heart instead of your head, when working with them.

Authority is built on service and sacrifice, if you think about it a little more deeply. Name one person whom you feel has true authority and you have respect for. Does this person in some way serve or sacrifice for you? The law of harvesting is you reap what you sow. You serve me, I'll serve you. When someone does us good, don't we naturally feel indebted? It is just that simple.

The truth of the matter is people don't like to discuss the word "love" in business settings. I am talking about the behaviour, rather than the feeling. What does love have to do with business? A lot! Love is built on will. Love in a nutshell is patience, kindness, humility, respectfulness, selflessness, forgiveness, honesty, and commitment. Does that sound familiar to you? Isn't that similar to being a servant leader? When we choose to love, we extend ourselves for others; we will be required to be patient, kind, humble, respectful, selfless, forgiving, honest, and committed.

When I loved and extended myself to Bibiana to help her with her business, it required all the components listed above, and when she extended her love to her teammates, her teammates felt unpretentious and thus a bond formed followed by loyalty.

These behaviours require us to serve and sacrifice for others; we let go of our egos, even on a bad day. We have to sacrifice by loving and extending ourselves to people we may not even like. Servant leadership is when we willingly choose to behave lovingly. When we love each other by extending ourselves, we serve and sacrifice. When we serve

and sacrifice, we build authority with people. And when we build authority with people, then we earn the right to be called leader.

In reality there are no shortcuts in developing leadership, which means that if you really want to achieve effective leadership you have to change. Leadership has very little to do with your personality, but everything to do with your character. It took me many years to understand that character and leadership correlate with each other. I had heard others say, "That is your leadership style..." "Your leadership style is driven by your personality..." But when I started to work on my leadership skills, I found that leadership had much to do with my character, my values, and my substance. Character is moral maturity about what I should do and not what I want to do, even if it costs others to complain or be dissatisfied with me.

When you have developed a relationship through servant leadership, people will entrust themselves into your care. They understand the reasons for your decisions, and they will take your feedback more seriously because you have their interest at heart.

Four Stages of Leadership

People fall into four stages of building good habits to become good leaders: those who are unaware and therefore unskilled in good habits; those who are aware that they are not good at it; those who are aware they do not have good habits and are starting to become skilled; and those who

are skillfully comfortable and don't have to try too hard to be good leaders, they have become good leaders.

Bibiana clearly moved through the four stages over the years. She understood the importance of servant leadership, especially in the direct-selling industry, where she needed her team to stay motivated on their own. Within a short period of six years, she has grown from not knowing how to manage her team to understanding what her team's needs and wants are. With her servant leadership, she became one of the top twenty-five income earners within the company. I remember when she was promoted to a "diamond director," which is a substantial leadership rank within the company.

As a congratulatory gift, I gave her a serving tray for the milestone she had achieved. When she saw it, she was confused, and I said to her, "Servant leadership doesn't stop here. It has just begun. This is to remind you to continue to serve and sacrifice for your team, and your future will then be bright."

~

I opened my eyes as the announcement came through to inform us that our plane had started to descend. The announcement call to fasten our seat belts and move our seats forward woke me up from the sweet memories of my childhood. I looked out of the window hoping to get an aerial view of China's Great Wall through the clouds. As the airplane descended below the cotton-candy-like clouds,

I started to catch a glimpse of the wall through the light haze. I have walked the Great Wall multiple times and I am still mesmerized by the breathtaking structure every single time I set my eyes on it. How majestic is this landscape? No wonder it is one of the recently chosen seven wonders of the world. Building this wall on these steep mountains must have taken a lot of determination and drive. Or it could have been as simple as just one man's vision. This someone must have been a great leader, as he led millions of people to complete his vision. I am sure he did not manage it by counting values. He motivated, inspired, and led by example of how to build the wall one brick at a time.

For the next few days in Beijing, the executive team and the top leaders in my company were confined in a boardroom, strategizing the execution of our new initiative. Once we listened to their concerns and empathized with their challenges, agreed to serve alongside them to face their obstacles, they were all ears listening to our change of direction. I left the meeting knowing we had accomplished our task.

At the end of the day, servant leadership still exceeds over other leadership styles; until you try it out you will have no idea what power it has for you.

The Expectations of Others

My Mother Nee

As the blazing hot Malibu sun shone into my eyes, I could no longer see the words on the screen. I shifted to another side of the patio chair to avoid the piercing sun, and the laughter of children playing in the pool with their parents distracted me. They looked so happy with their parents, I wished my mother could have done the same for us. Come to think of it, she didn't take us to sports, weekend getaways, or even out to dinner with just the three of us. Sometimes I wonder whether she had ever wanted children.

My mother Nee was born in Singapore in 1944, a year before the Japanese surrendered and left Singapore. Her father worked at the local steel factory, while her mother was a homemaker. She had a very traditional Chinese upbringing in Singapore, where there is a process in life that everyone must follow and live by. She is probably one of the most systematic people I have ever come across. She is very uncomfortable with change and unfamiliar environments.

New things to her have always been considered unproven, unsafe, and unreliable; thus, living in a new and unfamiliar environment would have taken years to convince her to think differently.

When my father left for Canada in 1974 for better opportunities, my mother's family convinced her that she should become a Canadian citizen as well, so she could be with him. After three years of constant family persuasion, she was convinced to take her two children aged nine and seven (me and my younger brother) to Canada so she could be reunited with her husband. However, she found out when she went there that Canada was not her cup of tea. She missed her "real home," where the real hawker food stalls sold mouthwatering Singaporean food, where the most convenient island public transportation runs twenty-four hours a day, and where her family lived.

Canada's harsh winter was much harder to endure than the usual 34° Celsius (93.2° Fahrenheit) Singapore weather. She found herself in the tiny little apartment that my Dad had rented with nowhere to go and no friends to see. Being an introvert, she had a hard time building new friendships with people. Soon she found herself all alone and very homesick. And the complications escalated when my father became involved with another woman. Not long after, my mother was looking to catch the next flight home.

Without having much of a discussion with her husband, she took me and my brother with her and returned to Singapore. After her short stay in Canada, my mother declared that she had no interest to return to North America,

which she branded as "the cold and unwelcoming country." But the truth was she felt that she had failed in numerous ways in fulfilling her part as a wife and mother.

Nee came from a very traditional Chinese family where the men worked and the women stayed home. A woman's job would simply be to look after all the chores at home and have the meals ready when her husband returns home from work. Women back then were given very basic schooling, as it was not a priority to educate girls. She and her siblings were the first generation to have high school diplomas. Although her entire family was proud of such an accomplishment, Mom's mission was to find the right man to marry and become a professional housewife.

Once graduated from high school, my mother's first job was in customer service at a local department store. There, she was quite content working in the men's department, thinking it would be a great place to meet her Prince Charming. Soon after, her father needed to help out a business associate who was desperate to place factory workers in his milk factory. Nee's father pushed his daughter into the position. Needless to say, that favour she did for her father diminished her dream of meeting her Prince Charming. And that factory job unexpectedly became her life-long career. She worked in the milk factory until she was sixty-seven years old; there her loyalty shone for forty-six years.

An "A" Student

Mother never had an issue with me at school; I was an "A" student throughout my preparatory school. That was the one thing mother never had to worry about, except for the fact that I was always bruised or cut coming home from school. I was self-motivated to be an "A" student.

I attended Ferries Primary School where they would separate their students between Class A, Class B, and Class C based on their intellect. Naturally, the smarter students would fill up Class A, and then average students would head to Class B, and the slightly below average students would funnel into Class C. I was able to maintain my position in Class A throughout elementary school. My mother was proud of me. My brother Maurice on the other hand, was constantly entering Class C, year after year; in other words, he was an unmotivated student.

I was not only a high achiever, I was also quite a hyperactive child. I remember constantly challenging everyone about his or her values and philosophical thinking. I would ask, "Why do we live in a more prestigious area? Why can't we walk to school rather than being driven? Why does she have to work and not stay at home?" My mother understood that I was quite demanding and inquisitive and she could not keep me in check, so she had Grandpa Lee discipline and teach me the ropes of life. Lucky me!

My grandfather always had an answer for me and I never won a debate with him. How is it possible for a man to be

so smart? He answered all my whys, hows, and whens; that man was a genius.

When my grandfather was alive, the Lee family had two mansions—one in Singapore and the other in Malaysia. During the school year, I would stay in Singapore; in the summer and other holidays, I would be chauffeured to my grandparents' summer mansion in Malaysia. Since my mother decided she loved to work six days a week, she asked my grandfather to sign me up for tutorial classes so my entire day could be consumed with more schooling and I wouldn't get into more trouble while she was at work. I recall the family locking up the gate the minute I got back home from school so I wouldn't go exploring in unknown territories. I was, in their eyes, a wild child.

When I completed my preparatory school, my mother had hopes for me to attend an all-girls school called Saint Margaret's Secondary School, as my grades were good enough to be accepted there quite easily. Saint Margaret's was a Christ-centred school where they believed all their young ladies would serve God, the country, and the community. It was also the top Catholic school in Singapore; it was a school every mother would love to have their daughters be enrolled in. Being one of the top schools in Singapore, naturally Saint Margaret's Secondary School's enrollment requirements were high; it was not an easy school for anyone to be accepted into; they were very selective with their student base.

Mother scheduled an interview for us to meet with the principal, who said yes to my admission without a second

thought, because of my outstanding grades. However, being a rebellious individual, I chose an average co-ed public school called Dunearn Secondary School, a secondary school that was at the bottom of the list for its academic scoring in Singapore. When mother found out, she was not only more than disappointed with my decision, she also knew she wouldn't be able to change my mind. She gave me the silent treatment for months and when September came around, I started my secondary education at an average public school.

To be frank, I cannot recall why I picked that school—maybe it was walking distance from where I lived or maybe one of the boys I liked back then was attending it. I honestly cannot recall. The students there were different from where I used to study. They were unmotivated and they came from lower income families. The teachers were very average—I recall thinking they weren't that smart at all. The classes were conducted in the least inspiring way and I was feeling extremely unchallenged at school.

To make things more exciting and to have a true learning experience, I would challenge the teachers on all bases, thus encouraging them to back up their theories. Most of the time, they would respond by quoting from the textbooks. The teachers taught straight from the textbook and didn't encourage creativity and opinions. That form of education bored me tremendously and caused me to drop my attention span, so I didn't stand a chance to be one of their favourite students in class.

One day when I was daydreaming about something more interesting, my English teacher was struggling to explain adjectives. She called upon me to give three examples in the use of adjectives in the hope of embarrassing me for not paying attention. To her dismay, I easily rambled off ten examples and on top explained their usage. She was shocked, perhaps even more unimpressed that I outshone her in her teacher's role. She then sent me off to see the principal for being disrespectful and for daydreaming in class anyway. How could I have been daydreaming when she called for three examples and I gave her ten? The principal called my mother in and they had a talk about getting me into more activities so I could redirect my energy into something more productive.

Mother went home that afternoon feeling defeated. She looked at me with the saddest eyes and she didn't say another word on our walk home. I could tell that she had no idea what to do with me. I knew I could make her happy by fitting in like everyone else, but I couldn't contain my boredom.

A few days later, she asked me to see her in her room. I went into her room and found her sitting there with Aunt Koan and that is normally not a good sign. Apparently she had asked my aunt, who was not married or a parent at that time, for suggestions and guidance for childcare development, so the three of us were discussing extracurricular activities that would keep me engaged and productive.

My mom and my aunt wanted me to enroll in a sewing program, a cooking class, and a first aid course—none of

which excited me at all. Why would I want to learn how to sew, or cook, or even to put a bandage on someone when we had two servants that could do that and a hospital around the corner if we ever needed first-aid? What a waste of time!

They took turns convincing me and finally I gave in. By noon the next day, I was enrolled into three new classes. I promised my mother that I would participate in every class and I would learn what I was being taught. In short, I would be a good student who wouldn't cause any issues or ask any difficult questions in class. The teachers at each of the classes were notified that they might have a bright but challenging student joining that semester. You can imagine what kind of weird look each of the warned teachers gave me when I walked into the class; it was like they were seeing trouble entering the doors of enlightenment.

Classes began and before I knew it, I became accustomed to these hands-on classes. I began to enjoy the creativity in cooking and sewing; in fact, I particularly enjoyed the sewing class. It was a pretty intense program for students. We learned about clothing: quilting, crafting, embroidery, patterning, and stitching.

To complete the course and receive a grade at the end of the semester, everyone in the class was to put a garment together. This final project was to construct a full-length dress within five hours. To prepare us for the final, we were given two weeks to take measurements and buy fabrics and materials of our choice. To my surprise, I was quite excited about the trip to the store. The thought of being able to

pick and choose my own fabric and design a dress excited me; it gave me the outlet for my creative juices to flow. And being as competitive as I was—and still am—I was sure I would design and sew the best "red-carpet" dress in class and receive the highest grade possible.

But things never turn out the way I imagine; I am just a very special child!

I had planned to make a trip to the fabric store on the weekend, so as to ensure that I got the newest and coolest materials out there. When the time finally came, I was bedridden with a bad flu. Not being able to go to the store myself and refusing to miss my final exam, I asked Aunt Koan to help out; I sent her to the fabric store with very specific instructions.

On examination day, I walked into the classroom with my face flushed red from an ongoing fever and I was still feeling light-headed from the strong medication that the doctor had prescribed. But I wasn't about to miss my opportunity to make that "red-carpet" dress and receive a top grade.

Grandpa Lee taught us children that we must always finish what we start, even if it is something we don't desire to do; we should always finish a conversation we start, complete our assignments we begin, and never fill our plates with food if we cannot finish eating it. He taught us that with every journey we start, we must have a completion point. That was embedded in my head at a young age, so this was just another project that I felt I had to finish to make Grandpa Lee proud—another one for his wall.

I walked into the classroom and to my surprise the teacher had placed us in different construction stations, each of them equipped with needles, thread, sewing machine, measuring tape, scissors, etc. And the construction stations were far enough from each other that we could not copy each other's ideas. I was not looking forward to cheating; I was more concerned that others might copy my ideas for the final project, so I was quite pleased to see the stations placed further apart.

She began the examination by saying, "Class, you have a total of five hours, from pattern drafting to cutting to sewing to finishing. Remember that your garment needs to show all the different stiches that you have learned this past term." With that she sat down and said; "You all may begin," and she looked at the clock and noted the time that we started.

The classroom fluorescent lights shone more brightly than usual. The light pierced my eyes and I had to squint in order to see properly. I opened the bag that Aunt Koan had given me that morning, the bag of material I had asked her to purchase. Because I was so sick with the flu, I hadn't gotten around to checking it so this was the first time I saw what she had purchased for me. I dug my hands into the bag and pulled out four pieces of fabric—each of which was different in colour, pattern, and texture from the other three. I had a piece made from silk, one made from cotton, one made from polyester viscose, and finally a piece of chiffon fabric. I stared at the pieces and wondered if my aunt had been intoxicated when she was at the store.

I continued to stare at the fabric in awe—my mind was blank on how I could make this work.

My classmates saw me staring at the cutting table and knew what was wrong. They began to chuckle—probably not too surprising. The teacher quietened everyone down, came to my station, looked at the fabrics, rolled her eyes, and made the most disgusting face, probably wondering what mischief I was about to pull before I graduated from her class. I looked around and everyone had started to draft their patterns onto one piece of material and I had four pieces of clashing material sitting on my cutting table. What was I going to do now? You remember the song from the eighties, "Under Pressure" by Queen & David Bowie? Well, that song was playing in my head over and over again.

By this time, my world had started to spin and my eyes were hurting from the bright lights. Between Queen & David Bowie, the extra bright fluorescent lights, and the medication for the flu, my world was spinning at seventy miles an hour, I told myself, "This is not going to stop me from creating my final project! I can do this! There has got to be a way to construct a garment with multiple fabrics."

I took my pattern pieces, and started to lay them out on the fabric. As my fabric came in four different sizes and shapes, I had to compromise to ensure each of them fit into the paper cut out of the pattern. It took me an hour and a half to carefully print the pattern onto the fabric before I began to cut. Once I had cut the fabric into multiple different pieces, I began stitching and sewing profusely. I remembered what the teacher had wanted, and that was to

incorporate the different stitches we had learned during the previous few weeks and ensure that we took time in the finishing work. I carefully sewed the different pieces that I had cut into a full garment.

This was probably one of the most challenging days in my teenage life. It would have been easier to call in sick and be excused from the assignment or to reschedule it for another day. However, I wanted to finish the project at the same time as my classmates and I refused to give in and call myself unfit to complete with the rest of the class. I attended the class and finished my final project. I was very proud of my work. Even though I was given four pieces of fabric that did not match, I was still able to complete a one-of-a-kind, full-length dress. I truly felt that everyone else constructed a dress, whereas I designed one.

I sewed the skirt portion in a full cotton blend, which gives the skirt a fuller flare. For the body of the dress, I used the silk material so it allowed for a soft draping around the chest. I used the polyester fabric for the collar and finally the see-through chiffon material for pockets.

I did it! Well, I didn't get an "A" for my project; however, I was very content that I had been able to cope with a difficult task in an unforeseeable situation and in a timely manner; that was far more important than getting a high grade at that moment. I had turned things around and was able to complete the task within the timeline—just like the rest of the class.

I went home that evening too tired to speak to my aunt; I collapsed on the bed with exhaustion. I woke up the

following afternoon to find my mom at the side of my bed and my project sitting on the floor in a bag. I was surprised to see her there as she normally works late every night. I asked her to open it up and said it was a gift from me to her. She opened it, and pulled out the odd dress. Although she looked somewhat confused by how the dress was constructed, she smiled and said, "Pretty good."

As my mom was finishing her sentence, my aunt rushed into the room and said, "Aya! Why is my cushion cover material in your dress?" I looked at her annoyed and Mom, seeing my expression, quickly put the dress away. She then rested her hand on my forehead and said, "You have a high fever and you need to sleep." She then turned off the light in my room and walked out.

Release All Expectations

I am sure my mother cares for and loves me immensely to be able to express how she feels by setting certain expectations of her two children. Being a mother myself now, I can understand why expressions are integral parts of our interactions and relationships. This is how I witnessed a mother tell her children, "I love you but...," "I am disappointed with you because...," "I can't believe you did this...," or "Why not do it this way?" As mothers, we often catch ourselves defending our own logic in disciplining our children. Instead of the above, maybe we should try saying, " I love you so much, you have a unique and special way of expressing yourself." Or "I am never disappointed

with you; I love you for who you are; have you thought of other options?" Or "I have faith in you, I will support you whatever you decide to do." With this, we are allowing them to take responsibility for their own decisions, make their own mistakes, and mature a little faster.

Sometimes, it is not just mothers or siblings who set expectations of us; we catch ourselves setting expectations of others. What should they or should they not do? How should they feel? How should they react? I used to think that it is human nature and we cannot help but feel that way.

My grandparents used to say to me, "We are correcting you because we love you. If we didn't love you, do you think we would bother to spend time addressing it and saying anything to you?"

As a child, that made a ton of sense to have someone who loves me constantly criticizing or providing me with meaningful feedback. Because that practice happened during my childhood doesn't mean that it is normal or acceptable in other families. I came to the conclusion that, as much as we like to set expectations for our loved ones, it is not conducive to their best development, because everyone has choices, even children.

Why do we develop expectations and opinions of others? Four very simple reasons: we think others think as we do; we have a motive; we are insecure; and we fear change.

If something is logical to us, we think it should be logical to others. The same goes with expectations. If we expect a certain outcome, then others should expect the same

outcome. If we don't have expectations, we start to ... emotions. Emotions can include being sad, excited, or even "bummed out." It is tough for us to realize we are doing what we are doing without giving ourselves time to stop and self-reflect. People think and react differently; we are not carbon copies of each other. This does not negate our common interest or our shared aspirations. We are born with different DNAs, which means our thoughts and emotions are like our fingerprints: unique from one another.

We do harbour certain outcomes or behaviours of what we would like to see happen, what we agree with. Wanting a certain outcome raises expectations and paves the way to cast our judgment on others.

Normally when we judge others, we are judging them based on what we don't like about ourselves. So we ask for feedback, and when we do we are actually asking for validation or approval. If we don't hear what we want to hear, we react strongly against it.

Ego triggers fears about change as well. If we see someone doing something that we are afraid of, we automatically react by telling him or her not to do it.

Many people think that releasing expectations of and opinions about others are about giving up and losing control. But the truth is they are about letting go of being attached to outcomes and needing to be validated. Does that make sense to you?

So here are the million dollar questions for when you set an expectation on another: What's your true motivation? Is it based on a genuine desire to engage in conversation or is it rather to act in a way that reflects your truth?

Our motivation is the foundation of our thoughts and actions. Be honest with yourself. We might be able to hide our intentions from others, but we can't hide them from ourselves. If we try, we'll create needless suffering. Think of your expected outcome and the worst-case scenario. Are we okay with anything less than our ideal result? Can we live with it? Have alternatives whenever you can. I'm a huge fan of having a plan B. Having alternatives helps us move on. If there is no possible alternative, peacefully close the chapter knowing that you did your best. I am thrilled to say that I have a ton of plans B, C, and D.

My mother always says, "Don't take things too seriously my child," and "You are supposed to enjoy life; leave the serious thinking to us adults."

Our expectations and opinions are ours only. The same goes for every other person; his or her judgments and opinions are theirs only. This is a simple shift in perspective, but it can dramatically change how we interact with others. We can move in a direction that's right for us without personalizing what others say or do.

Respect others for who they are and don't judge.

Act from your heart, not from your ego. Take inspired action. Do what matters to you the most, regardless of the challenges and the naysayers. The same applies to what we say. Speak from your heart. Only say what you mean and in the best, most supportive way possible. Words are very powerful; so let them reflect your truth.

We will slip and find ourselves agitated or annoyed with someone. Please don't beat yourself up. Accept human

frailty. Rethink and reframe—what can we do to accept the other person's actions or position without judgment? When others react in unexpected ways, give them the benefit of the doubt. They're human, too. Forget about it. This is the essence of letting go—saying or doing something and then completely forgetting about it. Don't sit around waiting for feedback or validation.

When we have faith that things will turn out for the best, don't second-guess. Accept the outcome whatever comes of it, while remaining open to guidance on what to do next. When we let go of our opinions and expectations of others, we free ourselves from attachment to specific results that are beyond our control. We can move forward with ease and clarity. We interact genuinely, without hidden motives or disappointment. We become better equipped at embracing what others have to offer. Our newfound freedom creates opportunities for us to be of service to others in more intuitive and authentic ways. To let go is to lovingly surrender to what is and to be at peace with it.

Chasing Butterflies

My mother's favourite pastime was to spend endless hours with her beloved mother. During her only day off—Sunday—she visited her mother. Her mother's home was a safe haven where she could be herself, and where she was truly happy. I don't know what she and her mother talked about on Sundays. They talked for hours all day long on anything and everything, and then they napped for the rest

of the afternoon. I remember watching them talk all day, from the minute she arrived at Grandma's to the minute she left for her in-laws', where we lived, and when she hit her in-laws' house, she wouldn't speak for a week as if she were saving up words for her mother on Sunday.

My brother and I would have to keep ourselves busy, because they paid no attention to us. At times, we snuck out to the playground and would try to keep ourselves entertained all day. Maurice was a quiet and patient young boy; he would build sandcastles all day, even when it would take him forever because the sand in the sand box was too dry to hold itself together. He would build it anyway. It would collapse but he would do it all over again. I often laughed at him and told him that he was wasting his time and we should explore the neighbourhood more. However, he was always the careful one who would cautiously remind me that we should stay within our safe perimeter. While he was still trying to hold the sandcastles together I, on the other hand, had lost interest of the constant collapses. It felt like we were building, knowing that it would fail so we could do it again.

So I started to search for butterflies. I would spend all day hunting for them and chasing them and hoping to catch one. To be honest, I was envisioning a display case of different-coloured butterflies that I had personally collected. Maurice would laugh at me saying that I was just chasing a rainbow and that I would never ever catch any butterflies even if I had the right equipment. I was using my bare hands then, but that mockery never stopped me from chasing those little creatures.

Other times when he was bored of building sandcastles and there were no butterflies for me to catch, we would play a game of human targets. We didn't have a dartboard at that time so we would use each other as targets. As children who didn't know the dangers, we thought we were being very creative to have come up with a new and innovative game, and we invited the children from the neighbourhood to join us. We drew straws to see who would be the moving human target board; the person who drew the shortest straw would have to start running pretty quickly before the others caught on and started throwing the darts.

I couldn't understand why I kept getting the shortest stick from the lot. Before I figured out why I had the shortest stick, those vicious unfriendly kids were running and throwing darts at me, even before I started to run. The children had forgotten that the game is based on a moving target.

We may not have had a target board, but we definitely had real darts. At one point, I had three darts stuck on my body; one on my knee, one on my arm, and one at the back of my neck. This innovative dart game didn't last too long. It was hard to hide the wounds from our mother and we both got some big whoppings from her, plus a lot of bandages. Maurice and I played well together; however, with all the commotion at home, and the adults debating whether darts are safe, we quickly switched back to building castles and chasing butterflies.

Keep Those Dreams on Fire!

As children we dream more often, we take risks, and we don't let others' opinions affect the way we act or behave. So what happens to us as we grow up to be bigger human forms? We learn to fear trying, experimenting, and, worst of all, we don't dare to dream.

Is there anything you have always been curious to try but it seemed too far "out there" from your actual life, and because of that you stopped yourself from even trying it?

It is crucial that we stay as true to ourselves as possible. Many of us rule things out before we have the experience or information to judge them. The honest truth is we continue to judge even when we have information to suggest we shouldn't. The majority of the time, before we see the possibilities, we automatically jump to a negative conclusion. For example, I want to learn surfing but I don't think I'll be good at it so I tell myself let's just forget about it. I would like to fit into skinny jeans but I think I will never be skinny enough to wear them so I just keep eating. We bitch and moan, moan and bitch, our mouths move more than our actions. We complain about the same thing all the time, and we don't do anything to fix it. If you think about it, it's pretty sad, isn't it?

The majority of us lead pretty routine lives. We work during the weekdays, we run errands on the weekends, we take vacations once a year, we pay our mortgage every month for twenty-five years, and we have a dog named

Chase. What we really need is to shake things up a little, try something new that's out of the norm, even if it takes us out of our comfort zone. Don't be afraid. We won't know whether we will like a new thing if we don't give it a good try, so let us not cut ourselves off because of ignorance or fear of the unknown, especially not from something that could be our key to a better future.

If you like to volunteer—then volunteer. If you don't want to work for someone—explore being your own boss. If you want to discover new places—it was Santorini in Greece for me—find a way to get there. Fulfill your internal desires and needs. Don't create obstacles for your dreams.

Many of us feel that we are pretty much set in life. We settle for what's in store for us, like my mother who settled for a job at a milk factory. She used to call it her destiny and say there was nothing she could do about it. She ended up working there for over four decades. The same job for four decades! I cannot even see myself doing the same job for three years! Come to think of it, it was forty-six years to be exact.

Almost everyone wants to be set for life; almost everyone wants to make more money; and almost everyone wants to stay healthy. These are dreams, not goals. We need to break them down further, so we can get to our dreams, like chasing butterflies. I dreamed that I would catch butterflies. But I didn't have any gear to help me catch them. If I had broken down the goals to acquire the proper equipment and planned the right time and the right place for catching, I might have ended up with one or two, if I had luck,

plus a ton of determination. My dream didn't come true, because I did not define my goals nor a way to get to them. I wandered aimlessly trying to catch one. So who am I to kid myself? No wonder my brother mocked me back then.

When I was running the Canadian market at my previous company, my goal was to grow sales in a fairly mature market of eighteen plus years. And how was I to do that? I broke the country down into provinces, then into cities, then into markets, then into events and promotions, and so forth. With that step-by-step strategy, I was able to piece the sales together to achieve the growth that I desired.

Getting to your dream is like building blocks: one block at a time to get to your final product.

If we dream of not working for someone, then source out opportunities to be our own boss. Start from the foundation. What does our capital look like? What kind of return on investment are we looking for? How much time would we devote to making our business work within a certain timeframe? The answers to all these questions have to be clear, and deliberate intention will make our dream a reality. We need to crystallize our vision so we can start to bring attention to our smallest actions, so that everything we do brings us a step closer to realizing our dream.

Mastering Dream Building and the Power of Visualization

Try to visualize achieving your dream—the Laws of Attraction and Manifestation work. But, please do not create goals that are impossible to achieve—for example, seeing yourself fly or teaching your dog to say, "Hello master,"—as you would be setting yourself up to fail. It is quite simple: when we visualize what our dreams look like, they should be realistic.

Your vision of success should be specific. For example, when you visualize yourself being your own boss, CEO, or founder of a company, picture yourself as part of the network of people you'll be meeting, see the free time you can find, envision the kind of space you'll be working in, and imagine the potential sacrifice in the initial stages of the business. The more details you inject into your vision, the more alive and vibrant your dream will look to you, and the easier it will be for you to work toward it. Feel it come true.

Remember the story of my sewing project; remember the multiple pieces of fabric that were not supposed to be in the paper bag? Even though I did not envision my dress to be in four different colours and textures for the exam, I did envision completing the assignment and reaching my dream of satisfying my mother.

Attach feelings to your vision. When you visualize yourself being your own boss, ask yourself how it feels to come

home every day knowing that you have put in a day of hard work solely for yourself and no one else. Isn't that fulfilling and satisfying? Picture yourself splurging for your family on a vacation that they wanted to take. How does that make you feel? How about picturing yourself driving a shimmery white BMW 700 series convertible? How do you look in that sweet thing?

By emotionally attaching yourself to your visualizations, you are approaching your dreams as if they already exist. Instead of injecting your dream with negativity, you are now indulging it with the feelings of success. Feel the abundance here. You will get back what you give out. So send positivity out into the universe and you will get positive things back.

Are you excited about it? I am feeling a rush just writing about it.

Like anything you do, excitement makes the process easier and more fun. Visualize yourself making a million or two a year doing what you truly enjoy; you canno but feel excited. Think about the process you have to go through to get yourself there, and then feel the happiness that surrounds it. That alignment will increase your enjoyment every step of the way.

I am a very visual person; I see things through pictures and graphics. One project that we can all do to help create success is to create a vision board. Everyone in this world should have a vision board. Be materialistic for once. Stick all the things you want on the board, like mansions with tennis courts, awards, around-the-world cruises, being on

the cover of a magazine. I have the mentality of "Go big or go home."

I have a hand blown glass "dream vase" in my living room, and every time I have a dream, I write it out and place it in my dream vase. Once I accomplish my desire dream, I would replace it with another dream. The more exposure you have to your dreams, the closer you are to making them a reality through your subconscious mind.

The truth is that visualization is a very powerful tool. Even the most famous, successful people like Oprah use it. Those who truly know what they want, outperform everyone else by far. Your imagination can create fear and limitation, but it can also break through such blocks. Start acknowledging your immediate actions, give yourself kudos for the little accomplishments you are making, reflect on your day, and refocus on your next goal. There are happy people in this world and dreams do come through, so why not yours?

" *Imagination is more important than knowledge.* "
Albert Einstein

CHAPTER FOUR

GOODBYES ARE TOUGH

AN AIRPORT GOODBYE

On May 10, 1988, there were at least thirty people at the Singapore Airport seeing me off: my grandparents, my mother, brother, aunts, uncles, and cousins all from my Lee Clan, and of course, my friends. It was a bittersweet moment. I had never left home even for a weekend trip, and now I had become the first member of the Lee Clan to step off our soil for an overseas education in Canada. The idea was quite fresh and prestigious.

I was excited yet nervous. On the one hand, I felt very liberated, while my family, on the other hand, felt a loss of control. I have not seen the Lee family, with such strong characters, shed so many tears. For once, my strong and solid Grandpa Lee, the rock of the family, was standing at the back of the group tearing up silently. Emotions are very contagious. Watching him being so emotional, streams of tears were running down the faces of the entire clan. In no time, they were going through boxes of tissues; it was quite an embarrassing moment. Other than my grandfather, the rest of the Lee Clan is definitely not the most discreet family I know.

The only person I zoomed in on was my Grandpa Lee. I saw true sorrow in his eyes. Grandpa Lee is not a man of emotions. He doesn't speak much if he doesn't have to, but his eyes were telling me that he wasn't going to let go of me anytime soon; in his eyes I was not ready to leave; I was still that baby in the crib wanting to be with her family; maybe in his eyes I would never be ready. Even though he didn't utter a word, I knew from his facial expression that he wanted me to stay. For a strong man to shed tears especially Grandpa Lee was strange to the Lee family, as they had never seen him cry before.

I went up to him, wiped his tears, and said, "Don't cry. I won't be away too long. I will be gone just a couple of years to study art. I will be back before you even know it, Grandpa."

I gave him a long hug, kissed him on his cheeks, and left for the security check-in. His piercing eyes were so intense that I felt them follow me through the gates. I couldn't stop the tears from rolling down, but I couldn't show him how I felt, as it would sadden him even more.

Little did I know that was the last time I saw him.

My Father Kin

Let me explain why I climbed aboard that plane. At Christmas in 1987, I had received a phone call from my father. We hadn't been in touch for such a long while, probably three to four years. He had left us when I was six and my brother was four. He seldom returned home to

visit us and I don't remember him even calling us on our birthdays.

I wondered, Why is he calling?

I found out later that my mother had spoken to him regarding my passion for arts. As she did not support my eagerness to study art, she hoped my Dad would talk me out of my nonsense. I don't understand why she thought someone who had not spoken to me for years would have any influence over my decision.

I could barely recognize his voice when I took the call. We went through our usual greetings: "Hi," and "Hello, how are you," "Fine," and "Thank you."

Then, I went ahead and pushed for why he was calling me out of the blue. He said he had found out that I had a keen interest in fine arts and wanted to discuss my options. He shared that he was a draftsman at an oil-sand refinery and was really enjoying his work.

"My dad has a creative side too," I thought to myself, and that was enlightening to know.

Our conversation became interesting when he topped it off by extending an opportunity for me to come to Canada to be enrolled into a reputable fine art school in Edmonton called Grant MacEwan College.

I was quiet for a moment, wondering how I should respond. He was inviting me to live with him, and to attend one of the finest art schools in Canada. How could I reject him? But I hardly knew this man. His offer was too good to be true. That meant I would have to spend time with him, get to know him, and attend a real art school!

Without thinking too much, I said a big, "Yes!" to him.

I told my mother and aunts that I had decided to study art in Canada. My mother was not at all pleased with our conversation. It was entirely not what she had planned and expected.

For the next few months we prepared for my return to Canada after a eleven-year gap, and I had to deal with a very unhappy mother. I had been just a small child when I first visited Canada in 1977, but this time around, there was a purpose for my return; I was ready to learn to paint a colourful canvas abroad.

Enroute

It is not surprising that the flight to Canada from Singapore was the longest flight I had ever been on, considering that I hadn't been on many at that young age. In fact, I felt the stares from everyone's eyes on me, probably wondering why that kid was all alone. I was nineteen then, but I felt like a thirteen-year-old, travelling on board this huge, giant Singapore Airlines Boeing 737, going on an adventure without her parents. I had a layover in Hong Kong for the night before continuing on with my journey.

The airport bus drove through the night streets of Hong Kong taking me to my hotel. That was the first time I had seen that city. Hong Kong is one of those rare cities that is even livelier and more interesting at night than it is during the day, yet most people's nocturnal habits consist of the same old, same old: dinner and drinks, then off to bed.

This city doesn't seem to want to sleep. The neon lights alone were enough to get one's adrenaline up and going.

I checked into my hotel, threw my luggage in the room, and headed out into the city. I wanted to visit Temple Street as I had heard a million times from Grandpa Lee about the energy that place has, the place where he would hang out after hours of cooking in the restaurant. I wanted to see it for myself. Temple Street market was starting to pack up its stalls. It normally started as early as 10 p.m., but the action does not reach a fever pitch until 4 a.m., when retail buyers negotiate with vendors, and tattooed, shirtless workers haul crates of apples and lychees.

My mother would never approve of me even hanging out after 10 p.m.; this liberation would have given her a heart attack.

Down the next street, people were fueling up with delicious bowls of noodles at the twenty-four-hour fishball noodles shop, and the tastiest seafood congee at the heavenly congee shop. There was plenty to keep me interested: street food, people bargaining at late-night knock-off clothing and bag stores, girls and guys happily heading to snooker halls, CD hawkers competing for sales.

The neon lights and the street food got me so pumped that I forgot it was 2 a.m. in the morning. I quickly tried to locate my hotel, but I had entirely forgotten where it was at that point. I could just hear my Aunt Koan's voice screaming out, "I told you to stay where you are!"

Luckily, people in Hong Kong were nice enough to direct me to my hotel, where I was able to catch a few hours of snooze before the airport bus came for me.

I boarded my flight to Vancouver early in the morning, still feeling quite stimulated from the previous night. If that was the freedom and lifestyle of an overseas student, I could totally "dig it"! When I touched down in Vancouver, British Columbia, my excitement was overwhelming. I gave my dad a call to let him know that I was on my way to my final destination of Edmonton, Alberta. All that occupied my mind was a visit to the art college Dad had raved about. It was an easy sell to me and I could not wait to see it for myself.

Edmonton , Alberta

I had a culture shock when I reached Edmonton. My first impression was, Why is it a ghost town? Where are all the people? In Singapore and Hong Kong, there are heaps of people roaming the streets, even at midnight, but the streets in Edmonton were empty.

On our way home in Dad's old station wagon, he said, "It is the weekend and everyone is out and about." If everyone was out and about, where were they out and about? I could hardly see more than a few dozen people on the streets. Back home on a weekend, you would see hundreds and hundreds of people, body to body, walking in all directions.

The streets in Edmonton were older and dirtier, the cars were run down, and there was hardly any greenery around. Everywhere I looked seemed brown and concrete; it was quite depressing. Was that what I had signed up for? I told myself that it wasn't permanent; it was only for a few years

and my goal was to graduate as an art student and return home to see Grandpa Lee as promised.

Just go with the flow, I told myself.

Although I was thrilled to be in a new country, it was not an easy feat to compromise myself to living in Canada. There were so many things I wished I could have but couldn't. Everything was new and exciting to a newcomer. I was learning the similarities between the two countries— most of the time laughing at the differences in culture and lifestyle. I had high hopes and expected great things to happen in both my education and my overseas experience. The thought of that gave me hope and wings to fly high.

The following day, I visited Grant MacEwan College. Right away, the minute I stepped inside, seeing the art, photos, and statues spilled all over the entrance, hallway and foyer of the building, I knew I belonged there. Creative individuals from dance to architecture to commercial and industry arts to music arts were all housed in this giant orange building on Stony Plain Road. I was ecstatic. I couldn't wait for the school admission officer to finish giving me the grand tour so I could grab a pen, fill out an application form, and submit my portfolio with it. I wanted to be branded as a Grant MacEwan art graduate so badly.

I waited by the mailbox for weeks for an acceptance letter. Months later, when I received a white envelope from Grant MacEwan College, my hands were shaking as I opened it. I read the first two sentences, "Dear Belynda Lee, Thank you for your application, unfortunately ..."

Unfortunately! What do you mean by "unfortunately"? It was a rejection letter stating that I did not qualify for their program based on a lack of admission qualifications. What did that mean? I met everything they had stated as admission requirements on the form. I had been rejected for the second time. First, the lack of support from my mother for registering into an art school in Singapore, and now that I had my family's blessing to finally study art, I was rejected yet again; this time by the school. Was it really my destiny not to study art?

I called the registration office the following day, inquiring about my admission. They explained that my Cambridge "O" levels were unrecognizable being at a foreign education standard, and recommended me to take an international TOEFL (Test of English as a Foreign Language) exam so that I could be considered an international student. They suggested that I reapply again in the winter the following year, six months away.

On the rejection letter, there was a statement that classified me as an international student with an English deficiency based on an unevaluated foreign education qualification. Were they serious? I was a top student in my class with flawless grades, especially in languages. I had finished my secondary education in an "Express" academic program, which meant I had taken four-year courses leading up to the Singapore-Cambridge GCE "O" Level (General Certificate of Education at the Ordinary Level) examinations, whereas other students were required to finish their secondary courses in five years. I was not sure whether

Grant MacEwan College knew that Singapore's education system has always been described as "world-leading."

Here in Canada, I had been classified as a possible ESL (English as a Second Language) student. I was both embarrassed and disappointed. I sat in my room for days, feeling thoroughly defeated.

One night I dreamed that Grandpa Lee spoke to me and said, "Stick it out—don't give up that easily, little one. No matter how hard it is—go through the tough times, just like I did when I was young, and aim to taste accomplishment before you return home. Do not be afraid of growing slowly; be afraid only of standing still."

I woke up the next morning feeling empowered. I let go of my ego and I went to apply for my TOEFL class and examination. I humbled myself enough to provide what was necessary for my entrance requirements so I could return home as an accomplished woman, just as Grandpa Lee wanted.

At the same time, I was undergoing stage two of being a newcomer. At first, I was feeling excited and agreeable. By the second stage, I felt homesick, frustrated, and confused. I felt that I could not overcome the challenges that were confronting me daily. The cultural and lifestyle differences were not fun anymore. I had started to be cynical about them. I felt symptoms of bipolar disorder. I would wake up one day feeling totally positive and the next day I wanted so desperately to catch the next flight home.

My dad told me that I needed to keep myself very busy so I would not feel homesick constantly. I took his advice, and

went looking for a job while attending my TOEFL classes. I got a job as a store clerk at a 7-Eleven store close to home, working the graveyard shift. It was an easy job, because no one wanted to work graveyard except me. I was the night-shift cashier/customer service assistant. The funny thing is I could barely tell the difference between a quarter and a nickel. I remember having my customers help me differentiate between a dime, a nickel, and a quarter; an interesting request from a cashier!

I was mocked daily by customers on my accent, my glasses, and my hairstyle. They asked the most redundant questions like, "Why are you in Canada and not back home in China? How come you can speak English when you were born in China?"

They were clueless as to where Singapore really was on the world map. Singapore is not even geographically close to China; it is in Southeast Asia. And English was and still is its first language. Canadians seemed adamant that all Chinese must have arrived from China, and all other countries around China were mere cities belonging to China.

I stopped correcting my customers after a while, and told them I had been adopted by a couple of gay Englishmen who had found me at their front door and taught me English. They actually bought that story instead.

After six months of figuring out the culture and the education system in Canada, I thought I had a good handle on my life when I was thrown by another huge learning curve. Edmonton was hit with the century's coldest winter. The

blizzard winters were reaching minus 50° Celsius (minus 58° Fahrenheit) not counting the windchill; that is below zero! Media were warning the public about proper attire during these extreme weather conditions, as severe frost-bite could cause permanent damage depending on how long and how deeply the tissue was frozen when exposed. They broadcast several severe medical cases that had taken place: people who were affected by severe frost bites that had caused blood flow to certain areas to cease, causing permanent damage to blood vessels, muscles, nerves, tendons, and bones; the affected area needed to be amputated. The news was too shocking for a newcomer from a tropical island city where the weather was pretty much constant throughout the entire year, no traumatizing weather news, no drastic changes in climate, just occasional rain showers.

I stayed indoors most of that winter, which in Alberta can last as long as five months. That didn't help much as my skin was reacting poorly to the drastic weather changes and my eczema was flaring up throughout my entire body. Some of the inflamed areas of my skin became blistered and weepy; other parts of my skin were cracking, dry, and itchy. It was so unbearable at times that I would be awoken in the middle of the night by discomfort; pills were the only way to catch a few hours of sleep.

That winter was my first adversity as a young, inexperienced adult who had never travelled before. I wanted so badly to return home. I felt tremendously guilty for leaving my family back home, especially my Grandpa Lee. I missed him dearly. I called home numerous times wanting

to hear his voice; the Lee Clan updated me with news that everything was great, but I could never reach Grandpa Lee. He happened to be out playing Mahjong at a friend's house every time I called.

Refusing to admit failure as an overseas student, I neglected to inform my family that I was still desperately trying to get into the art college and was working as a graveyard store assistant at a 7-eleven store. Life was not the most glorious and truthful at that time; I was again taken over by my ego and not by my spirit.

One day in early February 1989, ten months since leaving Singapore, I got a call from home announcing that Grandpa Lee had passed away the night before. I stood by the telephone, frozen, not believing what I was hearing. How could he be gone when I had just seen him a few months back? I had promised him that I would be home before he even knew it. I had promised him I would see him again. The loss of my mentor, my life coach, and the father figure in my life made me confine myself in my room for weeks.

Apparently shortly after I had arrived in Canada, Grandpa Lee had got very sick, and was coughing tremendously. When the family finally convinced the stubborn old man to see a doctor, he was diagnosed with stage-four lung cancer. The tumour had metastasized to other regions of his body, and had spread to his bones. The tumour was inoperable at that stage, and Grandpa Lee was not willing to be treated with chemotherapy and radiation. It was too unbearable for him to take at that age. Within a short

period of six months, he died on his bed with his one and only love, and life partner, my grandmother, next to him.

In order to keep me focused on my studies, my family didn't disclose his illness, because they wanted no distractions for me. During his last days, he was still asking for his first "grandson" who had won him over with bruises on her forehead and tears that longed for him in her eyes. He painted the day she won him over at the hospital so vibrantly as if it was yesterday.

Lee Yat Man passed away in February 1989; he was seventy-eight-years old.

Yat Man had lived a hard but a glorious life; he endured all the hardship that was dumped on his lap at the age of fifteen. As a young man, he was already acting as a single parent for his sister. He travelled, he begged, he suffered, he worked, he dreamed, he inspired, and he mentored. He lived his seventy-eight years wonderfully and he passed on so much to his family, so they could carry on his legacy of the family's value and integrity.

As Grandpa Lee would quote: "To enjoy good health, to bring true happiness to one's family, to bring peace to all, one must first discipline and control one's own mind. If a man can control his mind he can find the way to Enlightenment, and all wisdom and virtue will naturally come to him," (Buddha).

He taught us all well over the years. His words may now be silent, but his actions were loud. He was the rock for the family, and a great example for us all to learn from and to follow. Without him, we would not have learned the true

meaning of self-integrity; we would not understand why we should not compromise for what we truly believe in; we would not know why we should never be influenced by others' opinions; and we would not understand why we need to keep our beliefs as our highest priority.

> **"** *A wise man makes his own decisions; only a fool will follow other opinions. Always remember never to regret your decisions, treat mistakes as experience, and whenever you reach success, remain humble, because you were never alone on your journey.* **"**
> **Grandpa Lee**

Even today, I still grieve for the loss of this great man. I didn't return home for his funeral, because I was young and in denial. I think I still mourn for his loss. I don't believe he left us. I feel that his spirit has always been here beside me, guiding me and watching over me. Grieving for a lost one can take years; my grief has lasted a quarter of a century. Maybe it is because I did not witness his funeral or maybe it is as simple as the fact that I am not willing to let him go. Whatever the reason, losing someone I love so deeply is just a tough process.

Grieving takes time.

Grieving includes the masking effects of denial and isolation. When they begin to wear, the reality and its pain re-emerge. On one side, I told myself I am ready to face the truth and on the other side, I told myself that I am not

ready. My intense emotion was deflected from its vulnerable core, redirected and expressed as anger. My anger was aimed at anything that surrounded me: inanimate objects, complete strangers, friends, and even family. I even directed my anger at Grandpa Lee. Rationally, I knew that he was not to blame. Emotionally, however, I resented him for causing us pain and for leaving us. I felt guilty for being angry, and that made me even angrier.

There were days when I felt a sense of helplessness and vulnerability; I so desperately wanted to regain control. Secretly, I would make a deal with God in an attempt to awake one morning and find Grandpa Lee there. That was a weaker line of defence to protect me from the painful reality.

Sadness and regret predominated over the next few months of my life. All I had to befriend were a couple of colleagues whom I barely talked to at the 7-Eleven, and my unfriendly customers. There was no one close enough to share my sorrow with; thus, my depression turned subtle. All I needed was a simple clarification and some reassurance. Even a few kind words would have done the trick. A hug would have been nice too, but I kept the pain inside me for years, not knowing how to let it go until I was able to pen my pain into this book.

Death may be sudden and unexpected. Going through the process of writing about my grandfather's death has helped me see beyond my anger and denial. It was not necessarily a mark of bravery to resist the inevitable and to deny myself the opportunity to make my peace.

~

Nearly a year after I left Singapore, I was still not enrolled into the art program. I had missed the cutoff date the first time, and the following winter's intake was already filled up when I applied as an international student, because they would fill their seats with local citizens before offering space to international students.

That year that my entire dream took a downhill turn, I dropped the idea of attending the arts program, stopped my TOEFL classes, and threw out the one and only portfolio that contained all the art work I had done over the years, the only proof that I can draw. A dramatic change had me focus on a more permanent job; I took some upgrading classes so I could update my North American academic qualifications to fit into the new environment. That was also the year when I met Rob, the father of my two beautiful children. I had no idea that that year would be the beginning of a journey that I least expected, a journey that took me away from my dream of becoming an artist to being a single mother of two children who struggled to put food on the table with an entry-level job. That forced me to grow up and strive for a better life. It took that tough journey for me to become an inspirational speaker, an author, and an executive for a multi-million dollar international company.

Although I might not have ended up as a designer, I redesigned something that was greater than art—my life. I

went from being an insecure, invisible, lost individual with low self-esteem, to being an assertive, strong, outspoken, and confident woman. I did not arrive at this place with a wave of a magic wand, or on a flying carpet. I earned it through years of dedication, hard work, focus, and tenacity. And these are the elements I wanted in my life so my successes will last a day longer than anyone else's.

SELF-ACCEPTANCE: PICK YOURSELF UP, DUST YOURSELF OFF, AND START AFRESH

> " The ideals which have lighted my way, and time after time have given me new courage to face life cheerfully, have been Kindness, Beauty, and Truth. The trite subjects of human efforts, possessions, outward success, luxury have always seemed to me contemptible. "
> Albert Einstein

Many people know that they need to make a change, either personally or professionally; but they don't make the change because they are terrified of stepping into the unknown. The big question mark comes when they don't know whether they will be successful or not. If it doesn't

work out, it might be the end of the world for them. To many individuals, "failure" is a strong, hard word to accept. Some of us feel that if we fail, our loved ones and friends will think less of us, be disappointed in us, or even withdraw themselves from us. We tend to set an expectation of ourselves so that others can accept us a little more.

I know of a few friends and co-workers who increase their expectations of themselves just because they don't want to disappoint their loved ones or even their bosses. And all this has really nothing to do with anyone but themselves. Internally, they just feel that they need to be accepted and win the approval of others.

I personally set extremely high expectations of myself, sometimes so outrageously high that my friends think I am just being too hard on myself. Like writing this book. I am not a writer nor am I a reader. But because of my desire to write this book, I have been reading and researching a lot more. I don't think I have read that many books since doing my MBA (master's degree in business administration) program a few years back. Sometimes, we have to take a step back before we can move forward in life.

And often we don't try because we "can't" fail. So it falls on to doing the same old thing over and over again, accepting the current situation, and then spending our lives complaining. There are no two ways about it: failure sucks and it hurts emotionally as well as financially. It can tear you apart and beat you down; and some people just don't have the courage to climb back up after that.

Most people prefer a safe place to be, while others prefer

to take a little more risk. I am probably classified as the latter, which also explains why I fail more than most people. I have failed in ideas, in business, and in relationships. I could not comprehend why these failures had to happen to me even after I had followed through with all the checks. For that, I used to call myself a victim every time I failed. Why me? I asked myself.

Then I came across a quote: "Fail Faster, Succeed Sooner," attributed to David Kelley, a business innovator.

I took the chance to try new things more openly. I experimented with new ideas more bravely. I shared more than I used to, so that others could benefit from my advice. In return, what I gained was personal growth—I grew as a person and I became a better individual.

I finally figured out that failure is part of the process of reaching world-class status. The more falls you take, the more screw-ups you encounter, the greater your mark of excellence. The most loving couple fails more often than a divorced couple. The best companies fail more than average ones. The most successful people fail more than ordinary ones.

The biggest failure by my standards is the failure to dream and to try. You don't want to wake up one day and regret the things you didn't do. Instead, you can choose to laugh at the ones you did try that failed.

" *Insanity: doing the same thing over and over again and expecting different results.* **"**
Albert Einstein

Responsibilities Are Not Liabilities

I used to have an employee, someone I had personally taken under my wing, who kept saying that the reason she chose to do or not to do something was mainly because she didn't want to disappoint me; she wanted to make me proud. The funny thing was my job as a mentor and sponsor was to inspire her to be better at what she was doing and to conquer her fear of trying. I didn't judge whether she fell on her face or not, as long as she picked herself up for the next project. The reality was no one would judge her based on one failure, certainly not me. She was so concerned about getting the approval and acceptance of others that she prejudged herself even before anyone else had a chance to do so. She was denying herself success by putting the responsibilities on someone else.

I was having a cocktail with a business partner one day, and he blurted out "Do you know why you are so successful Belynda?"

I looked at him puzzled and asked, "Oh, Great One, please enlighten me."

He looked at me seriously and said, "It is because you 'DARE.' Just like a fearless child—you dare to dream big.

I have never seen you being in fear of responsibilities that will make that dream of yours come true."

The wise one was right again. Fear to dream will hinder success; responsibilities are not liabilities; being responsible shows character.

I have to say that falling on your ass isn't fun. Deflect all the negativities by mirroring them out of your life. People who are supportive of you will give you the proper feedback and advice to help you grow and advance in life. And for those people who judge you, you know what to do with them—don't let them in. You have the choice who you want and don't want in your life. Like a mirror, you can deflect away what you don't want. And as for the judgment you put on yourself, well, that's too bad—you are just stopping yourself from achieving yet another success.

Here's the key to overcome failures. When you learn that you've done something wrong, take the proper steps in the right direction. Use failure as an entry point for learning, a way into wisdom. With the right attitude, you can transform any setback into a guide for growth.

So I would like to challenge all of you to pursue your dreams, and understand that failures will be part of your journey. Failures will teach you how to succeed. When you meet failure along the way, tell him you are okay, and move along to meet your next one, because the more failures you meet the closer you are to success.

Making Choices; Taking Responsibilities

Ultimately, being responsible means taking responsibility for ourselves, for the choices we make every moment.

We have no idea how powerful we are as humans. We tend to see ourselves as tiny individuals in an enormous world, doing our best to sway the tides that come between ourselves and our desires. Change this perception! Stop the feeling of victimhood! Bring true freedom to yourself! Be happy and content!

What we focus on grows.

Our focus creates our reality.

If we focus on what is wrong in our lives and the world, we see more of what is wrong. If we focus on the things we love, the things that inspire us and fill us with joy, we start to see the beauty that blinded us before. You can transform your experience in life in an instant, just by turning your focus inward. Just by focusing on yourself rather than on the dramas and worries of the world, you will remove yourself from discontentment and any preoccupation with failure.

It is that simple. However, as adults, we somehow don't want ourselves to be happy. We prefer to fight for what we believe should be fixed, even if it is not broken. We don't want to surrender; we want to win every battle. Why not leave things the way they are? Because we are convinced that we know best how our life should be.

Children on the other hand are just the opposite. They embrace situations without questioning; and even when they are questioning, it is just for a few minutes before they focus on something else.

Let's focus on what we have achieved, on our lives, and on this wonderful world. Let's celebrate the passionate and inspiring people around us. Try this today: focus on enjoying each moment; give your best in each situation that presents itself. The power of focus is so huge that you can actually own your happiness by changing your focus.

Our society manufactures victim-consciousness. Mass media champions the victim, the underdog, feeding the idea that we are victims who need to be saved from our oppressors. This mentality is ingrained in us so deeply, that it is hard for us to understand that we are not victims. The idea might even give us a bad taste in our mouths. Many might think that approach is cruel and lacking in compassion. Our compassion should be to encourage inspiration and change; to push people into doing greatness, beyond their external situations. The most important and lasting service we can do for ourselves is to heal our own inner victim and our perception of victimhood in others.

It takes a lot of courage to be a creator. If you want to be a creator, you need to stand on your own greatness and take full responsibility for everything that happens in your world. The rewards are endless and the results are supreme satisfaction with yourself and your life.

Society preaches security and safety nets, which also makes comfort luxurious rather than stagnant. We have

learned to refrain from speaking the truth for fear of conflict and to avoid confronting our fears whenever possible. We agree that having a routine is probably better than the unknown, and security is safer than spontaneity. Yet the things that make us uncomfortable, the disappointments, and the losses are what challenge us most in our lives. What we don't see is that the storms make us stronger. They give us maturity and responsibility and direct experience.

Life becomes stagnant when we remove and avoid its challenges. If you spoil a child, when they grow up, they won't have the skills to be able to face the world and function well in society. The same thing happens when we overprotect ourselves and try to avoid conflicts in life; we may find comfort but we will not build the skills that lead us toward growth.

How did you grow from a child to an adult? Was it by making mistakes? The more mistakes you made, the better you became at facing challenges in life. We all have to go through some form of suffering before we fully understand, flourish, and grow as individuals. We must face the world head-on and embrace the losses and disappointments life gives us.

It is natural to have ups and downs in life; that is called the human experience. When we nourish unconditional love through self-love, we begin to embrace the contrasts in life; then we will find adventure in change and uncertainty. Success is about embracing the contrast of life fully, without fear.

So it is okay to move out of your comfort zone. Although we feel safe within our own confines, we are not challenging ourselves to be more; we are settling for mediocrity. I understand that it is safer to be in our success area, but the fear of failure clouds the perception of our full potential. The mind convinces us that we are not capable of more, so we stay put.

We would rather cling onto comfort because we fear our greatness. Isn't that ironic? Many of us want great things in our lives, yet we fear achieving them. Greatness requires the courage to stand alone and not compromise our truth. Greatness goes out on a limb; it does not stick to the status quo. To trust ourselves, to stand in our own integrity without abandoning ourselves in order to please others, that's greatness.

Now there is a certain complacency in our society, so to break away from that requires courage, but if we want to free ourselves from our own inertia, we need to stop worrying about what others might think. We must be willing to make mistakes, try new things, and have new experiences; we must dare to showcase and express ourselves.

If I stand out from the crowd and do something noteworthy, I am responsible, thus I put myself in a place of responsibility. It is easier to blame my financial situation, my upbringing, or society for not fulfilling my dreams. Yet I know I am capable of moving beyond my comfort zone and achieving greatness. The most inspired and celebrated individuals in history have all gone beyond all odds to realize spectacular achievements. They are the ones who say

yes when the world says no; they are the ones who could have used their extreme circumstances as an excuse to achieve nothing but choose not to.

So why are you staying comfortable in your life? Why are you sitting back? Excessive comfort will manifest laziness. Move out of your comfort zone, and start challenging the places of comfort in your life. Try new things. Take risks. Dare to be uncomfortable. When you do that, you will find comfort to be dissatisfactory. It leaves you uninspired, unhappy, and listless. Be direct, honest, and proactive. Push yourself to be more, and challenge ideas you have about who you are and what you are capable of.

> *You must take personal responsibility. You cannot change the circumstances, the seasons, or the wind, but you can change yourself. That is something you have charge of.*
> **Jim Rohn**

THE STRENGTH OF A WOMAN

The three of us—Benjamin, Sue-Lee, and me—were sitting around in our new living-room. We had just downsized from our home by the water to a beautiful cozy townhome. We were laughing and joking about our last vacation in Maui, Hawaii. The joy and laughter from my children, especially Benjamin, made me think of where that laughter would be if I had decided to have an abortion. It seemed almost yesterday when I discovered I was pregnant with my first child, Benjamin, and I wasn't sure whether I wanted to bring him into the world because I was mentally not ready to be a young inexperienced mother. Where would the laughter be now if my insecurities had won out?

I thought back to that winter of 1990. I had been in Canada slightly over eighteen months. I was about to make a call to my mom. This wasn't just the simple check-in call that we did once a year. I had something important to tell her and I was nervous. It took a long time for me to finally gather enough courage to pick up the receiver. I pressed the eleven numbers slowly to buy more time. The phone

started to ring. It kept ringing and just as I was about to hang up, my mother picked up the phone and in her soft and unenthused voice said, "Hello?"

"Hey, Mom," I said.

"Is this Peng?" my mother asked. "Why are you calling? What time is it there now?"

"Calling to say hi and it is past midnight here in Canada." I replied.

"Calling to say hi? Do you know how expensive it is to call just to say hi? I am fine, so let's not waste any money calling each other to say hi, okay? I'll call you if I need to speak to you."

That just meant she was about to hang up the phone and I would probably not hear from her again for months, if not years.

I quickly said, "No, Mom. Wait! I have something to tell you," to keep her from hanging up. I knew that if she did, I would not have the courage to call back.

"What is it? Come on—hurry up and speak. Long distance calls are expensive," she said harshly.

"Mom, I am pregnant," I said.

There was dead silence on the line for the next few seconds; it was probably the longest few seconds in my life.

"Mom!" I called out.

"Yes, I am here," she replied.

"Did you hear what I said?" I asked.

"Yes, I did. I am not sure how to respond to that." She sounded disappointed.

"Maybe, congratulations?" I was hoping for anything at

this point. Anything would be better than the awkward silence. But what she said was not what I had expected. What she said became a scar I carry with me even today.

"Congratulations? Congratulate what, Peng? You just turned twenty, you are unwed, and you have just left Singapore for a better education in Canada. What should I be congratulating you on?" I could hear her dismay over the phone. "What are you going to do? Should you be keeping the baby at this age?"

"What?" I was almost lost for words.

"Who is he? Does he have a full-time job? What's his name?" she asked.

"I met him at school. He is a classmate of mine and his name is Robert." I replied.

"In school? That means he doesn't even have an income. Oh, my goodness!"

All of a sudden, there was no hurry to hang up the phone because of the cost of the call. "Peng, this is not good."

"What do you mean that it's not good?" I asked.

"Having this baby will hinder your future and your career. You are still young and you still have so much to learn. Even if you want this baby, you must first have a legitimate marriage and a husband who is working and able to support both of you. Your future is still bright; it's not a good time to have a baby. Come home and we'll help you start a fresh life again."

What does she mean when she says, "...start a fresh life again"? Is she talking me into leaving Rob to return to Singapore to have an abortion? Since my father had left

us, she had always wanted her two kids to have complete families, so the thought of me having a baby with a man to whom I was not married was, for her, very wrong.

There was a long pause on the phone—no one was speaking. It was as if we were waiting for a magic answer from either one of us.

"It is embarrassing to have an unwed mother for a daughter. I think you should…"

My heart stopped for a moment waiting to hear what "I should" do.

"Peng, I think you need to live a little more before bringing another human being into the world."

"Are you saying that I should have an abortion?" I was nervous to hear her answer.

"Yes, I think it's the right thing to do at this time," she answered me quietly.

"I need to go now, Mom."

I hung up the phone without allowing her to say goodbye.

My mother's disapproval of my having a baby really left me feeling like a disgraceful child. I hadn't had much support or pressure from my mother before, but it was clear that I now had a ton of pressure from her to end my pregnancy. I agree that I may not have been an easy child for her to bring up and I had had my share of disapprovals, but this time, I heard great disappointment in her tone, and that hurt a lot.

Like me and my mother, there are women out there who plan and dream what their life should look like when they "grow up," and their lives turn out to be entirely different.

The difference between my mother's story and my story is my mother got stuck in her comfort zone at the milk factory. She accepted her life in the way it was; in other words, she was content. She believed that a woman's role was just to serve her man, to be his shadow, to be submissive in her environment, and to be satisfied with what society had branded all women to be. There would be nothing wrong with that, if the world were unbiased and impartial. But the truth of the matter is that even when my mother was polite and agreeable, in many instances, people around her disregarded her opinion and questioned her ability to stand up for herself.

Women in Power

There are many women out there who choose to take positions of power to prove true equality exists in society; mothers have been encouraged to continue to dream and acquire a successful career for themselves. Look at some of our historical female leaders around the world, like Margaret Thatcher, Indira Gandhi, Angela Merkel. These women probably suffered massive numbers of cynical comments from society before they chose to stand in front of millions of people.

Margaret Hilda Thatcher, Baroness Thatcher, the Prime Minister of the United Kingdom from 1979 to 1990 and the Leader of the Conservative Party from 1975 to 1990, was the longest-serving British Prime Minister of the 20th century. She is the only woman to have held the office. She

was nicknamed the "Iron Lady," because of her uncompromising politics and leadership style.

Indira Gandhi was the third Prime Minister of India and a central figure of the Indian National Congress party. Gandhi, who served from 1966 to 1977 and then again from 1980 until her assassination in 1984, is the second-longest-serving Prime Minister of India and also the only woman to hold the office. In 2001, Gandhi was voted the greatest Indian Prime Minister in a poll organized by *India Today*. She was also named "Woman of the Millennium" in a poll organized by the BBC in 1999.

Angela Dorothea Merkel, born July 17, 1954, is a German politician and former research scientist who has been the Chancellor of Germany since 2005 and the leader of the Christian Democratic Union since 2000. She is the first woman to hold either office. In 2008, she ranked number one in *Forbes* magazine's list of the one-hundred most powerful women in the world. She was awarded the Charlemagne Prize in 2008, for her contribution toward the betterment of the European Union.

Over the last fifty years, these women found their role as world leaders; they believed in a better place to live. Their desires were no different from their male counterparts'. They withstood mockery and belittlement from their peers and society before they could share the platform with the men. Their bravery gave them historical recognition for future female generations to continue shining and believing that women can hold a much bigger role in the world.

I am not asking for all of us to stand for the position

of prime minister or president of our countries; there are many executive roles that women can occupy in the corporate world. Female leaders and role models from the corporate world include Indra Nooyi, Chairman and CEO of PepsiCo; Oprah Winfrey, Chairman of Harpo; Sheryl Sandberg, COO of Facebook; and Meg Whitman, CEO of Hewlett-Packard. These are some of the women who worked hard to get where they are.

It is not an overstatement to say that women face real obstacles in the professional world. It is no wonder that many women, like my mother, choose to stay within their comfort zone. Either they don't have the energy to confront the issues or they lack the resources to address them. Women in the workforce face blatant and subtle sexism, discrimination, and sexual harassment. Many workplaces do not offer childcare and parental leave, making it difficult for women to pursue a career while raising kids.

" Men have an easier time finding the mentors and sponsors who are invaluable for career progression. Plus, women have to prove themselves to a far greater extent than men do. And this is not just in our heads. A 2011 McKinsey report noted that men are promoted based on potential, while women are promoted based on past accomplishments. "
Sheryl Sandberg

I have participated in boardroom meetings where the men dominate the entire discussion and, when the women speak, little or no attention is given to their input. Yes, that is intimidating! That could be the reason why we hold ourselves back in ways both big and small. We lack self-confidence for having no recognition so we choose to pull ourselves back instead of raising our hands. Is it wrong to be outspoken, aggressive, and more powerful than men? Why do we have to lower our expectations so we can be under the radar of criticism for being authentic and real?

My argument is not to punish all the men out there for our circumstances, but to understand that we do have unusual obstacles and we all need to speak up when we should. We have the power to choose when we can speak up.

Two Big, Drastic Decisions

I recently made two decisions so big and drastic that I cannot believe I am still standing up without passing out. Firstly, I resigned from a very successful nine-year career without any fallback plans. Secondly, I sold my dream home by the water and relocated my family to a much smaller townhome. All these changes happened within the same week.

I had heard of the glass ceiling before, but had not experienced it until now; it creates a limitation on moving forward. I was told I had peaked at the company, and they were having issues fitting a square peg into a round hole.

You may ask me why I considered leaving an executive role when I had reached a prestigious position; so few women hold such positions. Walking away from something has nothing to do with weakness; it has everything to do with realizing our worth and value. When you become sick and tired of having someone else put a price tag on you, you will understand why I made that choice.

I was at a point in my life where I needed another growth phase, and unfortunately I wasn't getting it where I was. Instead, I was constantly being reminded of my limitations and not fitting in. In life, there shouldn't be any ceiling. Human beings are simple: we all desire to dream more, learn more, and earn more so we can share more, and I am no different.

I had been with the company for almost nine years, and it was clear to me that no matter how hard I would try, I would not fit into the "old boys' network." I would never be accepted or trusted. Does that sound familiar? The invisible barrier of the glass ceiling was stopping me from advancing, regardless of my achievements and qualifications. I was no longer motivated, nor did I have the desire to stay for another decade. The unfair treatment was so strong that it made me leave my executive position—what I had thought was a lifelong career—to reinvent myself all over again.

It became crystal clear that it was time for another reinvention of Belynda, so I could move onto my next peak. Just because I had peaked at that company did not mean that I had reached my max. There are higher mountains to

climb and deeper seas to explore. I gave myself a mental enema, and figured what the next chapter of my life would look like. The word "empowerment" came into my mind instantly. I always have the passion to empower others, especially women; to have confidence, to believe, not to call themselves "victim." Why not spend more time in that area? That desire fuelled me to pen my first book, which is the one you are reading right now.

My choice of downsizing actually worked out in the long run. Grandpa Lee always taught us to be frugal, and never to live beyond our means. I was living in a beautiful home by the water; my executive salary was able to cover all my expenses. Without that salary, I had to relook at my financial situation, especially when I hoped to focus more time on writing the book, which will not yield an income for a while. I relocated my family to a cozy townhome nearby and we have been calling it home since. Come to think of it, our house by the water was way too big; we only utilized about 60 percent of it. Although we have a smaller home, the benefit is we are mortgage-free. Being debt-free is the most secure feeling one can ever have and I encourage everyone to reduce their mortgage or work toward being financially independent.

WOMEN FACE CHALLENGES

As women, we do face unique challenges. We lack female mentors and sponsors, so in return we learn from our male counterparts. Meanwhile, our male counterparts (quite

luckily) learn from their male mentors and sponsors who are so readily available for them. When a woman speaks up in the corporate world, she is considered aggressive and confrontational, whereas when a man does it, he is just showing the dominant side of his leadership style. When a woman asks for time off to attend to her sick children, she has "too much on her plate" and she is "just not organized enough." When a man asks for time off to attend to his sick children, he is "showing his sensitive side: what a great man!" Why do women have to work so much harder to be successful and likeable?

Society has shown me that the world judges "success" for genders very differently. When a man becomes successful, he will gain a few points in likeability from both men and women. However, when a woman is successful, both men and women like her less. Society looks at men as providers, decision makers, and drivers; whereas women are caregivers who are sensitive and communal. When a woman stands out to become somebody, the world looks at her as if she is opposing the men. There are hundreds of thousands of women in the world who are forced to become providers, decision makers, and drivers while being caregivers at the same time. They need to stand out so they can get ahead in life.

With the lack of support from our male counterparts, it is no wonder that women take the lesser role in the corporate world; naturally they turn their self-doubt into self-defense. So in order for us to protect ourselves from being disliked, we compromise, lower our expectations,

and downplay our achievements, especially in the presence of others. With such stereotyping, women find themselves "damned if they do" and "doomed if they don't."

If you asked my mother, she would tell you to suck it up and be happy because you still have a job. Who cares what the men think of us? As long as we get our paycheque in the bank to pay the bills, who cares what people think? That's not the point, Mother. This is about equal opportunity.

If our skillsets are way above our position and they deserve a higher pay-grade, we should learn not to settle or be easily satisfied with what we are appointed and seek for something that aligns better with our qualifications. Women make up half the workforce, but the higher you go the number shrinks. I am not saying that we need to create a group of cheerleaders just because we have to fill the quota for female executives. And ladies, we should never be doormats for the men in higher positions. All I am saying is we need to give proven, qualified, rightful, female leaders a chance at these higher executive positions. This is not about rah-rah girl power—No. This is a serious discussion about the reality of the glass ceiling for women and minorities.

When I took a managerial position with my previous company, I had fair warning that not many women would move far within the organization. They said if I wanted an executive position, I would be better off somewhere else. But I chose to put my ear to the ground to find out whether they were delusional or whether the company was having problems with female leadership. Sadly, it was the latter.

Here's the good part: even though we face difficulties in the world, we need to look at what we can do to improve the image of ourselves that the world and these men see. Data and society show that women do have a much harder time moving ahead. So if you are like my mother, who is easily contented with just working a job, stay where you are, please, because it is not easy moving upstream unless you are totally committed and trained to do so. Moving up the corporate ladder when working with men requires some serious "sportswomanship," professionalism, and a strategic mindset.

How Do We Make It, Wearing Those Heels?

Learn how to enjoy your own company. You are the one person you can count on living with for the rest of your life.
Ann Richards

We can make it, wearing those heels, by increasing the communication. I usually find male bosses to be direct, effective, and no nonsense, except for the one I used to report to. Men are quick at making decisions, they are objective and direct. Most of them give clear directions. (I have to say "most," because I had experiences with one who just couldn't seem to make up his mind.) So when you speak with men, make sure you don't beat around the

bush. Get to the point and make your case with examples and solutions.

No bosses, women or men, like to hear about problems without solutions. They are the least expected to solve any of your issues. Bring only solution-based issues to them and ask for their advice. If you want an answer fast, then learn how to communicate clearly. Once you have mastered clear communication patterns, it will reduce frustration and conflict amongst co-workers, improve performance and develop a positive work environment.

Ladies, no more foolish talk. As women, we often like to fill in the silent moments with our foolish talk. Stop doing that! Men don't care whether there is a sale at Saks Fifth Avenue nor do they care about your son's first tooth. Allow them to bring a topic in, and if they don't, realize that you still need to build a relationship with them. During meetings, make sure you don't adopt any negative body language or eye movements, because when you work in a corporate setting, everyone is watching. They may pick up gestures that you don't even know you are making. Be attentive and speak when necessary.

Don't freak out at everything and anything. Don't forget that you have been brought into the company to solve problems, and if you freak out on the most microscopic matter then you'll be too busy worrying all the time. Relax and be objective. Focus on resolutions.

Don't hold grudges, please! Especially between female colleagues. You need them on your side. You might resent someone for making a decision that you don't like,

or resent someone who is promoted and doesn't deserve to be. Forgive and trust that the universe is on your side. Things happen for a reason. In business, holding grudges can lead to contempt, sabotage, and erosion of trust, which are all detrimental to your career.

Don't bring family issues to work, leave them at home. Work is a professional place of production. If you are going through a relationship break-up, illness in the family, or pregnancy, ensure your direct manager knows of your situation and, if needed, take the appropriate time off as stated in the human resource handbook. Do not expect special treatment; just because you have some special circumstances in your life doesn't mean you should be treated differently at work.

Eliminate all gossip! I know it is extremely difficult not to be dragged into gossip, even though you did not start it. Gossip normally starts small and boils up to something huge. Even though it might not be malicious, gossip can hurt people's reputations and it is a form of relationship bullying, especially when the other party is not there to defend themselves. If you encounter some gossip, stay away, and do not participate in it. Allow the gossip to go away on its own. If it persists, ask the person who is passing it along to get facts and seek help.

And lastly but most importantly, men don't like to see catfights. It is already distinctly tough for a woman to move ahead in the corporate world, and when they do succeed, celebrate with them, be happy for them, and work with them. Conflicts between women in the workplace

are perceived to be more negative than male-on-male or male-on-female conflicts. Take your conflict partner out to lunch and discuss it there rather than at work. Show the men that we are an elite group of professional performers in the corporate world; that we are "sportswomen" ready for corporate battle.

Ladies, our historical female leaders have proven their success; they made it from corporate leaders who ran companies to leaders who ran countries. These women all have great communication skills, critical thinking skills, problem-solving skills, and distinctly strong strategic minds. Redirect your competitive energy to acquire these skillsets so you can move on to higher levels of the corporate ladder and the world. Even though the curveball is a fastball or a changeup (baseball terms), we women have internal strength to conquer all obstacles in life.

Whether we are mothers, wives, executives, homemakers, or students, at the end of the day we need to ask ourselves, Am I happy? Am I respected? Am I having fun? Am I making a difference? Have I changed someone's behaviour because of my example? If our answers are yes, then clearly we have no ceiling. Continue doing the great work!

66 *The strength of a woman is not measured by the impact that all her hardships in life have had on her; but the strength of a woman is measured by the extent of her refusal to allow those hardships to dictate her and who she becomes.* 99
C. Joybell C.

BELIEVING THAT WE CAN CREATE CHANGE

I have always believed that the biggest obstacle in my life is myself! It might be the same for you. So in order for you to create change, the first thing you have to do is to get yourself out of the way. You have a myriad of choices every moment, and your mind takes you wherever you want to be. As Zig Ziglar said, "You are free to choose, but the choices you make today will determine what you will have, be and do in the tomorrow of your life." Who would think that one simple sentence could capture the way we should live.

You create the life with the choices you make every day. That isn't always what we want to admit, because some of our choices lead to negative results. The truth is, we own our lives. Whether we are happy, unhappy, successful, or unsuccessful, we are accountable for our choices.

Many people are weighed down with challenges that are absolutely no fault of their own. Children are abused, parents get divorced, fat genes are part of life, and bad things happen to good people. However, as adults, we have the choice of how we deal with our past and present circumstances. The easiest thing to do is to point fingers, blame, withdraw, resent, or we can turn our faces to the future and focus on solutions. We can allow ourselves to be pulled backwards by our past experiences, or we can take the best, discard the rest, and move forward. The choice is ours.

When you choose to resist or deny ownership for your life and for your choices, you also choose stagnation, because as long as you are convinced that you are the victim, you simply cannot begin to heal and progress. If you truly want to improve your life then you must embrace the principles of choice and accountability. This is taking responsibility for your thoughts, words, and actions. These principles have the power to set you free from damaging beliefs.

We create a picture of ourselves based on the experiences, successes and failures, embarrassing moments, achievements, and the way people treated us, especially during childhood. From these we create a mental picture of ourselves. We stop to question the validity of that picture and start to believe that it is true. For example, I always loved to draw when I was a child and the praise that my grandparents gave me every time I finished a drawing or painting made me think that I was really good; soon I wanted to grow up to become a renowned artist. So I painted a picture of myself being an artist and selling my paintings for thousands of dollars.

Self-beliefs form the foundation for your personality and your behaviour. We act like the person we believe ourselves to be. Our actions are always in harmony with our beliefs, so we cannot act otherwise. Only ideas that are consistent with our core beliefs will be accepted; if they are inconsistent, they are rejected. Have you ever been told that you can never do something or you'll never be good at something, and you grow up thinking that you are never good at it or you'll never be able to accomplish it? Children who hear such remarks day after day, grow up to believe in them. And sure enough they don't excel in those areas.

The Power of Positive Thoughts

Ladies, this is such an important chapter for me; I cannot stress how powerfully thoughts can change your life. You are who you are because of the dominating thoughts you allow in your mind. You can either choose to attack or sabotage yourself with negative affirmation of your abilities or you can use positive thoughts to free yourself from self-destruction. Positive mental picturing is a key to healthy change. You are a writer, an actor, a leader, a singer, or a selfless mother. The person you see in your imagination will always rule your world. The secret is YOU. Do you believe that you can change, and are you willing to change your negative self-beliefs? Can you identify your needs? Are you willing to be humble and learn?

You also need to acknowledge your weaknesses and strengths; you need to know what's working and what's not working in your life, so you can fix it. Allow yourself to identify what your beliefs are, without being influenced by

others. Open up your mind to the possibility that some of your beliefs could be false. Allow the possibility that those false beliefs could be preventing you from moving forward.

Negativity swims around us all the time; we can choose to pay attention to it or to stop it. That is called "labelling." When you label a thought as unwanted, you are nipping it in the bud and stopping the negative thought from growing and festering. Be the "great wall" to negative thoughts when they enter—block them out, say, "That was unkind and nasty; that is not me," and then kick them out of the ballpark.

I grew up with an overly protective mother who aimed to stop me from doing everything and anything by injecting negative thoughts into my head so I would be afraid to venture into new areas. To replace negative thoughts with positive ones, simply spend some time to understand the person who is providing them to you. Think about their life experiences and needs. Put yourself in their shoes, and in their perspective. When I think back to my mother's comments, I know she was merely trying to protect me, because to her, the less I did, the more I would be safe and not be hurt.

Healthy thinking is essential to a healthier and happier lifestyle. Instead of focusing backwards, blaming others, or wallowing in negativity, fill your mind with positive thoughts that move you forward. It is definitely not easy, but it is possible. It is called "habit"! Allow yourself to change over a period of time and before you know it, you will be a naturally happy positive thinker.

Happiness is all about focus. Your attitude is key to the direction you are heading in life.

Attitude

> **"** *The remarkable thing is we have a choice every day regarding the attitude we embrace for that day. We cannot change our past ... we cannot change the fact that people will act in a certain way. We cannot change the inevitable. The only thing we can do is play on the one string we have, and that is our attitude ... I am convinced that life is 10% what happens to me and 90% how I react to it. And so it is with you ... we are in charge of our attitude.* **"**
> **Charles R. Swindoll**

You are in control of your life. What you think of yourself determines your success boundary and sets your limits. Improving your self-image will expand your boundaries and extend your limits. Have confidence in your abilities to control your thoughts—this is HUGE.

> **"** *The happiness of your life depends on the quality of your thoughts.* **"**
> **Marcus A. Antoninus**

A Mother's Love

"*Kindness consists in loving people more than they deserve.***"**
Joseph Joubert

"We don't have enough to pay for the gas bill," I said.

"Use the credit card," Rob replied.

"It's maxed out. There's no room on the card," I said with little patience.

"Use your other cards!" he said, as he was getting annoyed.

"Rob, there are no more cards—the credit card companies called and cancelled all the cards. We couldn't make minimal payments for the last six months now, and we are on their blacklist." I looked at him, desperate for a solution.

"I don't have an answer, Belynda." He sighed and walked away.

Rob was a property manager for a townhouse project earning a small salary and, since we lived onsite, we got a discounted rate on our small and worn out fifty-year-old apartment. I was working at a beauty salon as a receptionist,

earning slightly above minimum wage plus commission from retailing salon products. I would calculate the bottles of shampoo and conditioner I sold daily, just to see whether I had made a few extra dollars that day. But sadly, we would have already spent our paycheques before they were even deposited into our accounts. Our expenses exceeded our income by far and we were using credit cards to cover our monthly expenses. I loathe getting mail, because the only mail we ever received were bills, bills, and bills. We were both struggling hard to make ends meet.

One day I laid all the bills out on my bed: the grocery bills, the car payment, gas and insurance, rent, credit card bills, and incidentals. No matter how many times I punched in those numbers on my tiny calculator, they just didn't balance our income.

"Where can we cut?" I asked myself.

We needed the car. We needed a place to live. We needed food. We had been eating macaroni and cheese for the past week, so I knew we weren't spending too much on groceries. Some days we would go to our local food bank for any leftover produce and if we were lucky we might get some almost-expired bread and buns for free. Our days were filled with trying to cut spending on the necessities and at night the collectors would call, because they knew we'd be home.

Collectors are not well known for being polite. They were rude and mean, most of the time belittling—calling us liars for promising to pay but never doing so. It was not that we didn't want to pay; we just didn't have any money

left after rent, car, and food. There was one time that the utility companies threatened to shut down the heat due to overdue bills. I was so embarrassed that I had to borrow money from my dad who was also struggling with his finances. Life was tough for all of us.

Although the home front was not doing great, my work was. The effort I put into my work helped me get promoted to a key-holder; in other words, I took on more responsibilities for an extra $4.00 a day. But I would have to work Saturdays, which meant additional childcare costs. Since I couldn't afford babysitting, I asked my stepbrother Harold to help look after Benjamin on Saturdays and in return I would cook dinner for him. It was clear that my minuscule wage increase did not help with our expenses.

As an immigrant, I found it financially challenging to achieve more overseas, especially when employers did not recognize my native education. So it was pertinent for me to get some form of specialized training from a local college or university, otherwise advancement in life would be limited. Besides aspiring to be a designer, after watching Grandpa being successful in his business, I had wanted to explore a deeper understanding in running a business and managing people. I checked out some business programs at Grant MacEwan Business Facility and found a diploma program on Business Management Studies. The career counsellor convinced me that a program like that would land me in a managerial pay grade, which would also include health benefits for my family. That rang "security" in my ears. That simple decision of going back

to school, stair stepped my education from a Diploma in Business Management Studies, to a Bachelor Degree in Organizational Behaviour, and finally a Master of Business Administration (MBA) years later, while holding a full-time job.

Going back to school had never been more deliberate. When we were young we attended school because we had to, and because our parents told us to. We, as children and teenagers, never understand the value of learning. We learn basic skills such as reading, writing, and simple arithmetic to perform the most basic of jobs. Also, a general understanding of how the world works is necessary for being able to survive independently. Managing finances, balancing a bank account, and even paying for items at a grocery store depend on skills learned in school.

This time around it was different. Higher specialized learning was for career opportunities. The more knowledge I had, the more career opportunities would open up to me. It is important for everyone to go to school and learn skills above and beyond just a basic skill level. I needed a skilled education because it would allow a greater number of opportunities, long-term career advancement, and financial security.

I went to work the following week, explained to my manager what my plans were, and said that I would be going back to school in the fall to acquire a higher education so I could support my family. She was disappointed that she would be losing a top sales person at the salon, but she understood my situation and was happy for me. The summer

of 1992 was a glorious season, because I had hope. Hope for a better future for my family.

The entire summer was a preparatory season for me. Being a Type-A person, I tried to do more in less and less time in an apparently tireless pursuit of everything. I had three to-do lists: "high priority," "medium priority," and "low priority." For example, daycare for Benjamin and a student loan would be high priorities; a daily parenting schedule would be medium priority; and birth control fell under low priority. As everything else got accomplished, what was left on my list was priority agenda; it was time for an inventory of birth control pills. I asked my girlfriend to accompany me to a local clinic for a refill of my medication. I went through the usual testing procedure at the clinic, before they dispensed the birth control pills.

"Mrs. Wright, please fill the cup and return it to us," the nurse at the check-in counter abruptly shouted out.

I obliged quietly, and returned shortly after with a cup full of test sample. She didn't look up as she took the test sample, and said, "Take a seat and we'll call you when we are ready with the results."

A few minutes later, I heard my name. "Belynda Wright, please come in." I jumped up and hastily followed the nurse into the doctor's room.

"Mrs. Wright, I understand that you are here for some birth control pills. Am I correct?" The doctor asked.

"Yes, that is right, doctor," I replied.

"We are not able to dispense these pills to you right now," said the doctor.

"Why is that? There was never an issue before," I asked with curiosity.

"Mrs. Wright, you are pregnant," he said without compassion.

"What? Not now! I am starting college in a few months," I answered in shock.

"Well, your school will have to wait. You are due March next year. Congratulations and all the best." He then left the room as if I was just another patient he'd had to see.

We cannot have the child now; we are suffering financially at home with one child, and to bring another into the family with the little income that we have would be foolish. What else could possibly go wrong now? I had just been accepted to start college in the fall and I was pregnant with my second child.

I went home with a heavy heart; my mind was burdened, having to decide whether I should bring another child into the world or wait for another year to start school. My husband, Rob, wasn't too helpful either. When we had found out we were expecting Benjamin, we had done what most people would do—we got married in a heartbeat. We did not have money for a church wedding nor did we have any formal wedding celebration. We simply signed papers in the basement of a Justice of the Peace's home.

Over the following weeks, Rob was never available to have a serious talk, and on the few occasions that I was able to sit him down, his answers were short and brief.

"What should I do, Robert? I need some support here," I spoke with frustration.

"It's up to you. It doesn't matter for me whatever you decide; to keep the baby or not. I am fine with it," he said as he left for work. There went another opportunity to speak with him.

Alone with twenty-month-old Benjamin, I watched him play with his toys. He gave me a confident positive smile, and then continued figuring out his building blocks. His warm tender smile made me look at him differently—I saw a gift of life. Come to think of it, Benjamin was a gift from God; we had had no plans to have him; he was also an unexpected gift. When he arrived in my arms, I knew that keeping him had been the best decision. Even though we were sorting through our finances, we always found ways to come up with money to sustain our livelihood. It was as if there were spiritual beings watching over us, making sure we were able to survive. With that thought, I was consumed with faith. As Rob left, it felt like God had walked right in through the same door. It was Benjamin's smile that gave me the abundance of faith to receive God's second gift to me.

Mentally, I was juiced up with an influx of positive energy. Refusing to allow myself to feel remotely guilty about my situation, I made a decision. At that particular moment, it was an easy one to make. I decided to keep the baby and at the same time attend school that fall. I was convinced that I had had divine help over the years and it would walk alongside me in my journey. Stares at school would not embarrass or stop me from reaching my goal, because I was blinded by a sense of strong belief.

I started Business Management Studies at Grant MacEwan College that fall, slightly showing, but with absolute excitement about the new chapter in my life. For the first few weeks, I kept up with the other students and with the classes, and I wasn't too miserable. By the end of the first semester of college, I had gained over fifteen pounds—moving around had become uncomfortable. Even with the level of discomfort in class, I finished on top of my class that semester. Time passes so quickly when you have so much on your plate. Christmas holidays were around the corner and so was my second trimester of pregnancy. I suddenly blossomed and put on another twenty pounds. I felt so self-conscious as I put on a bigger maternity dress and looked like a bloated balloon. The stares didn't stop me. I waddled myself into college, made my way to the registration desk, and registered for all the classes that I needed to graduate.

Being a full-time student as well as a mother and wife is not an easy feat. I had to be so organized, before heading to school. I still had to ensure breakfast was prepared for Benjamin before taking him to daycare. My pregnancy was not an easy one—I was often short of breath; I had regular heartburn; my feet, ankles, fingers, and face were swollen; my breasts were tender; and I had trouble sleeping. It was challenging at times, but I kept with it—not letting defeat conquer me.

As a pregnant student, I had weight both in the back and front, books in my backpack and baby in my belly. The weight did not dissuade me from attending school; I was

more focused than before because my "why" was so strong and I knew what I had to do, and I kept all uncomfortable distractions in my peripheral vision.

The campus used to be an old office building, which was later converted into classrooms. The classes took over three floors with the cafeteria on the fourth floor. I remember the elevators were slow and, to avoid being late for my classes, I would climb three flights of stairs with the other students. I didn't want to be called a special needs student, and receive special treatment. I wanted to be a regular student in class, just like everyone else. Although my class schedule was tight, I kept up with it, just like everyone else.

By February, I was extremely large. I weighed a total of 175 pounds. I felt like a helium balloon, having gained over 55 pounds. I was undoubtedly uncomfortable at that point, but mentally still strong to run the race till the end. One day on my way to class, I felt a slight discomfort, which made me stop in the hallway to catch my breath. It was the baby kicking and probably turning; luckily it was a false labour. I started to walk toward my class and I heard my name yelled out from behind. It was Professor Paul, my academic headmaster.

"Belynda, stop right there," Professor Paul shouted.

"Yes, professor, what can I do for you?" I asked.

"Do me a huge favour and go home," he said.

"Why? I am fine." I replied.

"You may think you are fine, but I am not! I see you waddling up and down the stairs, from classroom to classroom. You are a great sport but you are making many of

segmentsegmentsegmentsegmentsegment

the academic staff very uncomfortable and nervous." He spoke sternly, as he held onto my arm and escorted me toward the lobby.

"I am fine, sir. I still have another three weeks to go, and I can wait till I am ready. I can't miss the classes. My mid-terms and my papers are due shortly—let me finish them before I go." I spoke with conviction, but I was a little short of breath.

"Oh, no, you are not! Young lady, you are heading home today. If I have to see you waddling in these hallways any longer, I think I'll be the one heading to the hospital. I will speak with your faculty head and get you an extension on your papers and mid-terms."

He showed me my way out of the campus and turned to return to his department. I was housebound for the next two weeks before my second child was born, and in those two weeks, I could have completed my mid-terms. I went back to college three months later and completed my program obligations so that I could progress to my second year in Management Studies. Everything worked out in the end anyway, just slightly more creatively than for a normal student, but the end result is the same.

Many women may ask, how could I have gone to college so carelessly while being pregnant. Many pregnant women spend days and sleepless nights dealing with bathroom runs, nausea, heartburn, and many other pains while waiting for their children to be born. I would answer, when you know your priorities and your "why," you automatically tune out all distractions in life.

Being a pregnant student may sound like a brave move, rather than a marvellous idea. I don't foresee women deliberately planning to be pregnant students, but rather falling into the situation unexpectedly.

Although it was very challenging being a student while preparing to be a mother, there were resources in place to make the process less difficult. I gave birth to my baby girl while securing my diploma in Business Management Studies. It wasn't easy; however, it can be done. And yes, I was a young mom with big dreams, juggling my role as a wife, mother, and relentless dream chaser, all while developing as an adult. I am the proof that early motherhood or unexpected motherhood doesn't define or limit us.

Being a Successful Pregnant Student

There are challenges if you want to be a successful pregnant student; there are strategies in place to guide you there. Plan your classes with being pregnant in mind. Try not to plan classes that are back to back—unless you really have no choice—or you will be running down the hallway from one class to another. And don't plan classes that are three-hours long; sitting down that long will literally give you a sore back for the rest of the day.

Talk to your academic advisor and professors ahead of time and let them know your due dates. The more people who are aware of your situation, the more support you will receive. By the way, no one can miss the bump that is in your way of getting into a seat in class.

Have you heard that, while being pregnant, you lose your memory? That is a true statement. So how do you remember all the assignments, team projects, and test schedules during the classes. Be organized! I had a day timer with me all the time, jotting down notes, and noting all assignments, projects, and tests. That day timer was a lifesaver; it kept me in line with my college's expectations.

Being fit is important as well, whether you take yoga classes or try to walk as often as possible. Walking keeps you fit without jarring your knees and ankles, and gives your heart a workout if you walk briskly. It is safe throughout your pregnancy and can be built into your everyday class routine. Remember to keep the heart pumping and the blood flowing throughout your body.

Pack a snack for yourself during classes, because you will be hungry more often than the other students. You don't want your stomach growling to distract the rest of the class. Don't pack a snack that is noisy or loud to eat—shakes are great snacks during classes. They are quiet to consume and full of nutrition. Make sure you are hydrated as well. Water should always be in reach while you are in class, and it will also help line your stomach to eliminate hunger growls.

As a pregnant student, make sure you do not expect special treatment. You may visit the bathroom more than usual and you may miss a class or two, but you should never expect extensions on assignments or lenient grades. The academic department respects your choice to be a pregnant student, and likewise you need to respect the integrity of the system.

For those women who are considering going to school while pregnant, realize it is not easy to be a pregnant student but you can do it. Just stay focused on the ultimate goal and know why you desire to attend school in the first place. As women, we have a lot more choice in life than men do: we can choose to keep or lose a child; we can choose to work or attend school during our pregnancy; we can choose to bring the child up as a single parent or not. But remember whatever you choose to do, accept full responsibility for your decisions, and don't expect special treatment because of those decisions. Stand taller, hold your head higher, and carry your bump with pride.

ALL MOTHERS ARE SELFLESS

Mothers are generally very selfless; mothers make sacrifices for their children. Have you heard the story of Elizabeth Joice, a cancer patient? Elizabeth was going through regular chemotherapy to treat her cancer, so she could live a day longer being married to her husband. When she found out she was pregnant, she delayed her chemotherapy so that her baby could be healthy and safe. After the delivery of her child, her cancer spread throughout her body, and it was too late to begin treatment. She died shortly after the birth of her child. Her selflessness led to her sacrificing her own life just to protect her own unborn baby. Many of us, including myself, are considered to be the more fortunate mothers; we only have to decide we would like to juggle more on our schedule so we can provide better lives for

our loved ones and ourselves. We are so lucky that we don't have to make a tough decision like Elizabeth Joice did.

The Number One Mom

I have been both a pregnant student and a working mother the majority of my life. Not easy for anyone, but for all working moms who may or may not choose to hold that title out there, here are some guidelines.

For those of you who are working moms, from doing the best at work each day to spending quality time with your children after the workday is over, do not feel pressured to wear that Number One Mom shirt underneath your suit. For the record, I don't own one. If you ask my children, they will tell you numerous things I have done wrong just in raising them. So give yourself a break, you cannot be everywhere at the same time and you certainly cannot do everything under the sun. Successful working moms require time management strategies to accomplish all the items on their increasing to-do lists. Learn to focus on each daily task, avoid ineffective multitasking, separate work and motherhood responsibilities, set reasonable goals, and don't be a slacker.

When you are at work, don't be thinking what you should be cooking for supper that night. Make sure you complete your work assignment and do that presentation before thinking of what you have in the fridge to cook or which dry cleaning you need to pick up for your husband. Your boss does not like to see his employees consume

themselves with thoughts of nothing but family while at work. Work time is work time; dedicate your time at work to work. Make sure you leave work at work and parental responsibilities at home.

If you are multitasking, please complete one task at a time. Don't be giving your kids a bath and ironing at the same time. You will be more productive if you complete one task and then the other. Or you could end up having a half-clean kid and a half-ironed shirt.

And when you are home with your family, try to be mentally and physically there. Your kids deserve your full attention, too. If you can't achieve that, make sure you take your family for a holiday trip at least once a year to ensure good quality time with them. And while you are with them, stick that smartphone somewhere out of sight.

Time management for mothers is about setting reasonable goals. Don't stress yourself with fitting in dinner, laundry, homework, and cleaning in an hour. You are just setting yourself up to fail. But at the same time, do not slack. Remember to keep to your daily tasks; don't put them off till the weekend or they will consume the time you really want to spend with your family.

> " *A Mother's love is something that no one can explain. It is made of deep devotion and of sacrifice and pain... It still remains a secret like the mysteries of creation...* "
> **Helen Steiner Rice**

My primary value and top priority in life was and still is to provide security for my family, so they don't have to worry about a roof over their heads or food on the table. If my decisions, schedules, and time spent are not geared toward that direction, then it is clear that my family's lives are not my priority. Authentic success and lasting happiness will not happen if your daily schedule is misaligned with your deepest values. If there is a gap between what you do and who you are, you are out of integrity, which is also known as an integrity gap.

My commitment then was to better my family's situation and I carried it out hopefully through actions of educating myself better and finding a higher paying job to cover my bills. My goals were simple and clear.

At the end of the day, everyone talks a good talk. But talk really is cheap. We should all talk less and act substantially more. Having a schedule that is filled with your purposeful actions will steer you to your right path. So, if you show me your schedule, I can guarantee that I can tell you what your priorities are.

> *" The key is not to prioritize what's on your schedule, but to schedule your priorities. "*
> **Stephen Covey**

FINANCIAL INDEPENDENCE

It took me three and a half years to complete my Masters of Business Administration (MBA) while holding a full-time job. The program taught me well in the fundamentals of business management, including functions in accounting, finance, marketing, and strategy. Since I understand the importance of having personal financial security, I want to spend more time talking about financial planning. It is definitely one of the most important things on my list; financial security provides a roof over my family's head, and an abundance of food on the table for all of us and our friends.

What is important to you? Let me ask this again. What's important about money to you? Once you understand what money is about for you, you will know what it is you are looking for in life. And understanding what you are looking for in life is the foundation on which all planning is based. How are you going to put together a plan for your future? What is it you really care about? Is it a better career? Is it a bigger home for a growing family? Is it paying for your children's college educations? That vision needs to be clear in your mind in order to move forward in planning for a better life.

What's important about money for you is the security it can provide, but if your current financial affairs have you living from paycheque to paycheque, does that not beg the question as to whether you should seriously reconsider planning your financial future? Clearly, your financial behaviour is out of whack with your deepest value. What's important about money for you is the freedom it can bring you, but in actuality you are tied to a job working eighty hours a week to pay the mortgage on an oversize large home, wishing that you could use the money to do something else. In other words, you are "house broke."

Money is not an end in itself. It is merely a tool to help us achieve our goals. If we do not align our money with our values, we are not going to wind up living happy and fulfilled lives. Once you figure out what you are looking for in life, then you can create a financial plan to get you there. Being financially free is probably the most important and most powerful leg of your journey to success.

As smart women, we shouldn't leave our financial plans with someone else, even if that someone else is our husband or our parent. Here comes the truth: if a married woman ever divorces, her average standard of living plummets. With the responsibilities of children, her expenses increase and her income drops, while her ex-husband's income increases.

Okay, you have a good man and, yes, there are very good men out there. That still doesn't mean you will have a happy and secure future. As wives and mothers, we have the responsibility to protect our family and our children.

If you were granted one wish and whatever you wished for from the universe would come true, what would it be? I am sure that whatever is going through your mind right now is a dream that you haven't fulfilled but want to; for example, the house that you have always wanted, the business that you wanted to start, the desire to cruise around the world, or the charitable organization you wanted to start.

It is a sad fact that the majority of us don't dare to dream, or worse still—don't dare to hope for the better anymore. We stop dreaming as we grow older. And money plays the biggest part in fulfilling our dreams. Lacking the resources, we find ourselves frustrated; eventually, we stop believing in dreaming at all. To make your dreams come true, you need to take a couple of essential steps: one is to know exactly what you are looking for and two is to have a financial plan around it. Money is necessary to make dreams into realities.

Because money was so scarce when I was a single mom, I recognized that it is a tool of survival that is essential for life. Don't let money or the lack of it stop you from dreaming as a human being. I need you to understand and accept the fact that for any dream to come true, you have to work hard at it. Be specific about what you want in life; define it clearly; don't be vague. Then figure out how much you need to put away and keep checking back as to how close you are to achieving that amount, for example by paying off the credit card or being mortgage-free.

David Bach wrote a book entitled, *Smart Women Finish Rich*, in which he lists the different types of investment for long- and short-term financial goals.

If you still have an issue about seeing your dream list, here is what you need to do. Take a deep breath and relax with a cup of nice sweet tea. Now reflect on how you feel and what you really want right now; not what someone else wants, but what you really want. Those are your values.

The question is, "What is important about money to you?" For me, money is security, peace of mind, freedom, making a difference, and independence. Freedom is important because it allows me to travel around the world and explore other cultures and places of interest; it increases my knowledge of the world. Without money, I can't do that.

I have discussed my values with friends and family, to see whether they think my evaluations are valid. At other times, my values would change depending on my current situation, and there is nothing wrong with that. Try not to have a value conversation by yourself, because others may see it differently from you; after discussing it with someone else, you might have another perspective in life.

THE WOMAN WHO CHASED HER AMERICAN DREAM

I met Kelly in New York in 2007; she was a new immigrant to the USA. She only wished to be able to sponsor her family from China, so they could live one day as a family again. Needless to say, she had not expected the tough life she was

experiencing while being in the USA. The only thing she knew about the country was that it is a place of hope; her vision was to be successful with her American dream as it was what all her friends and family painted for her. With their encouragement, she fought her way to the USA, and found that she was one of millions struggling to survive in "the Big Apple." With no formal education, she had a tough time moving upward and forward in that foreign country.

She went to work at a salon as an esthetician and then at a restaurant—life was tougher than it was in China. And then someone miraculously introduced her to direct selling—another term would be "multi-level marketing"—while she was sitting in the corner of a restaurant sipping tea. The first challenge she thought of was the fact that she didn't know anyone in New York so she wondered how she was going to market products or even earn a decent cheque each month through recruiting other business partners to work with her. Her business sponsor did a great job building a vision that she could not say no to: she saw herself living in a mortgage-free home, she saw herself travelling around the world with her daughter, she saw security and financial freedom. It didn't take her long before she signed on the dotted line and hoped to make her first big cheque by talking to friends within her small network.

She had no idea how hard it would be to convince someone that it is essential to stay healthy and that the nutritionals she was representing would make them healthy. It became even harder when she tried to sell them a business opportunity in the nutritional company. Every day, from morning to night, she would walk the dirty streets

of Flushing, Queens, New York, with her suitcase full of brochures and flyers, in the hopes of selling a bottle of vitamins or of finding someone who might be interested in working in the business with her. Some days, she would be luckier than others; she would find a few customers here and there. Blisters would appear on her feet from her cheap improperly fitting shoes and her ankles would get sore from all the walking. Just as she was about to give up, she thought of her family and her dream of sponsoring her daughter to come to the USA so they could be together again. This made her walk the streets for another couple of weeks. It was not easy at all. Life was definitely harder than she had expected.

It was her third month into her daily routine before she found the first person who believed in her and her products and who would even consider a business partnership with her. He made her promise him that she would work on her confidence and self-esteem, focus on the dream, and never, ever give up on herself. From then on, they worked extremely long hours, crunching through prospecting meeting after prospecting meeting, trying hard to sell the business opportunity. Eight years later, all her hard work has finally paid off. She not only has a team of business builders under her, she has an international team with an international clientele. Her hard work bought her a home in New York and another home in Long Beach, NY. Her bank account looks fat and sound; and her investment plan diverse. Most importantly, she was able to sponsor her daughter to join her from China, and they are happily living and travelling together, visiting the world.

There are no dreams with results that are ready-made for you whenever you want to pick one up; you have to work for them. Kelly worked very hard in achieving her dreams, by not giving up and not saying yes to defeat. The sacrifice you make today will give you rewards tomorrow. So when you dream, dream big; know that the bigger your dream is the bigger your sacrifice will be, but at the same time the bigger the reward you will reap.

I think by now, you know what I am trying to get at. As women, we need to have some form of plan, we also need to take responsibility, and we need to accept the hard work and sacrifice that comes with the responsibilities, so we can get a few steps ahead. However, that all means nothing if we lack self-esteem and confidence, because all this powerful information is merely entertainment if you don't fix your self-esteem. Low self-esteem is the poison that erodes the connection between our intention and our actions. Believing in yourself and believing that you can reach your dreams are essential parts of healthy functioning in all aspects of life.

Self-Esteem Increases Likeability

People who have positive self-esteem have healthier and stronger connections with others. They understand boundaries and know how to express their needs; they value that their contribution is part of an appreciative partnership. If you value yourself and treat yourself with respect, you will

be valued and respected. If you don't, then you won't. It is that simple.

Let's say you are a great caring mother and everyone praises you that you are the best mother in the world. However, if your self-deprecating attitude doesn't believe and won't accept the praise and the recognition others give you, your relationship with your children or your husband won't flourish.

Self-esteem is the key to success for any endeavour at home, at work, and personally. We cannot have a fulfilling life when we don't feel worthy or capable. If that were so we would shy away from life rather than engaging in it. Because we truly believe that we don't deserve success in our lifetime, we would sabotage our own success and happiness. Some of us have a haunting past that scared us mentally and we are still fragile because of it. So we end up denying the possibilities of happiness and success. We need to accept that our haunting past could be just life lessons that everyone goes through, just the part of life that helps us grow and matures our wisdom.

Self-esteem is a self-fulfilling prophecy. The more you like yourself, the more you act in likeable ways. The more you believe you are able of achieving something, the more likely you will achieve it. You will achieve what you believe. For those who are struggling with self-love, it is due time to start loving yourself again as a mother, a female leader, a young adult, or a pregnant student. We are so worthy to be loved.

CHAPTER SEVEN

THE HEART
BEAT IN THE
SNOW

Spring, summer, fall, and winter; each carries a unique hidden beauty about it, and each poses as the backdrop to many of our fondest and most heartbreaking memories. With every season that comes and goes, so do the beautiful memories and the gut-wrenching stories. Gone are the happy days of spring or the dark days of winter.

Being born and raised a Singaporean, I found that winter didn't exist in my life. "Snow" was never a word in my vocabulary and "skin-numbing cold" was beyond my imagination. All my childhood memories contain heat and humidity and, up until I migrated to Canada, the only cold I knew came from ice cream and air conditioning. Natural white fluffy snow was something I saw in the movies and, perhaps because I only ever saw it in a movie, winter was majestic, mysterious, and beautiful to me. My image of winter was a bright, white blanket of snow that covered the earth beneath it like powdered sugar on a large slab of cake. Under the bright sun the snow glistened like a natural sea pearl, but its beauty could never be admired

147

for long before it would hurt the naked eye. And at night, snow is just as beautiful, if not more so. The light from the moon reflects onto the snow and ice, producing glitters like diamonds hidden beneath the ground.

However, my image for winter completely changed one particular winter day. That is one winter I will never forget, and no matter how beautiful and bright the snow is during the day or night, winter remains the darkest moment in my life. On March 3, 1993, I suddenly felt a sharp pain in my abdomen, and I knew instantly I was in labour. Like every mother who is in labour, my first instinct was to seek help immediately. I went up to the bedroom to get my husband, who was lying lifelessly on our bed.

Gently I shook him, "Rob wake up, I think I am having contractions."

As I was doing that, I pictured him waking up frantically, running around the house, and getting all the bags ready for the hospital trip. I saw him tripping over couches while he put the stuff together. His nervousness and frantic behaviour would have been a treat for me to see for it would have shown love and concern. However, I wasn't given that pleasure. I kept shaking and trying to wake him for the next thirty minutes, but with no response. In between contractions, I continued to try.

"Rob, please wake up, honey. I am in labour. You need to take me to the hospital."

I walked over to the window and looked outside. I remember that it was a very cold winter that year and my backyard was covered with snow. We must have had a

snowstorm the night before, because all I could see were three to four feet of snow on the ground. I looked at my neighbour's backyard, and the snow had almost covered their entire fence. There was no end to the massive amount of snow on the ground. Also, frost had developed on the window overnight, which indicated that it must be chilly outside. I was living in Edmonton, Alberta back then, so it is not unusual to experience temperatures of minus 40° below zero during the winter months.

My contractions were getting consistent and closer by the minute. Another sharp pain hit me. This time I had to close my eyes. I took a deep breath to overcome the tense muscles cramping up inside me. I went over to the bed again, and tried again to wake up Rob. My patience was running thin. I was seriously thinking of hitting him with a frying pan, just to get him to wake up.

As I turned around and took another good look at him, I finally figured out he was not going to wake up to save me as I had imagined. He must have had a "big night" the night before, and I knew he didn't just drink alcohol. Addiction can be a very cruel thing. A while back, Rob had taken an evening job driving a cab. He was hoping that being self-employed would allow him to control his time and work more hours, thus bringing in more cash for his family. However, the clients he met at night while cabbing had introduced him to drugs. At first it was voluntary, but after a while, he was no longer able to suppress his desire for cocaine. Not long after, he became addicted to the drug. The income he brought in would be used to feed his addiction and we, as a family, lived on little to nothing.

During my pregnancy, there were days and nights when I would feel the baby kicking me. I hoped to share the excitement that brought to me with him. And when I got ill and became uncomfortable, I wished he were there for me. Even if he did not say much or do anything, his company would have been comforting enough. But because of his unpredictable schedule, he was never around for any of those moments. His excuse was that he had to clock in more hours in order to earn more cash for the family. We definitely saw less of him and we did not see more money coming in.

I had known for months that he had a drug-abuse problem, but never did it cross my mind to leave him. I chose to stand by him, hoping and praying that one day, he would come around. I had faith that one day something would change his mind; he would stop taking drugs and redirect his focus back onto our family. That day never arrived. Instead, drugs took him into a new level of ecstasy, and he became more disconnected from his family and more in love with his cocaine.

I looked at Rob again. I had never imagined, in a million years, that he would become the unresponsive and lifeless human being lying before me. We had met in college, and he was a very good looking and genuine man, the only man in a class of twenty-two students. Other than the fact that he was the only man in class, I hadn't taken much notice of him. However, I found after we started dating that he had always noticed me even from the first day of class. I cannot recall how he asked me out or where we went on our first

date. But after a while we fell madly in love with each other. We dated for less than eighteen months before I found out I was pregnant with his child. And then, we decided to get married before we had Benjamin.

We were in our twenties when we became parents for the first time. We rented a small one-bedroom apartment in a sad part of town; we did not have any money, nor did our parents support us financially. All they said was, "Good luck, you two."

We were on our own, but we were never scared or worried, because we had each other. Although we were both young, we tried all we could to be good parents and to make an honest living so we could provide for our child. I recall there were times when Rob used to read to our son at night to get him to sleep and like magic, Benjamin would instantly doze off in Rob's arms. Rob used to be so proud when he held our son in his arms, so proud that this little man would grow up and look up to him. Rob was so determined at one point to do everything in his power to protect and provide for our son. He was sure that money would provide his family with happiness.

Unfortunately, Rob took the wrong path and he strayed. Sometimes in life, choosing our path is important. If we take the wrong path, it can misdirect and misguide us to a different destination, or it can lead us to walk in circles, just like the game of maze. And he chose a path that led him in the wrong direction and no one could bring him back to us.

My next contraction was excruciating. I felt a sharp pain rush up my spine and it almost took my breath away. This was not good. I was now desperate to be in someone's—anyone's—care. I rushed downstairs to call for a cab. Unfortunately, because of the snowstorm, they were going to take hours to get to me. I dialed 911, and because of the poor weather conditions, the ambulance was not available for a while either. There were too many accidents on the road and I became a low priority for them.

My toddler was playing downstairs. He was still in his pajamas and unaware of the journey that we were about to embark on.

Always remember that dreams are within all of us; however, not everyone reaches their dreams easily without a good challenge. And sometimes, it is the heavy burden that weighs us down, forcing us to decide between leaving the burden behind so we can get to our dreams or settling for what we have and potentially regretting not reaching our dream.

In my case, clearly, my husband was the burden who was stopping me from giving birth to my baby. I had to decide at that very moment, who or what I needed to leave behind to reach my dream of having a second healthy baby.

At the age of twenty-four, I was faced with a tough decision. I decided to leave Rob behind and count on myself alone to get to the hospital, even if it meant walking in the minus 40° Celsius (minus 60° Fahrenheit), freezing cold weather. I knew the hospital was just behind the field, by the highway, but the journey was foreign for any mother in labour.

Should I walk there? I asked myself.

That was crazy. I could not possibly walk there in the cold; that was a ridiculous mindset. I must have been filled with motherhood hormones that I was not thinking straight.

But a little voice said to me, "Put on your winter coat and go dress Benjamin up. Make sure to dress him warmly, which means his thick winter jacket, scarf, gloves, and boots."

Who was talking to me? I looked at Benjamin and he was giving me a glowing smile, a similar smile to the one he had given me eight months earlier that gave me the encouragement to carry through with this pregnancy. I was enjoying just watching him when another contraction took my attention away. At that point, I was sure I needed to get to the hospital as quickly as possible.

I bundled Benjamin up in three layers of clothes; he looked so heavy that he was about to topple over, as though his little body would be unable to support the weight. The little guy was probably thinking we were going outside to play snow angels.

I kept telling myself to be strong and mentally ready to head out through that front door and into the bitter cold with my toddler, when suddenly my legs froze up. I stood there by the front door, petrified. My mind was telling me to go, but my body just wouldn't move, because reality had set in that taking a small child on an unknown journey was not only scary, but dangerous as well. I began to wonder whether I had made the right decision to take my toddler out into this brutal weather.

I had walked to the hospital during the summer and it had not taken me that long to get there. But I wondered how long it would take me under these horrible weather conditions? Would we even make it?

I was left with absolutely no choice in life: I could choose to do something or not do anything at all. I took a deep breath of courage and held back my tears of fear. I wanted to show Benjamin the strength I had. I wanted him to be proud of his Mommy. I held onto his tiny little hands, looked at his big brown eyes, and my voice started to crack up. "Benjamin, let's go for a walk."

He smiled and led me to take my first step through that front door onto the snow and into the cold winter.

For anyone who has never experienced labour pains, you will never know how painful it is. Labour pains are like menstrual cramps, but one thousand times more painful. And for the men, it can feel like having someone stabbing at your back over and over again. As you can tell, I was getting stabbed every ten minutes. Each time, the knife felt sharper and the pain it created got worse.

The wind had started to blow, cutting our faces with its sharp cold blades. My contractions were getting more intense. I felt them running down all through my lower back. Every time a contraction hit, my lower back would slowly began to seize up. It was like the muscles inside were slowly twisting harder and harder until they became almost unbearable, and then the pain would slowly subside, allowing me to catch my breath. The process repeated itself over and over again. It was more unbearable than I had imagined it would be.

At that moment, I was not about to let my son see any weakness within me. Crying would not help; with this dreadful weather my tears would have frozen onto my face just like the icicles on the roof. As we made our way through the field toward the hospital, the weather turned harsh and brisk. Every step that I took, the thought of betrayal entered my mind. How could the only person I relied on, abandon me when I needed him the most. Rob had left me to fend for myself in my most desperate moment. I felt lost, hopeless, and very helpless.

Giving up was very easy at this point. I kept wanting to turn back and go home where I would feel safe and secure. At each moment of weakness, I felt a firm grip from Benjamin's tiny little hand. Every time I looked down at him to check on how he was doing, I saw the little guy looking ahead and not stopping in his steps. He was focused on moving forward. He was almost telling me with his actions to keep going and not to look back. My two-and-a-half-year-old toddler was focused and determined. He was not giving up and I knew right away that I had to continue my journey along with him.

Whenever I needed to stop, Benjamin would wait patiently to allow me to go through another contraction and then he continued to walk with me. For the entire journey, he did not once complain about the distance or the weather. He kept up with me, but the honest truth was I kept up with him. How was it possible for this tiny little guy to be so strong for me? But there was no doubt he was the guiding light for this journey.

In the bible, his name—"Benjamin"—means "the son of my strength and the son of my right hand." That meaning of his name made so much sense now. The son of my right hand was giving me the strength that I needed to pursue my dream.

After thousands of painful steps, we finally arrived at the hospital.

Two hours earlier, I had stepped through a door of fear at home, and two hours later, I stepped into a door of hope. The minute I entered the emergency doors, I felt safe. I had never felt so relieved to see white uniforms everywhere. When they saw me and discovered that I had walked to the hospital, and with a toddler, no one was impressed with me. Under such distressing circumstances, I was given nasty reprimands by a few strangers called nurses and doctors.

They wheeled me into the delivery room, and took Benjamin to the nursery where a couple of nurses could look after him. In minutes, I was hooked up with all kinds of gadgets. They had begun to monitor my labour's progress. The nurses looked at each other puzzled, they switched places around the bed to check on the monitors. They went through the monitors and stats over and over again. They seemed to look startled. One of the nurses told another one to find a doctor immediately. Their expressions made me nervous. I knew something was wrong.

The doctor arrived in the delivery room minutes after. She looked at the machine and asked the nurse for more reports. One more nurse came and left, then another.

Within minutes, I had a room full of nurses and doctors. An ultrasound was called for immediately. I watched their facial expressions as they went through the reports. By now I was shaking. Something was not right, but I was too afraid to ask. I was afraid to hear any bad news.

No one said anything; but I knew there was a problem. In a normal delivery, you have your gynecologist and maybe two nurses working on you, not a room full of them.

Finally I drummed up some courage to ask the doctor, "Doctor, is there a problem? Why do I have so many of you working on me?"

She turned and looked at me with a serious look on her face and said, "Yes, we have a serious medical issue here."

As she said these words, I turned pale.

"Your baby is going through nuchal cord and may be suffocating inside you. We are not able to read your baby's heartbeat. Mrs. Wright, we may have a stillbirth here, and if we don't remove this baby from you, both your life and your child's will be threatened."

"What do you mean by 'nuchal cord' and what do you mean by 'suffocating'?" I asked.

"Mrs. Wright, you walked under distressing conditions. The stress, anxiety, and walking under those situations could certainly have caused your baby's umbilical cord to wrap around her neck. I am sorry but we are doing what we can and right now we need to operate on you right away so we can remove her from you."

"I killed my own baby?" I muttered out those words, stunned. "My baby is suffocating inside me. Please, doctor,

please. Please save her! Don't worry about me, just save her."

I went from calm to hysterical within minutes. By now I was screaming and begging for them to help me.

"Please save my baby," I sobbed.

The doctor ordered a shot of morphine to reduce the pain and to calm me down so they could concentrate on me without the distractions.

My doctor's words echoed inside my head: "It was the stress… The distressing conditions made my baby's umbilical cord wrap around her neck… She can't breathe… She may be suffocating inside me."

Guilt ran right through me immediately. Had I made a decision that killed my own child?

They ordered an operating room for a caesarean. Removing the baby from me was the only chance they had to save her and me. As they checked the reader one last time, they unexpectedly found a very faint and weak heartbeat. They looked at each other to confirm that what they were hearing was indeed a heartbeat. They were all elated. This told them that the baby was still alive, but they now had to work as quickly as possible before they lost her again. The doctor now gave orders for me to be induced, so I could have a quick delivery to avoid complications.

With my active labour starting from home to the hospital, my cervix had already dilated to ten centimetres, so I was more than ready to deliver this baby naturally. The doctor cancelled the caesarean and they kept me in the delivery room for a natural birth.

My uterus continued to contract, resulting in a lot of pressure that pushed the baby further down. But I was advised not to push at all, because the doctors needed to ensure that the umbilical cord was not tightening around the baby's neck while she was being pushed through; that could cause massive stress to the baby.

As they worked swiftly and carefully, I heard the doctors say, "One last push and that should do it."

The nurses were ready with their arms and towels. I gave one strong push, and I could feel the baby sliding through me and my contractions immediately stopped, as if the body knew that there was no need for it to work so hard— its job was complete.

They carefully picked up the baby from the delivery table and took her to their cleaning area, wrapped in a thick blanket to keep her warm. They measured her length and weighed her too. I heard a chuckle: "Oh, my goodness. This little one is chunky," one nurse said.

"Are you sure? Let's recheck the scale," said another. But the scale wasn't lying.

"Mrs. Wright," the nurse said, "Congratulations on your beautiful baby girl. She must be so comfortable inside your warm womb and trying to scare all of us with the nuchal cord attack. She is a very healthy girl and she is your ten-pound baby girl."

"Ten pounds! That is a baby and a half!" As they laid her down into my arms, I felt a gush of joy taking over my whole body. I am holding her in my arms for the first time. That feeling gave me the biggest smile on my face. Now

allowed back into the delivery room, Benjamin jumped onto the bed and wanted to take a look at his new sister. He touched her forehead gently and smiled. He didn't have to say much; I could tell that he was excited to see his new sister. It was love at first sight; he was in love with her the second he saw her.

She looked up at us a little with sleepy eyes as we dimmed the lights in the room, and she shared a smile with us, almost to say mischievously, "Got you, Mommy." And she soon fell into a deep sleep in my arms.

I named her Sue-Lee. In Chinese, "Sue-Lee" means "beautiful snow." She was beautiful the minute I saw her. She was also strong as she fought alongside Benjamin and me through a field of thick snow with her strength and determination to join her family. Miracles do happen in life, and I am living with one right now.

Focus on Being Joyful

In life, it is so important to focus on the joy, beauty, innocence, praise, love, and gratitude that are inherent in every moment. I don't think we focus enough on these things. The wonderful thing about joy is there is no fixed format. Joy is constant spontaneity; it nurtures and refreshes, flows and replenishes. Joy doesn't look for what is wrong. It doesn't criticize; it doesn't sabotage or seek culprits. Joy is open to love and being that love.

You would think that with what had just happened to me during Sue-Lee's birth, I would be angry, frustrated, and

depressed. I should have called victim, cried on my pillow, felt rejected and uncared for. But the truth was, I was depressed for a short while, but no matter how many tears I shed or how many negative emotions I carried, nothing was going to alter the experience I had while walking across the field of snow in labour. Although I was concerned about Rob's lack of interest in the family, I was more drawn to gratification that my baby girl was healthy and doing fine. So I chose to stay present and I didn't bother to wander off to the past or the future. It became essential for me to focus on celebrating the presence of Sue-Lee, as I could not change the past. I didn't know the future, and all I could do is to live and celebrate in the present moment. Blaming someone is always easier. I could certainly blame Robert for what he did to me, but what's done is done. Nothing will change what took place on the day Sue-Lee was born.

LET GO OF RESENTMENT

"One of the most lasting pleasures you can experience is the feeling that comes over you when you genuinely forgive an enemy—whether he knows it or not."
O. A. Battista

Emotions are a natural part of human life. We are constantly working on a better relationship with ourselves, learning how to embrace ourselves. Most of us learn from an early

age that certain emotions are "bad and inappropriate." For example, my Grandpa Lee always reminded me not to cry and never to get angry. Emotions were frowned upon at home. When I had to deal with Sue-Lee's birth alone, yes, I was angry, but because I had learned not to cry, I held my tears back.

My emotions became so distorted: anger becomes hatred or resentment, eventually exploding into fits of rage; sadness becomes depression. Even though I carried a smile on my face, I was a pretty messed-up case, and if I hadn't dealt with that resentment at an early stage in my life, it would have carried on and ended up demanding health, both mentally and physically.

Don't keep your emotions inside; learn from our young ones, the children. Children get angry and sad, sometimes spontaneously. Yet if you watch them closely, they have the ability to find joy and entertainment everywhere. They have a mechanism for not keeping anything harmful in their bodies. The world for them is a magical place where there is no harm and nothing is bad. We adults find danger, hurt, and pain so easily. Naturally we tend to jump into judgment mode when something new or something we disagree with comes our way.

When children get angry, their anger is intense but short-lived. A few minutes later, they have completely forgotten what they were angry about; they are absorbed in the excitement of a new moment, the next discovery. We have so much to learn from these little ones.

In order to release the built-up charge of resentment,

allow yourself to have feelings. Let yourself get angry, permit yourself to be sad. When you do, you will be able to recuperate the magic and innocence of childhood. Occasionally, I have big "let-outs," which are healthy, by the way; they are my way of communicating that "I am not a happy individual today." My son, Ben, knows that after such an outburst I am fine and will go on my merry way. So he doesn't take it personally and he allows me to vent once in a while, just to get the steam out.

We tend to seek approval by behaving perfectly. I can tell you that I am the most imperfect human being in the universe; I think everything that is odd or wrong was genetically bred into me. Even with such imperfections, I am generally a happy, bubbly person. I see the world as being full of goodness and happiness. Sometimes my kids remind me how old I am to be acting so childishly. I don't hold grudges against others, because that consumes too much energy. I may get upset for a day or two, but by the third day I have entirely moved on to something else.

Our image is what the world sees of us. If we are happy, the world sees us happy. If we are angry, the world sees us angry. If we are sad, the world sees us sad. If we are resentful, we lose the world, because being resentful means that we are blocking everything out from our lives; we shield the world out entirely. Don't shield yourself from the world. Be authentic. Be yourself and love your uniqueness completely. Then you will finally feel approved of, because you will be approving of yourself.

Learn to Love Yourself

> *"The more I like me, the less I want to pretend to be other people."*
> **Jamie Lee Curtis**

The moment I learned I had to walk to the hospital with Ben, I truly felt a huge wave of loneliness. The emotional pain was so strong that I felt like crawling up into the fetal position and drowning out the world, never wanting to live again. It took me many years to get it into my head that it wasn't me who wasn't deserving of Rob; it was Rob who wasn't deserving of me. And if I don't love myself, how am I ever going to learn to love someone else?

I had thought that Rob would be my forever partner; that we would be growing old together, and having grandchildren on our laps. Even though money wasn't there, it wasn't the most important thing in my life—my family was. The best thing that can ever happen to anyone is finding a dream partner. Unless we heal our relationship with ourselves, we will see our own dissatisfaction reflected in our relationships with others. Unfortunately, the relationship with ourselves tends to be the last thing we attend to. We normally put ourselves at the bottom of the list; many say that loving ourselves is selfish.

When you love yourself, your relationship becomes honest and transparent, because you lose the fear of loss. You

allow yourself to be real, to show yourself exactly as you are, and in doing so, people around you—especially your partner—will have the freedom to do the same. Honesty builds trust, which is the basis of truly loving relationships. With self-love, you lose the fear of rejection and the need for control. And when we feel complete within ourselves, we no longer feel the urge to be with someone else.

One of my friends called me "weird" once for not being attached to "stuff"; she said that I was cold and disconnected. Well, she did say "stuff"; maybe that is the reason, it's only "stuff." I think she'd have a better argument if she had said "loved ones" versus "stuff."

Generally, we tend to think that if we let go of the attachment to our loved ones, we will lose them; but actually the opposite is true. When you love without conditions, even if your partner or friends are not by your side, you will feel closer to them than ever before, for you will have found them within you. This sense of self-sufficiency comes with great freedom and the ability to truly enjoy the presence of people around you.

It took me many years to learn how to evolve conditional love to unconditional love. During our marriage, Rob and I were always agreeable about choices for dinner, how we should parent and make our plans for the future; he was always a good listener. Or I thought he was a good listener. I later found out that it was because he wanted me to stop communicating, so he decided to agree with everything that I said. I resented him for not expressing himself openly to me; the resentment grew inside me. I

so badly wanted the marriage to work that I held back my negative thoughts so he would be happier in our marriage. So how does this relate to conditional love? Conditional love is when one person loves the other as long as he or she is getting something in return. For example, I would cook dinner if he would read a book with me. Or I would attend to our children if he would spend more time at home. It was exhausting after a while, for having consistently to bargain on household tasks.

A truly loving relationship will meet the test of truth. We need to be honest about how we feel; then we will soon see the true nature of our relationships. From my relationships, I have learned that we cannot change others; we need to express our feelings with the goal of being totally transparent, of showing ourselves exactly as we are. By recognizing that fear is at the root of our tendency not to speak up, we begin to replace with love the emotional charge that could have caused resentment.

Unconditional love starts with self-love, because if we abandon taking care of ourselves in order to maintain a relationship, we are not being unconditionally loving, we are clinging to an external form that no longer serves us or helps us grow.

I was in a marriage with someone who had a record of substance abuse and an external love affair. It saddened me when I knew that even with a loving family, taking drugs was a way for him to fill his emptiness. I made many attempts to help him overcome the drug problem, until I realized that in reality I, too, was struggling with an addiction.

I was addicted to saving him. Instead of confronting my own internal emptiness and loving myself unconditionally, I had focused all my attention on someone who was clearly worse off than me, so I could feel good about myself.

I felt more like a victim, a losing victim, within this relationship. Because I could not trust my partner, I didn't feel valued. I kept asking myself, "Why am I not more important than the drug or the other woman?"

After a lengthy struggle with trying to "fix" Rob, I decided to create a loving relationship with myself and Rob fell away, because the mirror of the relationship was not reflecting the beauty I saw in myself. If a relationship makes you feel dependent on another, or if you are abandoning yourself in order to make your partner feel comfortable, it is based on need. If you find yourself in this kind of relationship, start speaking your truth. If your partner doesn't feel comfortable with this, you have two choices: to accept yourself as you are or to move on.

As you cultivate unconditional love for yourself, you will find the unconditional love you seek to express for your children, parents, friends, and colleagues. You will become a universal mother: a mother of the world.

MOMMY, I LOVE YOU

It was a warm spring afternoon, only months after Sue-Lee was born, when Rob decided to take his leave. Just like on any other day, he came into the nursery while I was feeding our baby girl. I smiled at him with joy, because in my arms was our miracle baby girl, whom I had nicknamed, "my little sumo baby." She looked so peaceful and content. As I gently laid her into her crib, she let out a smile and then a chuckle; whatever she was dreaming about made her happy. Her smile brought me comfort. I felt so blessed and so content. My beautiful baby girl was happy and healthy. My family was complete. I felt that I had everything I had ever wanted or needed.

I finally turned around to see what Rob was doing. I couldn't really see his face with the bright sunlight separating us, but I could make out his silhouette. He stood there by the door and said in a very firm voice, "Hey, I am leaving."

"Oh, where are you going, honey?" I asked with a smile.

"I am leaving and I am not coming back," he said.

"I am sorry, but I don't understand what you are saying," I said.

"I just can't deal with this family thing anymore," he said without any remorse or guilt.

Without another word, he headed toward our room and started throwing his clothes into a bag. I stood there, speechless and numb, watching him as he shoved more clothes into the bag. I was in a state of shock. He had caught me by surprise. I stood still, unable to move or utter a single word. When the initial shock finally subsided, fear moved in quickly and took over. I finally pulled out a few words.

"What am I supposed to do, Rob?" I asked him.

"I don't know. I am so sorry," he said.

Within seconds, he dashed out the front door and slammed it shut behind him. And he was gone. It was not the first time I had seen the back of his figure, but I knew this time, he wasn't coming back. The house was dead silent. I can still hear the sound in my head of that door shutting as I watched it close. The picture of the door swinging shut seemed to shut out all the light that was coming into the house. In that moment, my world was completely pitch black.

A thousand thoughts now came rushing into my head: betrayal, money, single parenthood, insecurity, responsibilities, failure, and fear attacked me from all corners of my thoughts. The feeling of abandonment took over slowly; the same feelings of abandonment I had experienced at the age of six, when my father left us, suddenly resurfaced. I couldn't fight them off. I allowed them to slowly consume me as I lay down shaking from shock. I lay in bed in the

hope that it was all just a bad dream, until the sound of Sue's crying awoke me to realize it was all very real.

The reality was I was now officially a single mother. I had two children to attend to, a mortgage, car payments, and endless bills to pay. As a couple with dual income, we were already living paycheque to paycheque, and now I had only one income. How was I going to do all this on my income? How was I to take care of my children alone? Who should be picking them up after school? How could I manage a full-time job and raise my children at the same time?

Please, let me wake up from this nightmare.

I walked around the house aimlessly until an urge inside tempted me to call my dad, hoping that he would have a solution for me. I held back my tears as I told him what had happened, but before I could finish I was choking on my own tears. On the other end of the phone, there was nothing but silence. He was surprised and shocked as well. He asked the same questions I had asked myself, but he wasn't offering any answers. I was thinking to myself, "You are not helping at all, Dad. You are injecting more issues into my one big problem."

He never once asked if I was doing okay. He was focused on finding a solution quickly to get me out of this mess. Maybe that is a masculine mentality, because men tend to jump right into solution mode without focusing on the emotions.

Dad ended the phone call with me and proceeded to call Rob, to ask him the same questions, but Rob had already turned us off.

That night, Dad drove down from Fort McMurray to Edmonton to check up on me. I will never forget when he decided to drive four hours in the middle of the night after working an eight-hour shift, just to provide that support. It was the first time I had felt unconditional love coming from him. It was a rather emotional week for both of us, as we tried to figure out my bleak future. Before this had happened, my father and I had never shared a close or loving relationship; it was only then that the two of us started to bond and I saw the fatherly love he had for me.

My dad, Justin Lee, worked in the oil sands and at that time he was living with his second wife and their three kids in Fort McMurray, Alberta, a small town northwest of Edmonton, where I lived. It was mainly oil companies and their employees who populated Fort McMurray. Dad had a demanding job as a draftsman. Raising three young kids with his second wife filled his plate, but that didn't stop him from caring for me. Over the next few weeks, my dad kept checking in to see how I was coping. He had managed to get in contact with Rob and through their conversation, he was sure Rob wasn't coming back.

Weeks passed, and then months. Doing everything all by myself as a single parent was very hard, and I would not wish for anyone to go through that. Trying to cope with a full-time job and being a full-time parent is not an easy life to lead. Many nights I cried myself to sleep, not just from the hardship of life but also from missing Rob. Being a single mother was even tougher than I had imagined. With time, I noticed I was faced with not only financial

and emotional challenges; I was also constantly trying to resolve logistic and social challenges.

Financially, we were now living on one income—mine. Having to look after the children all by myself limited me to working only a small variety of jobs. I could not work a job that had night or weekend shifts without having to arrange for childcare. I needed to have a job during the day that allowed me to work while my children were in school and be off by six o' clock in the evening in order to pick them up. I ended up working in a beauty salon as a receptionist for the second time around.

Rob did not leave me with nothing: he left me with a ton of bills. With my slightly-above-minimum wage, I had to take care of the mortgage, the utility bills, the car payment, the childcare, groceries, and overly extended credit card bills. I couldn't manage them all; my figures at the end of each month were worse off than before. At the age of twenty-five, I was left with no choice but to declare bankruptcy.

Being a young single mother living in Canada with no credit and no savings was the most painful experience I have ever been through. I had to penny pinch on everything. There was no cash for extracurricular activities for the kids, so they never joined in any sports or music clubs after school. Their usual pastime would be television; television and more television with occasional board games at home. I remember having to watch the same movie with Benjamin so many times I secretly wished my VHS machine would break down, so I didn't have to watch those silly Ninja Turtles playing martial arts ever again! Then

one day my wish came true: the VHS tape had been played so much it snapped. As poor as I was, I went out to buy Ben a brand new tape to keep him happy. That tape kept him entertained for another few months, but it also meant that we wouldn't have eggs and cereal that week.

Going to the grocery store for me became an ordeal. I feared going to the cashier after picking up the groceries, because I wouldn't know if what I had in my pocket would be enough for the groceries I needed. I'd watch the cashier ring in each item and as the numbers added up, I'd start feeling anxious. I knew that I would need to ask her to put a few things back. The cashier would look a bit annoyed while the shoppers behind me would stare, wondering why I couldn't afford an extra five dollars' worth of groceries. Even today, generating an executive income I still get anxious going to the checkout. I ensure I have plenty of funds in my bank account before I shop for the smallest items like milk or bread, so I won't ever have to go through the embarrassment again.

Our meals were very simple—chicken and rice every day. At that time, the cheapest protein in the freezer would be a box of frozen chicken legs for $5.99 per five kilograms. I didn't know or care how fresh it was or whether the meat was full of injected hormones; I just knew that this box of chicken legs would feed my kids for a while. That box would last us three weeks, or sometimes even longer if I used it sparingly. I became a pro at cooking chicken. I would steam, bake, fry, stew, and cook the chicken any way possible to give the kids a bit of variety in flavour so they

wouldn't get sick of it. For years, we had chicken at every meal.

One day, while I was making coffee in the morning, I heard Benjamin crying. He came running down the stairs with tears running down his cheeks screaming, "Mommy, I had a bad dream."

I gave him a big hug to calm him down. "What is it? Did you dream about a monster?"

"No," he said sobbing.

"What was so scary, honey?" I asked.

"They were chasing me, Mommy," he said.

"What was chasing you, baby?" I asked.

"Chickens!"

"Chickens were chasing after you!" I was shocked by his answer. I thought to myself, "What have I done?"

As a result of eating chicken meal after meal, day after day, for so many years, my child was dreaming that chickens were now chasing after him. Emotions took over me. What kind of life have I given these kids? I had brought them to this beautiful world but I had not given them all the things they deserved. I had not given them the basic necessities most kids should have. I felt like a horrible mother at that moment. I held Benjamin in my arms and cried.

The role of a single parent is not an easy feat. Logistically I couldn't travel around or do errands on my own. I couldn't afford a babysitter so I had to take the children with me wherever I went. Even the simplest trip to the corner store would become a huge ordeal, strapping them into car seats, sweet-talking them into running to the corner store

with me. I had to take them everywhere even if they didn't want to go. Even a simple errand would take a long time to complete. However, I did learn one important trick when dealing with children—a reward system! Tell them they will get a prize if they behave well. In other words—bribe them! It works every time!

Each day after work, I had to rush to the daycare to pick them up. I had not a moment to spare. I prayed that there would not be any traffic congestion on the highway so I could get there in time. If I showed up late, there would be an additional cost for extended childcare, and that would be funds I didn't have. We were living paycheque to paycheque already; sometimes I would have already spent my next paycheque before it was deposited into the bank. Life was tough.

I had to act the roles of both a father and a mother at the same time. I had to discipline like a father and nurture like a mother. Being a young divorced mother, my self-esteem wasn't too high, and most of the time I was filled with anger and depressed at being stuck in my situation. I used to blame everyone and everything around me for the circumstances I was in. As an experienced single parent, I can confirm that my children were also emotionally challenged by the situation.

The toughest challenge for me was the feeling of loneliness. I had to deal with every situation alone, with no one to consult or even share it with. Twenty years ago, in the 1990s, resources were very limited online. I think everyone was just getting set up with their email accounts. You could

not Google "parenting" and get a ton of information, and there were no social media available. And even if there were, I wouldn't have been able to afford a computer.

So I had to figure out the best possible way to raise my kids. I went with my gut feelings. I disciplined Benjamin and Sue-Lee based on what I thought was right and fair. And what I considered right and fair was based on my family values and what Grandpa Lee would have done in those situations. I watched the other parents I knew and I followed their styles of parenting, too. I learned throughout the years as a single mother never to speak negatively about my children's father; when they grow up and mature into young adults, they will figure out for themselves what had actually taken place.

I knew from the beginning that I would raise them liberally, allowing them room to make mistakes, but yet being there to support them when they needed me. I prayed daily that my children would grow up to be independent and mature, and eventually develop into their own individual selves.

My everyday life was cooking, cleaning, taking care of the children, and paying the bills. I didn't have time or extra energy to have friends or even a social life; that's probably why I don't have many friends even now. Having a social life almost does not exist for single parents. I was already in financial, logistic, and emotional turmoil, so to be honest, I didn't want to be around anyone else. I couldn't afford to have friends back then; friends can be time-consuming and expensive at times. The costs of having a night out

with friends would have to cover babysitting, movie, dinner, and drinks, which could add up to be a week's worth of groceries. So a social life was almost non-existent for me.

Back then, I did not always have clarity in my life. There were countless days and nights that I felt really defeated. I constantly asked myself, what kind of lifestyle have I provided for my children? I brought them into this world and it is clear that I am ruining them before they even know it. Crying myself to sleep was almost a nightly ritual. I would cry till there were no more tears, because the constant thought of being alone, poor, and helpless was slowly eating me up.

I hated myself for being so weak. Slowly, the confidence I once had disappeared and, without even knowing it, I started becoming uncomfortable even in my own skin. Self-doubt had taken over and I had totally lost faith in myself. I felt totally incompetent in being a parent and in being a person.

My children had no social life; they didn't eat properly. Being on the single parent welfare program didn't help with my morale either.

I had grown up in a very elite neighbourhood with a family who loved me. We had money and we had hired help. I attended the most prestigious schools and I had a family who provided well for all of us. It was clear in my mind that I was incapable of doing the same for my children.

"How in the world have I ended up in this predicament, scrambling to buy a loaf of bread?" I asked myself. I should have listened to my mother; she was right. I was not

ready to be a parent. I should have just returned home to Singapore.

I remember waking up one morning having cried all night. My eyes were so swollen I could hardly open them. Benjamin had woken up before me that morning. He came into my room and sat on my bed patiently, trying not to wake me up.

But he couldn't help himself from asking, "Mommy. You okay?" in a childish but caring voice.

"Yes, I am, Benjamin," I replied as I tried hard to open my eyes.

He placed his hands on mine as he started to play with my fingers and out of nowhere he blurted out, "Mommy..."

"Yes?" I asked.

He was silent for a few seconds, probably thinking how he should articulate his words at the age of three.

"I love you," he said with a shy smile.

I stared at him, as tears streamed down my cheeks. I could not have imagined him to be so sensitive about the situation. It is unusual for a three-year-old to understand what his mother was going through. Benjamin, for the third time around, had saved me. Guiding me through that wintry night, holding with his tiny hands while I was in labour, and now he had dived in to save his drowning mother from sorrow and depression.

How can I ever thank you, Benjamin, for your unconditional love?

Those three words were so powerful, they never left me that day. In fact, those three words have never left me at

all. Those are the three words that strengthened my mind, cleared my tears, and implanted another three words into my life: "Don't Give Up."

At that moment I made up my mind—I refused to be a victim of my own circumstances. I had been ignoring entirely that I was calling myself a victim and hadn't really paid attention to any solution. In a selfish way, I was reluctant to work harder than my husband who had abandoned us without having to commit to any responsibility for his own children. I was not willing to be the only parent contributing to their lives. But Benjamin showed me his love, even when I was too tired to make him cereal for breakfast or dress him in the clothes he wore from a second-hand store. He loved me unconditionally—and without prejudice. His actions and his words redirected my path from self-pettiness to self-care, and gave me the desire to stand on my two feet so I could give him and his sister a decent loving life.

I had forgotten what Grandpa Lee would have done and that was always to focus on the solution and not the problem. He would say to me, "He who treads softly will go further and it is the journey, whether easy or hard, that is the reward my child."

There are moments in time that transform us. From one thump of a heartbeat to the next, in a single second, or the blink of an eye, these moments come unforeseen, unplanned. Yet, they become ingrained forever in our memory. These moments could forever change the way we think, live, and love. They could come in the form of a pleasant surprise or a gut-wrenching heartache.

In my case, my moment came as a beam of bright shining on a world submerged in complete darkness. My life-changing moment came that morning. When Benjamin set his tiny right hand in mine and uttered the words "I love you" in his soft little voice, my world completely changed. My world might not have changed physically—I was still poor, uneducated, and fighting to put food on the table, but mentally I was no longer scared to walk out of the darkness toward a brighter future. I had the courage to plan out a course toward a better life and the tenacity to walk on that path no matter how tough the road would be. I was ready to become better than what I'd been told I could be, and I wasn't afraid to show people that.

From that moment onwards, my life changed, because my thoughts had changed.

Since that day, I have refused to allow myself to feel emotionally attached to issues. I treat each challenge as an opportunity and each suffering as life training. I decided to put in a hard day's work every day of my life to achieve what I want for my future. I tune out all distractions. I became determined to get us out of poverty—and I couldn't do that by crying all night.

" *All that we are is the result of what we have thought. The mind is everything. What we think we become.* "
Buddha

The saddest part is that we carry negative beliefs through-out our lives. We develop limiting beliefs about who we are and what we're capable of from our earliest years and then we carry those beliefs for decades. If it were not the fact that Rob left us and I was stuck with being penniless broke to support my two children, I would be content as a stay-at-home single parent. Instead, I chose to work harder to set an example for my children of not settling for second best. Because of my choice to take the rougher more stren-uous journey, I have become a better person. For that, I have to thank Rob for leaving.

Rich Is the New Sexy

Ladies, you have probably heard that money cannot buy happiness, and unfortunately, I know that poverty can't buy happiness either. Money does make the world go round—but is that money or love? Give it a good think. Love makes life special, but without money we are in deep trouble. Isn't that a painful reality? Without money, we are without a home, a car, food, and clothing.

We work so hard, living paycheque to paycheque, and many of us don't even know whether we can retire com-fortably. So we need to do ourselves a favour: learn about securing our retirement plan, because without money, we won't be able to take our children and grandchildren on luxury vacations, we won't be able to retire at an age we want to, we won't be able to take that cruise around the world, and, in the worst scenario, we won't be able to pay

our mortgage or buy ourselves food. Understanding your finances is as important as knowing about your health.

I was once young and unprepared, which put me in such a vulnerable and desperate state. I told myself that I would not like to see anyone be in the same situation as me. That is why, whenever I speak at various platforms, I focus on having my audience understand the power of having independent means. Don't wait till the last moment before you find out that being financially independent is indeed important.

A majority of women today watch their finances being planned by their loved ones, but instead they should be participating in planning them. There are many reasons why women should take part in their financial plans: women still make considerably less than men. Some statistics say we make 25 percent less than men. When companies downsize, women are the most vulnerable. And lastly, unattached women and divorcees struggle to maintain a family with less than half the income they had when they were married.

A friend once shared that she was making $30,000 per annum and she didn't have much in her savings account. Later she found another job that paid her $100,000 per annum, and still her savings didn't grow. Why was that? Making more money doesn't mean we will be richer; we need to do some financial planning, However, making more money is a great start to financial freedom. Find out what your net worth is. Does your income cover all your expenses with a 10 percent savings at the end of the

month? Can you retire comfortably at fifty-five years of age? Do you understand how to maximize your tax savings each year?

My friend, Sandy Botkin, Certified Public Accountant, Attorney, and Tax Expert, will tell you that you are paying too much tax and there are ways you can save on taxes so you can put that saving toward your RRSPs. When a woman has money, she feels secure, she has more freedom, she has more time with her family, she feels calmer and happier, she feels like she has a life, she will live longer, and she will give back and make a difference. That is the ultimate purposeful life for a nurturer—the woman.

During one of my business trips, I asked a few men what they would do if they had extra money and their answers were they would buy cars and boats, attend boxing matches in ring-side seats and, of course, drink beer and go to parties. They tend to have slightly different priorities compared to us women, but in this book we are talking about women and not men. So when I turned around and asked the women in the audience what they would do if they had money, they said take vacations with the family, pay off the debts, lower the mortgage, and retire my husband so we would spend more time together. Women are generally less selfish and more selfless.

What exactly are your values and goals when you have some money in the bank? One of my highest priorities is to pay off my house, be mortgage-free. Second on my list is to have a healthy RRSP plan so I can retire comfortably, and third is to be totally debt-free so I can set cash aside for

a rainy day. If companies can be totally debt-free, why can't we personally be debt-free? For those who have not come across serious financial planning, it would be a great start to plan for a healthier personal financial portfolio if we treated our finances as though we are a company, making a profit versus a loss.

THERE IS A PLANNING SYSTEM

Write down your goals. If you want to be serious about achieving a certain goal, you need to write it down on paper. Put a dollar figure on a piece of paper and keep it somewhere so that you can take it out to remind yourself every so often. Think about it. How many times have you had an idea but didn't put it on paper? You can literally forget about it if you don't write it down.

I have a girlfriend who has her "little dream box" and whenever she has an idea, a dream, or a goal, she writes it down and puts it in her dream box. Believe it or not, most of her dreams come true, because she manifests them into words and lets them out into the universe.

If your goals are worth focusing on and giving time to, then they must be worth recording, and if you don't record them, who will? In a nutshell, writing down your goals makes them real and easier to focus on. Hopefully, from now onwards, you will record all your goals on paper. No more excuses.

Once you have committed to recording your dream goals, they need to be specific, measurable, and provable.

If you've written something that really can't be measured or proven, then it is a wish not a goal. For example, "I want to have heaps of gold." Now, that is not measureable. What is "heaps" to you may not be "heaps" to me. Or, "I want to be wealthy." That is even worse; it is a useless goal.

Instead, name a specific amount. Let's say you make $70,000 net income a year and you want to put away $30,000 in the next five years. By saving 10 percent on each paycheque, you will have $35,000 in five years. If you want to be debt-free, then your goal could be to pay off your credit card bill, mortgage, or line of credit over the next six to twelve months. The point is if your goal is vague, it will be difficult to attain.

The next step is to put a timeline onto your goal attainment; in other words, where's your finish line?

I had always wanted to own a vacation home on the tropical island of Maui in Hawaii, where I could retire and live for months each year. Now that was a long-term goal for me; realistically, I could not achieve it in a year or two, but I could certainly accomplish it over the course of ten years. I needed to have a price in mind; I needed to do some research with local realtors and ask for pricing; then I needed to add some inflation on top of the price.

The key is to do something and not just have the goal in your mind. Take action—it can be any action—and that will make the goal you have written down more real and specific.

I stick all my dreams and goals in my hand blown glass "dream vase"; I call it "B's-Dream Vase." Some people have

dream boards, some tape their dreams on a mirror, and some write them on their smart phone. The point is that you should remind yourself by looking at your dreams regularly so that you are consciously being reminded of them. If you can look at them every day, even better, because reviewing your goals every day helps to make them clear and, ultimately, very personal and real to you.

Now that you have been specific about your goal, written it down, taken some action, and stuck your written goal somewhere so you can remind yourself of it, the next step is to tell someone about it. Whether it is an outrageously lofty goal or an easy one, you need to share it with someone. I shared my financial goals with my kids and at first they thought I was nuts, having such ambitious goals, but after seeing that I slowly accomplished them over the years, they now encourage me to shoot higher.

By keeping your goals to yourself, you are keeping the world from helping you achieve them. Why do I say that? When you share your goals with others, there will be people out there waiting to help you achieve them. Let's say that your dream is to generate a second income so you can take your family on an annual vacation and someone heard that dream. They might have connections to get you started on a second income or even get you started in your own business. Isn't it fantastic to be connected to resources? When you make a decision that is pure and honest, the universe will send back good energy, work out the kinks, and help you achieve it.

Let's say you share your goal with someone, and that

someone says, "You can't do that," or "Your idea is dumb, you'll never be successful." Don't take it personally. He or she knows only what he or she can or cannot do. The intention may be good, but people will tell you that you can or cannot do something based on their own capabilities. Ignore these people. Their negative beliefs are their problems, not yours.

If your friends really don't support you and your goals, maybe you need a new set of friends. I am blessed to be surrounded by a very supportive family and a couple of really close friends who always believe in me and support me in whatever I put my mind into. The essential takeaway is there are a few components that will affect your success and the people with whom you surround yourself are one of them. When I told my friends and my ex-boss that I am writing a book, my friends were so supportive that they wanted to be my accountable partners. They regularly check up on me to see whether I am writing. My ex-boss, on the other hand, without even asking for more details, said he knew someone who wrote a book and had gained nothing out of it. Then he told me to stop wasting my time. Well, I am happy to say that I no longer work for him: he is my ex-boss. You cannot have people around you who burst your bubble. Remove them like you remove negativity from your system.

Your plans for a more secure financial future have to be in alignment with your values. As I mentioned before, my future goal was to own a home in Maui, Hawaii, so I could spend my vacation there with my kids, and they can use

it for themselves and their families. Don't you think my family is going to support me on my decision if they know that they are a big part of my reason to build a more secure financial future? I make them my partners in crime so they can help me achieve my goal.

Goals do change due to life changes. Review your goals yearly and redo them if you have to. Set a date for yourself every year so you can check whether you are progressing toward achieving your goal. It is also an opportunity to refocus your efforts and recommit your goals to make them real. If for some reason, you cannot recommit, then rewrite your goals. It is okay to have a new list, as long as you have a list. Your list is a planning process, not a to-do list.

BESIDES BUYING HEELS, HERE ARE A FEW MUST-DOS

Always learn to have money put aside for a rainy day; plan for a healthy emergency fund that will cover any unexpected emergencies, like a loss of income, a flood, or a broken hot water tank. A solid emergency fund is perhaps one of the most important tools in developing and sustaining financial security. Most financial experts recommend having between three to six months of living expenses socked away because, no matter how well things are going, bad things will happen from time to time. These things happen. We can't always be prepared for the emotional toll or the hassles, but we can be prepared to handle the bills.

It sounds simple but survey data reveals it's anything but

that for many Americans. According to a 2011 survey by the National Foundation for Credit Counseling, 64 percent of Americans don't have enough cash on hand to handle a one-thousand dollar emergency.

To handle a crisis, 17 percent of respondents said they would borrow from family or friends. Another 17 percent said they would neglect existing obligations; 12 percent said they would pawn or sell belongings; and 9 percent said they would get a loan from a cash advance store. When we're living like that, we are just one unforeseen accident or event away from complete financial disaster. The economy we live in today is just too unpredictable. We can't live six months on our credit card; it'll take us years to pay off.

Once you figure out how much you need each month, put away at least twenty-four months' worth. Whether you put it in an RRSP, a GIC, or a high-interest savings account, just make sure you have the money set aside, in case you ever lose your income. You may think that twenty-four months is a lot, but realistically, it will provide you with more security and it will provide you mental comfort by having a cushion to fall back on.

Do you have a living trust? A living trust is a bit like a will. It basically states who gets the money when you die. We all have to be responsible for our loved ones; to have nothing in place is very irresponsible. You may think that you don't have enough money to will it to anyone. But have you thought of the car, the equity in the house, or that heirloom piece that your grandmother gave you? All those are assets.

Life insurance is another must-do. Ladies, if you have

financial dependents, you need to protect them by buying life insurance. Not many people like to discuss life insurance, because it means a protection—just in case something were to happen to you—against death. But the fact of the matter is that is life—people do die—and what will happen to your loved ones if you die unexpectedly. If you are married, insure your husband and children. If you are a single mom—you had better overinsure. I always like to caution single mothers; their situation relates so strongly to the way mine used to be. Think about it, ladies. If something happened to you, who is going to take care of your children? You don't want to leave them financial burdens even before they begin their lives. I know you have parents, and think they would take care of your children. However, it is a hard and expensive obligation to inherit. The upbringing of children is not cheap at all.

Disability insurance is another one that is reaching the top of the list, because this insurance covers anyone suffering a disability prematurely, whether it is an accident or an illness that causes you to lose your income. If you lose your income, that means losing a primary means of financial security; and your income is probably the most important asset for everyone.

Hire a financial coach, for heaven's sake! In order to be rich, you need someone who understands how to help you invest your money. Believe it or not, rich people don't manage their own money; they have someone professional do it for them. Top-notch financial professionals are trained well to keep up to date with the financial world, and that

takes time and skills, time and skills that you don't have because you will be too busy making the money in some other way.

Take Control of Your Career and Your Life

How are we going to have some rainy-day money if we don't have a decent income? When it comes to asking for a raise, whoever it is you are dealing with, ask for what you are worth. The biggest downside to us women is we are too nice to ask for "big" items. If you are putting in long hours—when I talk about long hours, I am talking about hours that exceed sixty to eighty hours a week—and you feel that you are not getting compensated for that, talk to your boss about your concerns. If he or she wants you to stay, they will listen. Communication is always the best solution to any grievance one may have. Or you can start talking to your employer's competitors and/or other companies to see what the market rate is in your area. If you are worth more than you are being paid, do something about it rather than complaining day after day, week after week, and month after month. Once you have collected the information, make a decision to stay in the company and stop complaining, or leave for something else. It is that simple a decision.

Ask yourself why you aren't talking to your boss about a raise if you think you deserve more. I know of someone who has had a similar issue for years, and the reason she

didn't ask was because the company wasn't doing well and her boss was really "nice" to her. Hello! Companies pay for services that we render, and if we have a unique skillset that is hard for them to acquire or hire, they will have to pay for it. Now, I am not saying that everyone deserves a 30 percent to 40 percent increase. There are individuals out there whom I have personally hired, whom I feel I overpaid for their services. In the end, we are talking about being fairly compensated and not being greedy about it.

When you ask for a raise, it needs to be factual and reasonable. Use facts like inflation, the local cost of living, because living in Vancouver, British Columbia is more expensive than living in Winnipeg, Manitoba, and living in Malibu, California is not the same as living in Portland, Oregon. What you pay for a huge home in a less-desirable area would be comparable to owning a studio or a one-bedroom suite in an elite area.

After hearing your facts, your employer will rationalize letting you have a little extra income, because the cost of replacing you would be expensive. Think about the hours of training someone all over again. The cost of replacing a trained employee often totals as much as twice the original employee's annual salary! Then there are other additional costs of downtime and training, not to mention the hassle of interviewing and screening candidates. If you are an executive, companies hire executive recruiters, and they charge a percentage of the new employee's salary for a period of time—there's a high cost there as well. The bottom line is clear; it is not worth losing a good employee for the sake of a few dollars a month.

If all else fails, leave your job. If you are currently being underpaid, underappreciated, or underdeveloped in your career or business, I fully recommend that you consider finding something else. This may sound extreme, especially to people like my conservative mother. If you know in your heart that you really should quit your job but are afraid to follow your instincts, ask your gut feelings. If your gut tells you that you have bills, payments, and responsibilities, then stay where you are. Ultimately, you have to be comfortable with your decision!

On the flip side, here is a million dollar question for you. Is it okay to work at a place you don't love, to work with people you don't like, to work for a company you don't respect, to work for a company that doesn't respect you, to work for less than you are worth, to put your life energy into something you don't feel passionate about, and don't feel secure? If that work is killing your spirit, is it worth staying for?

I think it is a terrible mistake to decide to spend your life doing something you don't love. If everything I say is true, then I think you need to really consider Plan B.

Many would say, "Belynda, the economy is down and it's hard to find something that is comparable."

Okay, fair statement. Have you heard of starting your own business that has low investment and low risk? Nowadays, we have more women starting new businesses, and at twice the rate of men. Check your industry stats within your country.

There are many reasons for this trend; the majority of the

women I speak to are sick and tired of the corporate world and its invisible "glass ceiling." Others just want to be their own bosses, and some are empty-nesters who have some time now that their children are all grown up, and they can at last do what they enjoy doing. If you are thinking of owning your own business, I can tell you I have worked with hundreds of entrepreneurs who start on a part-time basis and, whenever the income that was generated from the entrepreneurial business surpassed their employment income, they switched over and started to focus full-time on their own businesses.

Whatever you choose to do, don't settle for mediocrity. There are more and more women making names for themselves; these types of women rise above their competition. These are individuals who are connected and will make things happen. If you work for someone or own your own business, you want people whom you can count on. Unfortunately, there are not a lot of people out there who share the same values. I can name quite a few people I work with, people who don't take pride in their work, people who settle in their jobs, people who are too complacent to change or to work a little harder. Doesn't it sound depressing? The great news is you don't have to do much to stand out. You just have to be accountable, reliable, polite, happy, and punctual, and never settle for just an okay job. Take that extra step to do something better than the last project manager or the last event. Always stay ahead of the game.

Work every day as if it is your first day at work, excited, enthusiastic, and keen to learn. Many people count their

hours at work, and by 4:00 p.m. they are already winding down their work. By 5:00 p.m., they are in the parking lot. I know of individuals who call in sick just to exhaust their sick-day allowance. On my last job, at one point I had over two-hundred hours of vacation, and many of those hours had already expired, because they didn't carry over. I am not saying that everyone should be a workaholic; I am merely stating that we should have integrity about our work.

"Be Yourself; Everyone Else Is Already Taken"

As this advice from Oscar Wilde indicates, we are each blessed to have talents that make us special. I have been in sales since I was sixteen years of age; I still remember how I accidentally got into that job. I was a normal teenager who wanted the most popular school bag that everyone else had, but my mother would not buy it for me. So I went to one of my friends and confided in her about my dilemma. She then said she knew someone who could help me but I would need to get to a location and search for a white van that would be parked in the parking lot, where someone would give me more instructions. Young and naïve, I went without asking for more information. All I could think of was the brand new bag that I would be carrying to school on Monday.

I started to look for the white van that would be waiting for me. A man stood beside it. Once he saw me, he

confirmed it was me he was expecting before handing me a bag. "Sell everything in there and I will give you $30.00 when you come back with it empty."

He was wearing a pair of dark shades, so I couldn't read from his eyes whether he was sincere or not. I took the bag from him and headed toward the residential flat. The bubbly confident teenager was soon deflated when I opened the bag and found stacks of illegal cassette tapes of various singers. They wanted me to sell illegal tapes. I looked to see whether there were any cops around, and I looked up at the residential flat. Then I told myself, "I can get this done in two to three hours and by this afternoon I can go purchase my bag."

I went knocking on the first door. The sale was quick because they slammed the door on me. I went to the next door, they did the same and told me to leave the building. That went on for a few floors and I didn't sell any tapes.

I was getting anxious, all I could think of was not getting paid. By the fifth floor, I panicked. I sat on the stairs wondering what I could have done wrong. Well, I had been busy trying to sell something I was not even familiar with. I didn't know these singers, and honestly don't even read Chinese well, so I could not make out what songs they were singing. If I were a customer, I wouldn't buy it from me either.

So I needed to change my strategy quickly, I knocked on the first door on the fifth floor, and this time a middle-aged lady opened the door. She asked me what I wanted. I looked inside the bag and thought for a while, and said; "Madam,

can you help me out and tell me who these singers are?"
She was very helpful and started to rattle off the different
singers and albums. We started to chat, building a relation-
ship over the tapes. Needless to say, she bought quite a few.
I went through the entire building using the same strategy,
and I sold all the tapes in the bag.

That experience taught me a good lesson. We must always
build a trusting relationship with our customers. Without
that trust, it doesn't matter what you are selling: you will
not succeed. Relationship marketing comes before selling.

That evening, I collected my first $30.00. It took me lon-
ger than just two to three hours; it took me eight hours to
sell the entire inventory. As he was handing me the cash,
he said, "You are good. I have not seen anyone sell the en-
tire bag of cassette tapes before. Come back tomorrow and
I will increase your pay to $32.00."

I didn't go back the following day. I had bought the
bag I wanted and I was content. That experience led me
to other sales positions, and I later realized I had been in
the sales profession for years. At one point, I wanted to
try something new, so I switched 180° and took a job as a
procurement officer. That was a wrong move. I hated that
job. I couldn't stand going into work to negotiate payment
terms, shipping ETAs, and bulk pricing. I missed the small
talks with my customers. I think that was the shortest work
experience in my career.

Nevertheless, making that move was a good thing for
me. I found out what my talent is and what I really enjoy
doing: it was the people relations that I was drawn to. I

also enjoyed having the ability to educate my clients, to help them differentiate between what they needed versus what they wanted, and to see past the marketing jargons. There are salespeople who sell products, and there are others who help bring intangible dreams into reality; to help dreams come into fruition is so rewarding. I have been blessed with the ability to use my talents in helping people and at the same time make an income from it. Doing what we love is one of life's biggest gifts in the world.

What makes me sad is I come across many people who have given up their dreams of doing what they truly enjoy. When I see them working at jobs I know they aren't passionate about anymore, that makes me realize that they have forgotten what it is that makes them unique. And that leads to an increasingly unhappy life. Start to exercise change in your life and start doing things that you truly are in love with; we only have one life to live. If you use your talents (the talents that God has given you), and start to work with them, the chances are they will take you to a place in your life you can't even imagine right now and your income will grow in a major way.

This chapter is not just about money or having a lot of it to make ourselves "sexy." It is about taking care of ourselves and at the same time doing what we really enjoy doing. How we live our lives now determines how others will remember us. No one will remember how much I have in the bank, but people will remember Belynda for who she is, what she has done, the values and integrity she holds, and what she has contributed. Not that nice things aren't worth

having; if you ask my close friends, they will tell you that I love my collection of luxury items. But there are bigger things in life that we should be focusing on. The biggest is your life purpose and once you can differentiate what it is, everything else will come naturally.

THE BLANK CANVAS

> **"***Life is a beautiful thing and there's so much to smile about.***"**
> **Marilyn Monroe**

I just returned home from a trip to New York and I texted my daughter right away.

Me: "I have landed, Sue-Lee. Can you pick me up at the airport?"

Sue-Lee: "Okay, Mom. Let's grab some dinner on the way home."

Me: "Sure—sounds good."

It was a longer than usual trip and I was missing my children terribly. I couldn't wait to give Sue-Lee a hug, even though she was at an age when she was not too keen on giving hugs.

My business trip that started in Washington State went through California to Texas and on to New York. I was speaking on opportunities for a home-based business. During the tour, many people in the audiences questioned the longevity of their corporate jobs versus owning their

own businesses and being entrepreneurs. The stress they were enduring at work while dealing with office politics and people dynamics was getting higher and higher. Lack of quality time with their family was making them question the quality of their lives. In the rat race, the majority of higher-level managers and executives have to bring their unfinished work home. My audience was looking for better solutions outside their environment; they were looking for something that would give them a decent income and still enable them to spend quality time with their family.

Joey, a fresh grad, came to me when I presented in New York. He was smartly dressed in a black suit, and he must have been around his mid-twenties. He shared that he was struggling to find a decent paying job to cover his basic monthly expenses like rent, food, and student loan. He had borrowed $60,000 in student loans to finish his MBA. And he could not believe that even with an MBA degree, his job ended up barely covering his expenses, which included his 450-square-foot studio apartment.

An older woman named Dong came up to me quickly after my speech. She held onto my hand and looking at me from her withered face, she shared her story of being tricked into working in a sweatshop for years. My heart sank and my eyes welled up with tears. She had been born and raised in China. She explained that she had immigrated to America two decades earlier. Her wish was to build a better future in her new home—the USA—but she had had no idea that she would be tricked into a sweatshop working a minimum of ten to fourteen hours a day in the

Big Apple, one of the wealthiest and most prestigious cities in the United States. She would leave her apartment at 6 a.m. and return home by 9 p.m. six days a week. During busy seasons, her six-day workweek would turn into a seven-day workweek. That had been her life for the past two decades; her hopes for a better future in the United States were diminished by needles, threads, and an old sewing machine.

My business trips have always been great opportunities to meet people, but listening to their stories sinks my heart like a huge rock stuck in my gut. It was difficult not to think of the poverty in the country, even in a country where many dream to come for a better future. Every time I hear these stories, I carry an even heavier suitcase home. Nonetheless, it inspires me to want to extend help to these individuals and to provide options and alternatives to make their lives easier, and as a result, to put them more at ease.

My daughter waited for me at the terminal as I came through the international arrivals door. She wore a big grin on her face when she saw me, and that always brings my heart so much joy. I hugged her as if I had never hugged her before. She was wondering that evening why I was being overly affectionate. I was filled with pure joy from the inside out just knowing that she had taken the time to pick me up and we were spending some time together over a meal.

We went to our regular place called the Flo Tea Room, where they have the best Asian food in Richmond. We

ordered our usual dishes and started to talk about her school and the sports she was participating in. It is always a pleasure to talk to Sue-Lee. She is full of life and spirit. Nothing seems to stop her bubble of positive energy; the world seemed to be in alignment with her as she planned her senior year school trip to Europe. She explained how excited she was about the trip and which excursions she and her friends were going to participate in. Listening to her made me forget about the numerous sad stories I had taken home with me from my business trip.

Having finished dinner, we took our usual route home from the restaurant. The night was dark and it was raining. Not too heavily, but enough to create poor vision on the road. Richmond streets have never had great streetlights. The low lighting conditions made it really hard to see. Sue-Lee didn't want to drive in those conditions, so she asked me to take over the wheel instead. Even though I was tired after the long flight home, I can never say no to her. And, since she had just passed her driving test a few months earlier, I agreed.

We took our normal route home from the restaurant onto Gilbert Road, the quickest way home. I was so tired after having been travelling for the past twelve hours that all I had on my mind was that I could not wait to get into bed. The rain was coming down harder and harder. I drove at a moderate speed heading southbound, when suddenly we saw a shadow walk slowly across the road. We could not see whether this person was hurt or whether she knew she was crossing a busy street in a diagonal fashion. I slowed

down to let her cross, then turned and looked at Sue-Lee, commenting that it was strange for this person to act in such a peculiar way. Or maybe she was drunk, because her stride looked rather unstable.

As I focused on my driving, Sue-Lee turned her head to make sure the woman crossed the road safely. Then she yelled out, "Oh, my goodness! She is hit, Mom. She is hit!"

I quickly adjusted my rearview mirror to look in her direction and saw a car's red brake lights on. The street was so dark that I could not see anything else.

"Are you sure?" I asked Sue-Lee.

"I swear, Mom. She's been hit," Sue-Lee replied in shock.

I took her word and made an illegal U-turn to the other side of the road heading northbound on a red light. I sped up toward the stationary car and saw a person lying on the ground. The traffic light behind me had now turned green and there were oncoming cars moving in our direction. I swung my car sideways, so the entire side of the car would protect the woman on the ground, while I asked Sue-Lee to stop all oncoming cars that were driving northbound.

I think neither of us expected to be on the road, on a dark rainy night, stopping traffic. As Sue-Lee was directing traffic, I ran over to the body that lay on the ground. She was very still, but still breathing. Her coat hoodie was over her face; it must have fallen over her face when she fell. I gently removed it from her face to see how she was doing. To my astonishment, I saw a senior Caucasian lady, probably in her late sixties.

The driver who had hit her—an Asian lady in her fifties—stopped her car and ran to the body. She was in distress by now. She kept saying, "I didn't see her, I didn't see her. Oh, my God, I really didn't see her!"

"What is she doing walking home alone in the dark at this time of night?" I thought to myself.

The rain was pouring down strongly by now. Her pale face was getting drenched, so I covered it up with the hoodie while I dialed 911.

"Nine-one-one," said the emergency operator.

"I need help—there has been a car accident on Gilbert Road and an old lady has been hit." My voice was shaky.

"Is she alive?" asked the operator.

"Yes, she is," I replied.

"How does she look and where is she?" asked the operator.

"She is on the ground, but she is soaking wet from the rain. The rain is coming down hard and it's cold out here," I replied.

"I want you to follow my instructions while we wait for the ambulance to get there. Are you fine to help me?" she asked.

"Yes, I am. I will do whatever you want me to," I said.

"Locate a blanket and cover her up. Try to keep her warm," said the operator.

By this time, people from the stopped cars were starting to gather around us. They were curious to find out what had happened.

"Does anyone have a blanket or a spare jacket right now? Anyone?" I yelled out to them for help. Someone ran and

grabbed me a blanket from his car and gave it to me. I took it and gently covered her up.

I went back to my 911 call and said, "Yes, I got a blanket and I have just got it over her. What should I do now?"

"Good. I want you to find her pulse for me. Tell me what her pulse is like," the operator said.

I placed my fingers on the right of her neck. I still remember the texture of her skin: it was fine and soft but loose with wrinkles. She was shaking, so it was not easy for me to find her pulse. Once I found it, it was very weak. Her eyes were shut, but I could tell that they were moving as if she wanted to open them.

"Her pulse is weak. Actually very weak," I said.

"Try to see whether she is breathing heavily," said the operator.

I put my ear by her nose to hear whether she was breathing and found that her breathing was just the opposite of heavy: it was short and quick.

"Can you tell whether she can hear you? You are doing well, by the way," the operator said.

I went closer to the woman and said, "Madam, can you hear me? Madam, how are you feeling?" She did not respond.

"Keep talking to her and try not to let her drift off to sleep," the operator instructed.

"Okay," I responded, at the same time shaking with cold. I continued talking to her; I asked her what her name was, where she lived, and told her not to fall asleep as help was coming. She lay there lifelessly, not responding.

By this time, the rain was hitting us harder; both of us were drenched and soaking wet. I looked over to Sue-Lee and she was standing with the crowd, shaking—probably both in shock and cold. There were about ten people surrounding us, all from the cars and also from the neighbourhood.

I looked down at the victim and kept talking to her as instructed by the operator. "Help is coming stay with us—you are going to be just fine," I said. Even though I didn't get any response from her, I continued to make sure she knew that we were there and waiting for help just like she was. I could feel her pulse was getting weaker and weaker by the minute.

While I was still on the phone with 911, I asked the operator when the ambulance was coming. She reassured me that they were just around the corner. This time, I moved my finger from her neck and placed my hands on hers, so she would know someone was there with her.

Within minutes, I felt a hand on my shoulder saying, "You can let go now. We are here." I looked back and saw the paramedics—joy must have consumed me that very moment, because I felt tears of joy streaming down my cheeks.

They helped me up as they took over in assisting her. Sue-Lee and I walked over to the sidewalk, like everyone else, as instructed by the paramedics. Soaking wet from the rain, we held onto each other's hands, hoping for the best for the old lady. Another ambulance came shortly after the first had arrived. There were five paramedics working on her now.

We heard them say, "Quickly, go get the ECV—we are losing her here."

We saw them work as quickly as they could, and they pulled out the electrical cardioversion machine to regulate her heartbeat. Apparently, she suffered a heart attack shortly after the paramedics arrived. Every second counts when someone is having a heart attack or a stroke. The paramedic laid the ECV on her chest and applied electricity onto her body. We saw her weak body jerk as the electricity passed from the ECV into her heart and body. Watching the ordeal, Sue-Lee started to cry. I grabbed her and held her tightly.

"She will be fine, honey. She is in good hands," I said.

They worked on her for the next twenty minutes, but unfortunately they had to pronounce her dead at the scene. It was painful to watch them lift her lifeless body up onto the stretcher and slowly cover her with a white blanket. Unconsciously, we felt a black haze fix itself over the sky, perilous lightning struck a couple of times, and the moon glowed over her body, creating a sudden sadness that surrounded us all. I could not believe that, just over an hour ago, I had seen her cross the street, and now she was deceased.

Is life really that fragile and unexpected?

Even though I didn't know her personally, I felt a sense of loss and pain. I had connected with her when I felt her weak pulse, when I touched her wet and finely textured skin. Her struggle for short breaths, trying to keep herself alive for another minute, was conquered by an unexpected heart attack that took her life away.

That experience left something really deep in my heart and in Sue-Lee's. That rainy night, we witnessed the fragility of human life. For the first time in our lives, Sue-Lee and I witnessed a lonely death, right before our eyes. What a sombre way to leave the world. The old lady died on the cold asphalt ground in the dark and in the rain without her family and friends. She was in the hands of strangers trying to keep her alive. There were no loved ones around her. The old lady died in the arms of strangers trying to save her. The darkness reflected a dark canvas.

I hoped and prayed that she had had a soulful life. A life so colourful that it reflected onto her canvas. I hoped I was wrong and she had experienced all that she wanted to in life. I hoped she had been loved and been in love with the people she cared about. I hoped she had travelled and explored places she had never been before. I hoped she had been appreciated for all that she had done in life.

That moment made me realize that life is just too short for us not to live it to the fullest. We should maximize our true potential to make the most of ourselves, push ourselves to reach higher, think bigger, and live richer.

THE CANVAS OF YOUR LIFE

What does your canvas look like? Is it painted with vibrant colours or is it monotone with just black and white? I guess at the end of the day, the colours on the canvas would depend on how you like your painting to look. Colours can reflect the journey that you have travelled to reach your

goals, accomplishments, and successes. Colours can also represent the happiness in your life.

My canvas is full of different colours injected from different periods of my life so far, some are darker and some are brighter than others. Each colour represents a challenge, a battle, a win, or a loss; some colours are intentionally painted on and some are accidentally dripped onto the canvas. All in all, they look fine together.

I have always aspired to be an artist, whether in fine or commercial arts. I loved to draw even when I was a little child. Every summer, I would sit by Grandpa Lee in his summer mansion and draw all day long. We didn't converse without a reason. He allowed me to express my thoughts through my art and his strong silent presence was enough to give me creative power to put colours onto paper. There would be a stack of drawings at the end of each day; he must have collected heaps of my amateur artwork.

His few words of affirmation gave me a desire to pursue my career as an artist. I would save my pocket money just for art supplies. Whenever I had enough cash, the first thing I would do is head out to the supply store for pens, paper, paint colours, and markers. I love the art supply store. I remember spending all day just looking at the differently textured papers, the variety of intensity of colour in the pens and markers. The smell of crayons, acrylic paint, and brushes used to send me to heaven.

After high school in Singapore, I spent a year in college studying commerce and figured out it wasn't my cup of tea to be an accountant. I enrolled myself into a private art

school with the money I earned over summer at a part-time job. After three months of just pure joy in exploring my creativity and passion, I told my mother that I would like to further my career as a commercial artist. Being a rather practical woman, she believed that art doesn't put food on the table. She refused to pay for my school, and stated that if I insisted on pursing art, I might as well just go get a job—any job. I was so heartbroken—my passion as an artist was shattered.

WHAT ARE YOU PASSIONATE ABOUT?

The majority of professionals today can't identify what they want to create and achieve in their lives. They are in the dark about themselves. But there are some people who do know what they want, and can articulate it clearly, with passion. I know hundreds of stressed-out, overwhelmed women who long for more balance, control, and flexibility. Suddenly, in a desperate hunt for a new way to work, they embrace the belief that chucking their corporate life and launching an entrepreneurial venture will be the answer to their prayers. The problem is that an entrepreneurial life is not suited to everyone, and it is certainly no antidote for work-life imbalance. What they don't understand is that there are certain core values, mindsets, traits, and behaviours that are essential for entrepreneurial success. It takes an amazing amount of effort, skill, know-how, leadership talent, and vision to make it work.

Thousands of professionals choose the wrong "form" of work in an attempt to fulfill the right "essence" of what they want. They know what they want, but have taken a misguided path to get to it. Then, after crushing failure, they give up and stop moving forward.

To some people, the grass is not greener on the other side of the fence; they would refuse to change. Pick a lifestyle, not a job title. Select the lifestyle that you want; for example, working at the leisure of your own time and not someone else's clock, or have the ability to spend more time with the people you love. There are very few people who maintain the same career throughout their lives. Leave yourself wiggle room to switch careers, because there is every reason to believe that your interest may change due to circumstances.

We spend the first two decades of our lives in school being conditioned to have an intense results-oriented focus on almost everything. We set out to do X, Y or Z, and either accomplish them or not. If we do, fantastic, and if not, we have failed.

I have learned that life doesn't actually work that way all the time. Sure, it's nice always to have goals and to have something to work toward, but I have found that actually attaining all those goals is beside the point. When I was twenty, I sat down and wrote a list of goals I wanted to accomplish by my thirtieth birthday. The goals were ambitious and I took this list very seriously, at least for the first few years. Today at forty-six, even though there have been some delays, I've accomplished quite a few of those goals

and many have shifted along the way. But I'm actually really happy about them. Over the years, I have discovered that some of the goals I set for my life were not things I actually wanted, and setting those goals taught me what I want and what is really substantial in my life. The value in any endeavour almost always comes from the process of failing and trying, not in achieving.

Make sure you don't quit too early. Many people are impatient for the reward and want it yesterday, without making the commitment. People who have risen to the top of their field, are also making a large contribution in the world. By and large, they have worked for many years to refine their craft, perfect their messages, amass knowledge and expertise, and close their integrity gaps between who they are and what they do. They have demonstrated intensive long-term commitment and incredible courage—walking through walls of fear and resistance to make the impact they want.

The biggest obstacle in the way of achieving large career dreams is an unwillingness to "stretch." The stark reality is that you can't go from Point A to Point Z without transforming yourself. To be successful in anything, you have to continually stretch and expand yourself far beyond your comfort zone and learn to walk directly into experiences that would scare the "old you" to death.

I believe in dreaming big and expanding myself. Don't let your ego stop you from being bigger than you currently are. Ask for help if you need to, and reach your goals in a realistic and committed way. Remember, the bigger the

dream, the more you have to work at it, because nothing comes free.

Life is a Story, Make Yours the Best Seller

"*Your imperfections are what make you beautiful.***"**
Sandra Bullock

We are all authors of our lives. Believe it or not, we write our own stories. It could be a romantic comedy, drama, fiction, or even inspirational. The chapters of our lives may depend on the events that happen, but how we deal with those events paints the words on a white piece of paper and, as the story evolves, pages are then added onto the book.

A good romantic comedy doesn't just happen, it is created with the mentality of being a jovial person who loves to entertain and be loved. Designing your story is hard work. In order for us to have a great design, it is important to set our principles early on so they provide a powerful metaphor to guide us throughout our story.

A good inspirational book requires the author to experience a life-changing odyssey, taking that adventure and converting it from darkness into light, negatives into positives, and sadness into happiness. It requires taking his or her own lessons and showing others different ways to improve theirs; different choices others can choose from.

Three Powerful Gifts

Three most powerful gifts in life are the power of choice, the power of change, and the power of our minds.

The Power of Choice

Have you heard of analysis paralysis? Overanalysis can lead to paralysis. Don't be afraid to make a choice. Trust that if you start down the wrong path, the universe will correct you and set you right again. Happily successful women are decisive. As soon as we decide to live a happier and healthier life, the universe moves in miraculous ways to get us there. Yes, happiness is a choice. Everything that surrounds us is energy-driven. If we shift our attention, we also change the vibration of the energy. If we focus on negative events in the world, we vibrate with that negativity and we feel negative and we create negative situations. If we focus on the loving events of the world, we vibrate with that love and we feel love and we create loving situations. It is that simple.

It is like the law of attraction: "like attracts like" and "birds of a feather flock together." It is like an energy magnet. If you are unhappy, it is because of the choices you have made. If you are happy, it is also because of the choices you have made. The choice you make can catapult you to success and happiness or it can plunge you into failure and sorrow. That is why it is so important to choose to be happy.

We make choices every day, from the tiniest most un-conscious choice of picking the brand of toothpaste to the most challenging and thought-out choice of leaving something behind to follow your values and dream. Some choices we make with purpose, and some we make by not taking action—simply by choosing to go with the status quo. Some choices are life-changing, like career choices, life-partner choices, and value-based choices. If you have a hard time deciding what to do, ask yourself whether this change is important to you and your goals. If you make this choice today, what will it mean tomorrow? Next month? Next year? Whatever you choose to do, do not flip the coin. Just make your choice with intention and follow through.

THE POWER OF CHANGE

Change is a scary word. The majority of human beings do not care for change too much. Our brain functions in a way that it dislikes changing habits, habits that have devel-oped slowly over the years, like the route we drive our kids to school or the way we like to wear our hair. Changing a habit is not as easy as it sounds because we have already programmed our mind to think a certain way. Emotional change is even harder; it takes determination to make ad-justments in the way we think—especially in connection with our self-esteem, confidence, and self-acceptance.

Self-esteem is an issue for many women and, in these days of ultra-thin models and supermom expectations,

that should not surprise us. What is surprising is how quick we are to accept another person's judgment and how serious our lack of faith in ourselves can become. I grew up in an environment where boys take precedence over girls, and I had to work so much harder to get a little more attention. Then I experienced the man I adored not staying around too long. It is no wonder I react the way I do when I look at myself in the mirror. Self-esteem can be hard to define. More than just feeling good about yourself, taking pride in your accomplishments, or liking what you see in the mirror, self-esteem is concerned with the way we judge our own worth. I started to wonder whether there was something wrong with me, and that thought shook my confidence and self-love. Over the years of negative thoughts, I had convinced myself that I was worthless.

If it were not for Benjamin's three powerful words, "I love you," which injected the idea that someone actually loved and cared for me, I think I would still be swimming in the pool of low self-esteem. It took me years to work on myself, change the way I think, and start to be more comfortable in my own skin. I even changed my environment so I could have a fresh start, but recovering a sense of self-worth takes more than just a change of scene; it requires a change of perception. The world can be a scary place when you don't like yourself too much.

In 2000, God came into my life. I learned that we are each given tough experiences in life to make us stronger and bigger, and during my journey he was with me and always will be.

> " *I have chosen you and have not rejected you. So do not fear, for I am with you; do not be dismayed, for I am your God. I will strengthen you and help you; I will uphold you with my righteous right hand.* "
> **Isaiah 41:9&10**

As I learn more about my relationship with God, I learn how unconditionally he loves me, and when I experienced the ups and downs of life, he at the same time was sending angels to guide and protect me.

Ladies, it is due time to know that you were created to be beautiful and magnificent, and that you deserve the best of the best out there: the best life, the best partner worthy of you, the best career, and the best wardrobe. Do not put yourself on a discount rack! Price yourself as high as possible, because in his eyes, you have always been the special one that he created for a purpose. You are priceless. I am very thankful for the life he has given me. Although I had to walk through the snow while in labour and I had to count pennies to buy a loaf of bread, the lessons that I learned made me a stronger individual than before, and now I am his messenger to deliver the beauty of our strength as a person and take others under my wing to help them become even greater people. Go to a mirror and look at yourself and say, "You are beautiful and I love you!"

Recently I received an unexpected phone call from someone who called herself "Laura." This call started like

this, "Belynda, you don't know me, but I know you. I want to be you. Teach me to be you and to be as successful as you. Show me how to dress like you, talk like you, and have a position like you have." I have encountered many tough questions in my life, but not one that left me speechless.

After a moment of silence, I realized that this is a woman who is crying for help. She does not want to be like me; she just wants to be a better person. So I said to her, "I cannot teach you to be anyone. What you see in me is a final product of many years of mistakes, fear, loss, tears, and a lack of self-esteem. I am not who I am without being open to learn, to grow, and to have self-acceptance. It is through patience, diligence, and resilience that success has eventually rewarded me. I cannot teach you how to be me. You, however can make the best version of yourself. You need to be yourself. In order for you to be yourself, you first need to find yourself and know what exactly you want 'You' to look like. Don't try to be anyone else, because you are special in your own way."

Ladies, we are meant to chase dreams with zeal until we catch them; I know it is a lot of pressure watching others become successful more quickly than you. And because of that we exhaust our options and experiment with every formula in pursuit of the life we want. A huge part of our success is a simple matter of showing up, standing taller, and refusing to give up. There may come a time when you have tried everything and still success seems so distant and you don't understand why it continues to elude you. No matter how hard it may be—don't quit!

Stay open to learning the possibilities of improving and guarding yourself. "Luck is where preparation meets opportunity." Prepare yourself for the next battle. You may lose a few battles, but if you keep training and preparing yourself, you will eventually win the war. Trust yourself, trust the universe, and believe that you can be bigger than you are. When you trust yourself, the universe opens up infinite opportunities and possibilities. The more open you are, the greater your ability to receive happiness.

Just like fashion, life is forever changing. As you evolve with life, you will learn to accept recreating and reinventing yourself through mistakes. Be fluid and open. Nothing is ever permanent in our lives. Tell yourself that change is a good thing; that keeps life interesting. Remember that every good intention will reap rewards. They may not be immediate; they may not be in the near future; but if you give unconditionally, your fruits will yield without limit.

THE POWER OF THE MIND

Keep telling ourselves, we are in control, we are in control, we are in control. Sooner rather than later, the thoughts we manifest will become the truth.

Remember Forrest Gump? His mother kept telling him that he was "stupid is as stupid does" and his entire life, he was told that he was not going to be a bright kid, so he just settled for being dumb. For someone whose mind has been infested with thoughts of not being intelligent and accomplishing nothing more than the ordinary, his

success was amazing. Well, at the end, Forrest earned a scholarship at the University of Alabama, was named as the All-American football player, and received a Medal of Honor while serving for the United States of America. Who would have known that someone with a below-average intelligence would have such accolades in his life?

His mind was simple but strong and focused. That is a common mindset of all successful people out there. Successful people practise positive thinking frequently. Their minds have no room for negativity at all. Positive thinking is a mental and emotional attitude that focuses on the bright side of life and expects positive results. A positive person anticipates happiness, health, and success, and believes he or she can overcome any obstacle and difficulty. Sadly, positive thinking is not accepted by everyone. Some consider it as nonsense, and ridicule those who follow it, but there are a growing number of people, who accept positive thinking as a fact, and believe its effectiveness.

Positive and negative thinking are contagious. We affect, and are affected by the people we meet, in one way or another. This happens instinctively and on a subconscious level, through words, thoughts, and feelings, and through body language. Is it any wonder that we want to be around positive people, and prefer to avoid negative ones? People are more disposed to help us if we are positive, and they dislike and avoid anyone broadcasting negativity. Negative thoughts, words, and attitude create negative and unhappy feelings, moods, and behaviour. When the mind is negative, poisons are released into the blood, which cause more

unhappiness and negativity. This is the way to failure, frustration, and disappointment.

Another side of mental strength is known as mental toughness; it is something that mostly athletes and sports people train in. Mental toughness is a compilation of attributes that allows a person to persevere through difficult circumstances and emerge without losing confidence. Once you acquire mental toughness, you then have the ability to outperform others easily, and consistently perform at the upper level of your talent and skills. How do we develop mental toughness? First of all, we need to establish our core values; core values are our morals. Our core value is what you value and what you think is ethical. For example, are honesty, integrity, hard work, dedication, and self-discipline in your book of core values? If you are still unsure, you need to spend some time in finding out what your core values are.

Have you heard of the law of success? The inside of our heads determines the outside of our lives. Our thoughts and feelings attract our life to us. The way we view the world is how the world views us. We are how we think. If we are critical of ourselves and other people, we will attract more of what we are critical. Garbage in, garbage out. Greatness in, greatness out. By simply managing our minds, we can change the effects of our lives.

The law of self-talk is the conversation we have with ourselves. How we talk to ourselves is how we will think, act, and believe. Our self-talk can single-handedly change our destiny. Yes, we are our worst enemy or our biggest fan.

Start using some of these self-talk messages: I am a winner; I deserve to be successful; I have the power; I am in control; I am strong; great things happen to me; I deserve greatness. Positive self-talk will build your self-esteem, and until you have high self-esteem you cannot truly love someone else for who and what they are.

We are so close to a new beginning for you. Desire greatness in your life, and once you are ready as a student, coachable and teachable, your teacher will appear. Learn to listen well and apply what is being taught. Don't be ungrateful and disrespectful to people who have helped you along your journey. Persevere all the way, because perseverance allows you to fulfill your dream and not allow others to get in your way. In order to achieve great dreams, you will need perseverance to get through the tough times and cherish your success. Lastly, learn to compliment. Be loud with compliments and quiet with criticisms. Complimenting others will help build self-esteem for the person giving the compliment and the person receiving the compliments. It is a win-win situation.

Now look at your canvas of life. How does it look? Does it have a ton of colours that are vibrant and bold? Go enjoy your life, make it your mission to create, express, and inspire. Love life. Enjoy the creative process. Play and have fun. Commit to growing. Make different decisions. Even the great can be greater. You are not too young to teach nor too old to learn. Last but not least, trust that whatever you believe in, it will come true.

> *"Two important things are to have a genuine interest in people and to be kind to them. Kindness, I've discovered is everything in life."*
> **Isaac Bashevis Singer**

As the Master of Ceremonies read the description of the next award—Spirit, Success & Soul—at the 10th Annual Vancouver WOW (Women of Worth) Conference at the Grand Villa Resort Ballroom in Burnaby, British Columbia, the audience quietened down and anxiously waited to find out who she might be. I, on the other hand, was secretly hoping for her to announce the name of my dear friend, whom I had nominated for the award. I wanted to see my friend go on stage and proudly receive that honourable award. She was Sue Dumais, who had just finished writing her third book, *Heart Led Living* (Influence Publishing 2014), which focuses on soulful living by listening to your heart.

At this tenth WOW Conference on May 31, 2014, I also happened to be nominated, for the "WOW Leader of the Year" award; I had been selected as a finalist for the category. The women of worth credo is crystal clear to many. The organization recognizes women who are not only true and authentic, but at the same time exemplify self-value, self-respect, act as courageous role models for others, have learned from their challenges with fortitude and grace,

lead through empowerment and inspiration, and bring collaboration and celebration into the world.

Sue is more than just an author to me; she is a true friend who has shown me the power of healing. She has always been able to tell when I need to see her and when I need some healing time. My phone would ring and I would hear a softly spoken Sue saying, "Belynda, I think it's time to meet."

At first, I thought it was a coincidence. It is as if she has magic powers. Then it felt spooky. But after numerous calls that occurred every time I needed someone to speak to, I started to believe and accept that she is a gifted intuitive healer. She can feel and sense, even at a distance, the pain and feelings another person may have. Numerous times she would reach out to me to make sure I was okay, even when she was struggling with her own health. It was the first time in a very long time that I had encountered some-one who didn't know me that well who unconditionally cared for me as a person, without expecting anything back. In my eyes, she deserves more than just an award.

The only way for me to thank her and to show her how much I appreciate her for her kindness was to nominate her for a "WOW of Spirit, Success & Soul" award. It was a substantial recognition to someone who truly deserves it. And I had my fingers crossed for her category as they an-nounced the finalists. As they were describing the winner, I knew immediately it was her: they did such a fabulous job drawing the beautiful Sue Dumais, the one I know in my heart.

When they finally called out, "Please welcome on stage the winner for the WOW Spirit, Success & Soul award— Sue Dumais," I cheered so loudly at the top of my lungs that everyone around our table was probably wondering, "Who is that woman?"

I was truly happy that she had finally received the recognition she deserved, and not just any recognition, but one that Christine Awram, the founder of WOW had created and many women look up to. At that moment, I entirely forgot about being a nominee myself and I was totally content with being a finalist.

Three hundred women and men filled the room, all of them humbling, all of them ready to learn and celebrate others' successes, and all of them willing to push hard without ego and without judgment to share their experiences so others can learn from them. As I looked around the room, I was mesmerized by the glow on the women's faces, the genuine smiles and the beauty that shone from within. Christine Awram has done a superb job modelling the essentials of a successful woman and educating others about what it is to be purely authentic and real.

Many mistake success for status, money, and material goods. The truth is we cannot talk about success without mentioning happiness. Success cannot be without happiness; however, happiness can be without success. Happiness is a state of mind and it depends entirely on our thoughts. Our minds feed the hunger of self-fulfillment and self-contentment, and once we have those qualities, they radiate and manifest out to others, giving them permission to do the same.

I have known individuals who have heaps of money but could never find happiness. These individuals have mansions, cars, yachts, and bonds in the bank that would last them two lifetimes; yet they feel empty and unfulfilled. They are looking forward to acquiring their next equity, thinking that it will be the ultimate one leading them to happiness. Some are searching for things that they hope can fill the void in their lives, for example, being with a trophy partner whom they don't love; being part of an elite group in which they have to constantly maintain status, even as they involve themselves with narcotics and drugs; or even staying with a spouse they no longer endear, just so they can be portrayed as a complete family. True happiness is within you! It is in your heart, sitting there waiting for you to discover it. One cannot judge what the other wants in life.

I have not seen a happier and more fulfilled person than Sue Dumais. She lives with her husband who loves her, a step-daughter and son who look up to her, on an acreage with her Boston cross Bulldog, Chihuahua, and a few farm animals, and she drives a 2003 Jetta. Some may not see her as successful; but to me she has it all. Sue Dumais is able to be her true authentic self, spending time doing the things she enjoys, like healing and helping others, one at a time and in groups. She is, in my books, the most giving individual on the planet.

"*True giving happens when you give from the heart.***"**
Mohammad Ali

When I was young and growing up in an elite family, I was taught to build a huge bank account to portray my ultimate success. Well, that is partly right. Having money will definitely solve a lot of your security issues; but it does not provide a deeper sense of fulfillment, which will then harness self-confidence, self-love, and self-respect.

There are two phases in being a successful woman. Phase one ensures we are financially sufficient and phase two focuses on bringing happiness and fulfillment into our lives and others'. You determine what brings you happiness and fulfillment.

Remember in the last chapter, I talked about how our thoughts and feelings attract life to us. My goal was to share my analogy of Success for Women by communicating from various platforms. Well, just a few months ago, I received a call from Sharon Lechter, the founder and CEO of Pay Your Family First, and author of *Outwitting the Devil: The Secret to Freedom and Success*; and *Save Wisely, Spend Happily*. She is also the co-author of fourteen other books in the international bestseller series *Rich Dad Poor Dad*. Recently, she penned yet another great book called, *Think and Grow Rich for Women: Using Your Power to Create Success and Significance*. I thought to myself, "Why would a renowned author like her be calling me out of the blue, and how on earth did she find me?"

She later explained that while she was in the process of finishing writing a book, she thought of incorporating quotes from female leaders from different facets of life. One of them was to come from network marketing, and as she and her team sourced for female leaders, my name kept coming up. She wanted to include women who have created financial success for themselves and their families, while becoming leaders and mentors to millions of other women within the network-marketing industry.

I was totally sold by the idea of sharing, yet again, via another platform, so I have more opportunity to guide and mentor even more women. And this was my contribution to all her readers:

66 *Success is a creative act. It is also the best route to fulfillment, and totality. So while you are chasing success, start with doing things that make you feel complete even if they are out of the norm. There is nothing wrong with being a unique, elite performer. On your way to success, you may have opinions put upon you; ignore them and feed your hunger. Stay focused in igniting your greatest gift. Because once you have success, it will awaken joy, and that in itself is significant when you have both.* 99
Belynda Lee

Building a sisterhood of female leaders is key to bringing the leadership together so we can celebrate an open and nonjudgmental relationship, and at the same time, bring others under our wing for sponsorship and mentorship. We should always share our successes in terms of experience with the young ones, remembering that as females we do not have the abundance of sponsors and mentors that our male counterparts do. Thinking this way, in 2008, I started a "Women in Business" (WIB) tour where I worked, celebrating businesswomen in the company who have "made it" and were leading and mentoring others toward financial freedom. The reason was to encourage other women to strive for a better future by witnessing the success of any ordinary woman on stage sharing her story and her journey.

Nothing in life comes free and without work, and that was a great forum to teach and inspire others. After a few years of constant WIB conferences, women in the company felt a sense of recognition and accomplishment for what they have done. The morale was higher and their drive was stronger. Even the men started to show up, as they too realized the importance of learning from these women. I was overjoyed when I saw the results of years of planning and congregating female leaders across North America. Now, there is continuation of the female leadership; knowing the importance of bringing women together was the key to sustainability and succession planning. As a result of those conferences, women who once felt a lack of confidence and self-respect began to see the future they can possibly hold and the potential that they have.

" *Giving never happens by accident. It's always intentional.* **"**
Amy Grant

In 2012, host Sue Dumais, on behalf of the Women's Information Network, recognized the work that I had done through "Women in Business" and awarded me with an Outstanding Leadership Award at their Global Women's Summit in Vancouver, British Columbia. I didn't expect it; it was the very first award that I had received and even though I was honoured, I felt that I was merely doing the work that I love, which is to empower, educate, and show women the possibility to shoot higher and think bigger.

That recognition showed me that I was doing something right and ignited me with the power to shoot for something a little outside my comfort zone. By now you have read Chapter Seven - The Heart Beat In The Snow, which is an event I tried hard to erase from my memory, to not think of; I kept telling myself it was just a dream. No one wants to feel abandoned; no one wants to feel unloved and uncared for; and certainly no mother who is in labour wants to walk to find help in the blizzard with their toddler.

A few years ago, I was asked a life-changing question: "What do you really want to do in life?" The first thing that came into my mind was, "Help other women," and from nowhere, I blurted out, "Be their martini at the end of the day." That was an epiphany for me. Something so insubstantial turned into a giant revelation. It was an awakening

moment, knowing that I wanted to help people—especially women—to know that they are not alone in this world. People who are successful are ordinary people just like other ordinary people and each of us has a chance in life to accomplish more if we choose to do so.

I remember being told that I have to start sharing my story more openly even if it hurts, and that when I start to share more, I would also heal internally as well. I was filled with faith to step outside my network and slowly enter the mainstream, where my audience wouldn't know me on a personal or work level. I thought to myself, if in my world I could touch someone and change his or her direction by just sharing, that would be the happiest moment in my life. I began attending women's events, story forum events, conference calls, and locally driven communities events, so that I could have an opportunity to share and grow, and at the same time broaden my network; in other words, make new friends.

Through one of those events, I met Dwight Pledger and Dan Smith from Story Forum. These gentlemen have been personally trained and developed by motivational speaker Les Brown himself. They are high powered, strong storytellers who share their stories at various platforms just to touch and empower lives. After hearing my story at one of their events, they selected me out of the entire audience. They were moved and shocked from the pain and hurt that I had been carrying for so many years alone. They came to me that evening after the event and said, "Belynda Lee, we want to work with you. You have a powerful story that

the world needs to hear plus the gift of a speaker's voice so your audience hears you clearly. We think you are here for a bigger reason, which is to share your life experience and help others as well as yourself in the healing process. Please call us next week so we can chat more."

After just a few short sentences, we parted ways that day.

The following week went by so quickly, I almost forgot to call my new mentors. I picked up the phone and dialed the numbers they'd given me. I was not expecting much, except for them to tell me how much they charge for coaching. We spoke for roughly an hour and I popped the question, "So Dwight and Dan, what am I looking at for your coaching sessions?"

There was silence on the other end.

"Belynda, you are unique," Dwight said. "You have a story that would give people the shivers. You have the courage to step into your most uncomfortable place and willingly share your most painful experiences so others can grow and heal at the same time. Because of your desire to put yourself there, we will coach you at no cost. However, you need to promise us that whenever you have an available platform, you will share your story as widely as possible."

"You are going to coach me without a fee?" I asked in disbelief. They chuckled and confirmed.

"Yes we are, and we hope you can accept us as your coaches, mentors, and even sponsors. We feel that you are not only open, you are extremely coachable. So when a student is ready, I guess the teachers will appear. We know that you have experience onstage, but even the great can be greater!" Dwight replied.

"But always remember never to put yourself on a discount rack. From what we saw last week, I don't think you know what talent you possess, and your desire to empower the world—that just gave us goose bumps. Yes, we want to be part of your journey. And by the time we are done with you, you will be amazed at the audience you shift and the lives you change," Dan said.

We started to put a schedule together shortly after our call. They planned regular sessions with me every two weeks, but with my busy work schedule I was only able to make it to three sessions in four months. At every session, I cried uncontrollably as I shared my story, because it unravelled the most painful memories of my life. However, it did get better as I got into it and the more I did it, the more I was able to go deeper into my wound to pull out the darkest memories, even those I had tucked so far back that I had almost forgotten about them.

Dwight Pledger and Dan Smith continued to work with me without complaining about my absentee rate. They coached me on my tonality and content; they dug deep into my memory banks and discovered more pain. Those sessions were painful; however, I didn't stop. Instead, I wanted more because they had helped me heal so much in a very short time. Most importantly, I then understood that life contains both light and darkness, and not until you let go of the darkness is there room for the light to enter. I learned to give myself full permission to cry and express my utmost feelings, but I always remember that every time I visit my darkest experience something good will come out of it.

I have always been a positive individual, but their coaching made me an even more positive individual. A few months later, I was invited to a Story Forum teleconference where both influential and ordinary people would dial in to get inspired and at the same time have permission to critique the speaker in the presence of the entire audience. Dwight and Dan were hosts on the call and they were featuring a "Series of Women's Stories"; they invited me to share for the first time after the sessions that we'd had.

This was a different platform from the one I was used to. They were shocked at what they heard, after just three coaching sessions. I leaped into the call with authenticity. As I told my story, the memories of pain and suffering forced tears to stream down my cheeks as if it were the first time I had ever shared it. That was what we wanted to work on—the courage to speak from the heart. The pain was there but my goal was clear and all I was hoping for was to have a struggling single mom in the cyber audience who was in need of guidance and direction, and my story would give them hope.

After forty minutes of telling my painful journey and twenty minutes of questions and answers, offering constructive criticism on how to improve my story, Dwight and Dan were impressed that I handled it well, and blurted out, "You have finally done it! After just a few short sessions, you trusted and allowed yourself to share your story from the bottom of your heart, in hopes that others will learn from it, even when it pains you."

They were more than pleased with me that I had finally opened up to become vulnerable. I was so grateful to have them as my coaches (more like angels) who have come into my life unexpectedly to guide me along my journey.

On that Story Forum teleconference was a very influential woman from the African-American community named Dr. Deavra Daughtry, Founder and CEO of Texas Women's Empowerment Foundation. She was touched by my story, particularly by the fact that I held a high executive position and still wished to serve the community by changing others' lives via speaking and empowering. That year at the 7th Annual International Financial and Leadership Summit presented by the Texas Women's Empowerment Foundation in September 2013, Dr. Deavra Daughtry recognized me for an Outstanding International Leadership award for my leadership role as a vice president and my contribution to society as an inspirational speaker at various empowering platforms. I was the first Canadian to have received such a prestigious award. This esteemed award has been presented to many famous individuals like John Maxwell, Les Brown, and Daymond John to name a few. I was recognized along with these influential people. That just confirms that when you are ready to receive for the right reasons, the universe will be there to support and open new doors for you.

That award was another engine firing me up to continue my empowerment journey and the promise I had made to Dwight and Dan that I would share my story at every possible platform so I can change and touch as many lives as possible.

Even trying to empower others through all the speaking opportunities that I garner, inside me, I still sometimes question my own worthiness. "Have I done enough?" and "Should I do more?" are some of the questions I would ask myself. Those questions circled around me for years.

On February 28, 2014, I received an email from Christine Awram, Founder of Women of Worth saying, "Congratulations, Belynda, you've been nominated by Linda Li, for one of the highly esteemed 2014 Woman of Worth Awards 'Leader of the Year.' You've made a difference in someone's life to the extent that they went out of their way to take the time and energy to honour you with a nomination. Please take a moment to breathe in that gift, because you inspired it and are worthy of it..."

In April, I received another email from Christine Awram, mentioning that WOW had received another nomination for me, this time from Germain Lafortune. By now, my heart was not only beating with gratitude, it was thumping with delight that finally someone had truly recognized me as a woman of worth. The word "worth" swam in my head for days, if not weeks. It has been one of the most important qualities that I constantly struggle to convince myself that I have. "I am a woman of worth—a true woman of worth." This became my mantra to convince myself I am worthy as a person.

A week went by and a notification came that I had been shortlisted; two weeks went by and I was notified that I had made it to the finals. WOW Leader of the Year is not an easy award to win; WOW takes its recipients very

seriously. I really wanted that award more than anything else, because I wanted so badly to be branded as a woman of worth.

As much as that was so important to me, when I heard Sue Dumais' name being called, I was more than happy heading home with being one of the finalists.

My mind was filled with joy as the Master of Ceremonies announced the next three awards that they had created in addition to the original ones because of the high calibre of nominees they had received in 2014. At my table were my ten closest friends and Benjamin, my son. My daughter Sue-Lee would have loved to have been there, but she was backpacking in Europe. I remember that morning having received a text from her saying, "Go get them, Tiger," which put a smile on my face. The room was filled with women and men all celebrating, and recognizing these deserving women.

Finally, the Master of Ceremonies announced the final award of the night and the most prestigious of all, the Leader of the Year. They then proceeded to describe the recipient.

"She is a trail blazer. She walks the path least travelled and turns it into a high-speed, high-traffic super highway. Within nine short years, she escalated from the position of office manager to director to general manager, and finally she acquired the position of vice president of Canada and the North American Asian market within the company. Her job was to grow national sales by growing the sales force, composed entirely of self-employed independent

distributors working from home. Almost 70 percent of them are women. She hit the ground running; she understood that before leading one must listen, and listen well. And so she did. She believed that the secret to substantially increasing national sales was through organic growth—meaning growth within—by nurturing, supporting, and coaching the existing key players and turning them into leaders.

"Since then, she has consistently, year after year, successfully grown national sales by double-digit growth. She has done so by empowering individuals—and most of them women, not so coincidentally—to achieve their own individual success. Indeed she created a legacy of leaders allowing hundreds (if not thousands) of self-employed individuals to achieve professional excellence and in the process, find financial security and beyond. For her, it was far more than sales and money or corporate targets; it was a concrete means for her to empower women, too many with humble beginnings, to grow into their full potential, to thrive as professionals, to have a sense of purpose at work and beyond, and in turn, to have real options in life, autonomy, and ultimately help more women achieve the same.

"Referring to the butterfly effect, she is fully committed to empowering women to empower other women so that the growing positive ripple effect will make this a better world for all of us. She walks the talk. Her success became a source of inspiration for her colleagues, employees, associates in the field, and the industry at large. She embodies

the very principle she teaches. Many of her protégés have reached nothing less than a spectacular level of financial success including qualifying for the company's elite group of the top twenty-five international producers, where many of them remain year, after year. She, in many eyes, has exemplified true leadership.

"Ladies and Gentleman, please help us welcome on stage the 'Leader of the Year' recipient for 2014, Belynda Lee."

I felt so honoured, especially when competing with a group of entrepreneurs as award finalist. I did do something right—thank GOD! As my entire table stood to support and cheer me to the stage, in my mind I had the most-unprepared thank-you address for the entire audience. Telling this story still brings up the emotions.

It took a lot of convincing for me to write this chapter, because I didn't want it to come across as a chapter of bragging. I trust it is rather a chapter of hope, of belief. I sincerely think that success doesn't come easily, but it takes a lot of hard work and tenacity to push through a day at a time, sometimes even going through hurt and pain to get where you want to be. But most importantly, we need to always have an internal reality check of where we are.

I am so blessed and thankful for the recognition that I have received. I want to thank all the people who nominated me, who believed in me, the organizations that recognized me, and especially those who have helped me heal and grow individually. But accolades are accolades. I am still the same Belynda Lee as I was years ago or even the young Belynda Lee who was trying to find acceptance

from her family. The only difference—which is quite significant in my case—is that I finally found myself. I have evolved through reinvention. My life experiences have provided me with more skills to help fulfill my life's desire and that is to continue telling stories, sharing what I know, and encouraging women to consider taking someone under their wing to guide, mentor, and help those in need to achieve their own independent success.

When I left my executive position recently with no back-up plan, was I nervous? Actually no. I was really at peace, because my mind was clear that I wanted to be surrounded by like-minded individuals. When we make a decision that is pure without vindictive repercussions, the universe tends to work with us. I will always be thankful for the opportunity that I was given. Although our paths together were brief, I am grateful for the experience I had. The decision to leave my job was not an easy one, as I have left hundreds of new friends that I made over my tenure there. However, I do need to fuel my urge to grow and expand.

Shortly after announcing my departure, Elizabeth Lawson from Lawson Executive Search called and said there was a giant company in the industry that was very interested in having me on board their executive team. Two days later, three more great opportunities came my way. I had a total of four fantastic job offers within two weeks after I departed from my position as a vice-president. To choose between the four offers wasn't easy at all. They flaunted their infrastructure, their buildings, their manufacturing facilities, and their potential.

I was pretty smitten by it all, but when it came right down to it. I was looking for something more than just organizational structure; I was looking for a heartbeat in the company. I wanted to be associated with people with servant leadership, and a team of people who purely want to help improve the lives of others. My vision has never been clearer. As a servant leader, I want to celebrate, serve, and empower the individuals who surround me, and my life mission is to associate myself with the same company. Birds of a feather do flock together.

Ladies, we are at the end of our journey here. Remember, once you find the fire inside you that you are totally passionate about, open up your heart to receive, as angels come to touch or help you along the way. Successful women are well prepared, resilient, and reign in their perfectionism; they are coachable, disciplined, and understand how they leverage their strengths.

Let us all pursue authentic happiness. A successful woman is also a happy woman, and happiness can literally prolong your life. Be happy in the everyday activities of life. Find satisfaction in whatever you do. Help others. It is a divine gift to be happy when life is a routine. Abraham Lincoln once said, "Most people are about as happy as they make up their minds to be." If that is right, then happiness is a choice. Pretty much everything we pursue because we believe it will make us happier, whether it is a relationship, money, changing careers, discovering our life purpose, gaining wisdom, or even losing weight. Happiness is one thing we pursue for our own sake.

While searching for happiness, don't forget to love yourself while helping others love themselves, and remember to say, "I love you," to the person in the mirror every morning.
With love,
Belynda XOXO

" I am strong because I know my weaknesses. I am beautiful because I am aware of my flaws. I am fearless because I learn to recognize illusion from real. I am wise because I learn from my mistakes. I am a lover because I felt hate and I can laugh because I have known sadness. "
Anonymous

With more than twenty years of sales and management experience, Belynda Lee has a vast knowledge of the relationship marketing industry. Her ability to work directly with those in the sales field to develop winning strategies has resulted in many individuals achieving personal and professional success. Her leadership and mentoring skills have created growing sales forces internationally and have won her several top awards across a variety of industries. She is also an expert in sophisticated sales models and has a vast knowledge of the direct selling industry. She has outstanding success in building and maintaining relationships with key corporate decision-makers, establishing large-volume, high-profile accounts with excellent levels of retention and loyalty.

Exceptionally well organized with a track record that demonstrates self-motivation, creativity, and initiative in achieving both personal and corporate goals, Belynda is extremely passionate about empowering women. In 2008, she started the Canadian Women in Business tour to highlight the success of female entrepreneurs. In 2012, she was presented with the Outstanding Leadership Award from

Global Women's Summit in Vancouver, Canada for creating a platform to recognize successful female entrepreneurs.

In 2013, at the 7th Annual International Leadership and Financial Summit, Dr. Deavra Daughtry, CEO of Texas Women's Empowerment Foundation, presented her with an International Leadership Award for her leadership role as a vice president and her contribution to society as an inspirational speaker at various empowering platforms. Belynda was the first Canadian to have received such a prestigious award.

In 2014, she was awarded Outstanding Chinese Woman in Canada by the United Global Chinese Women's Association of Canada and the Government of Canada. Most recently, Belynda was recognized as Leader of the Year at the 10th Annual Woman of Worth Conference in Vancouver, Canada.

It will always be her life passion to continue her journey to inspire, mentor and sponsor other women in helping them reach their highest potential in life or career.

Corporate Executive, Inspirational Speaker, Author

With more than 20 years of sales experience, Belynda Lee has worked directly with those in the sales field to develop winning strategies. Her leadership and mentoring skills have created growing sales forces internationally and have won her several top awards across a variety of industries.

Lee is passionate about empowering women and has worked with countless non-profits, business groups, and international associations/networks as a corporate executive and public speaker. She has appeared in the media in the U.S. and Canada, and has been the recipient of numerous awards.

Website: www.belyndalee.com
Twitter: @belyndalee
Facebook: /belyndalee

Past Speaking Events

- Conscious Diva
- USANA Health Sciences
- Direct Selling Association Conference
- Nerium International
- Women in Business
- Story Forum

Awards

- Outstanding Leadership Award, Global Women's Summit (2012)
- International Leadership Award, Texas Women's Empowerment Foundation (TWEF), 7th Annual International Leadership and Financial Summit (2013)
- Outstanding Chinese Women in Canada Award, United Chinese Women's Association of Canada and the Government of Canada (2014)
- WOW Leader of the Year, 10th Annual Woman of Worth Conference (2014)

If you want to get on the path to be a published author
by Influence Publishing please go to
www.InfluencePublishing.com

Inspiring books that influence change

More information on our other titles and how to submit
your own proposal can be found at
www.InfluencePublishing.com

on USANAtoday.com.

I truly love my job and the opportunity it gives me to work with amazing Associates like you. I look forward to continuing to watch your businesses grow and to see you fulfill your dreams.

Belynda Lee
Vice President of Canada & North American Asian Markets

your **health**. your **life**. your **way**. 21

CPSIA information can be obtained at www.ICGtesting.com
Printed in the USA
LVOW11s0722100914

403269LV00001B/6/P